D1270793

LEON BATTISTA ALBERTI

On Painting and On Sculpture

EDITED BY
CECIL GRAYSON

LEON BATTISTA ALBERTI

On Painting and On Sculpture

THE LATIN TEXTS OF

De Pictura and *De Statua*

EDITED WITH TRANSLATIONS
INTRODUCTION AND NOTES

BY CECIL GRAYSON

PHAIDON

701
A334o

PHAIDON PRESS LIMITED, 5 CROMWELL PLACE, LONDON SW7

PUBLISHED IN THE UNITED STATES OF AMERICA BY
PHAIDON PUBLISHERS, INC.
AND DISTRIBUTED BY PRAEGER PUBLISHERS, INC.
III FOURTH AVENUE, NEW YORK, N.Y.10003

FIRST PUBLISHED 1972
© 1972 BY PHAIDON PRESS LIMITED, LONDON
ALL RIGHTS RESERVED

ISBN 0 7148 1552 7
LIBRARY OF CONGRESS CATALOG CARD NUMBER: 75-190598

NO PART OF THIS PUBLICATION MAY BE REPRODUCED, STORED IN A
RETRIEVAL SYSTEM OR TRANSMITTED IN ANY FORM OR BY ANY MEANS,
ELECTRONIC, MECHANICAL, PHOTOCOPYING, RECORDING OR OTHERWISE,
WITHOUT THE PRIOR PERMISSION OF THE COPYRIGHT OWNER

N Alberti, Leon
7420 Battista
.A413
1972 On painting and On
 sculpture.
701 A334o

PRINTED AND BOUND IN GREAT BRITAIN AT THE PITMAN PRESS, BATH

Dabney Lancaster Library
Longwood College
Farmville, Virginia

CONTENTS

73-01560

Preface

THE principal object of this volume is to make available the texts of two major works of artistic theory, which in part reflected and in part determined the practice of painting and sculpture during the Italian Renaissance. In spite of their long acknowledged importance as the first modern treatises on these two arts, and in spite of their frequent use and quotation in all kinds of studies, the texts themselves have remained comparatively neglected, difficult of access and not infrequently misunderstood.

Alberti prepared two versions of his work on painting, in Latin and Italian. Of these the Italian version has undeservedly enjoyed the greater editorial fortune; less full and less precise in expression than the Latin version, it has been published several times and is available in a modern edition. The Latin text, on the other hand, has remained unpublished since 1649, when the first and unique Basle edition of 1540 was reprinted: neither of these editions is easily accessible outside major libraries. Yet this Latin text did survive in another form through a translation into Italian, done by Cosimo Bartoli in 1568, which passed for almost three centuries as Alberti's own Italian version, and served as a basis for translations into other languages, until Bonucci discovered and published the author's Italian text in 1847.

Alberti wrote his short treatise on sculpture in one version only, in Latin, but its place has for a long time been usurped by an inaccurate and wordy translation into Italian, also done by Cosimo Bartoli in 1568, from which other translations in various languages derived. In spite of Janitschek's edition of the original Latin text in 1877, which is now difficult to obtain, scholars have largely continued to accept as authentic and to quote from Bartoli's translation.

The time is, therefore, ripe for a critical republication of the Latin texts of these two works, and for a fresh attempt at their precise interpretation. With these objects in view, and in the belief that the texts can and should largely speak for themselves, this volume presents the original texts, reconstructed from manuscript and printed sources, together with an English translation on the facing page, which aims at an accurate and readable rendering of Alberti's written word. In view of what has been said above, it is hardly necessary to add that these Latin works have never before been translated into English. In other forms they have of course been the object of considerable commentary and study in editions, articles and books, and to these I

am much indebted for the preparation of the Introduction and Notes to this volume.

The Introduction is intended primarily as a presentation and general illustration of the texts. A full study of the many problems connected with them would require more than one volume and far exceed the limits and intentions of the present publication. I have confined myself to giving some indication of what these problems are and of the more recent studies devoted to them. Further information and illustration of a more detailed kind are provided in the Notes. In order not to encumber unduly the pages of the texts, the footnotes have been limited to brief indications of classical and other sources; more extensive commentary and diagrams will be found at the end of the texts. Finally, it seemed appropriate to gather together what little information we possess about Alberti's own activities as an artist; and this forms the subject of the short appendix, which concludes the volume.

Introduction

I. The Texts

(A) DE PICTURA

WRITTEN originally in Latin in Florence in 1435, and dedicated, probably between 1438 and 1444, to Giovanfrancesco Gonzaga of Mantua. Done into Italian by the author in or before July 1436 for the famous Florentine architect Filippo Brunelleschi.

Three MSS survive of the Italian version. Only one of these offers a reliable text; the other two suggest progressive corruption through what may have been a succession of workshop copies. It was first published in 1847 by A. Bonucci, and has been edited three times since then: in 1877 by Janitschek, in 1913 by Papini, and in 1950 by Mallè, in all cases from the same MS II.IV,38 of the Biblioteca Nazionale, Florence. The English version by J. R. Spencer is based on Mallè's edition.

There are twenty known MSS of the Latin redaction, which offer a complex pattern of variants such as to make it virtually impossible to construct a satisfactory stemma. All are of the latter half of the fifteenth century or later. None is autograph or bears autograph corrections. They fall, however, roughly into two major groups, and one of these groups, which significantly lacks the dedicatory letter to Gonzaga, would appear to represent an early draft, possibly of 1435, which was later emended by the author, perhaps at different times and on different copies. This hypothesis has some support also in the fact that the Italian version is akin to the group without the dedicatory letter, and that sporadic correction on different MSS and inattention to preparing a definitive redaction appears characteristic of Alberti in other works. This is a situation of little comfort to an editor who is faced with the task of reconstructing what the author might have done himself. To complicate the matter further, the first printed edition of the Latin text, published in Basle in 1540 (and reprinted in Amsterdam in 1649), hitherto used sporadically by scholars as an aid to elucidating problems of the better known Italian version, differs in no small measure from the readings offered by all the known MS tradition. In the circumstances it is difficult to accept this printed version as Alberti's authentic text. No further editions have been published since 1649.

The present edition is based on a group of six MSS which appear to represent the corrected version presented to Gonzaga. I have not hesitated, however, to accept

some readings from the other MSS and even from the Basle edition, where it seemed essential to integrate or correct the reading of the group taken as the base text. For easy reference I have divided the text into numbered paragraphs.

For a complete and detailed account of the MSS and of the textual problems involved, the reader is referred to the article cited at no. 13 in the following bibliography. He will also find there some discussion of the relationship between the Italian and Latin versions, whose similarities and dissimilarities can, however, only be fully appreciated when the two texts are published side by side (see item no. 14 of bibliography).

Bibliography

Editions

A. *The Italian version*

1. 'Della Pittura Libri III', in *Opere volgari di L. B. Alberti*, ed. A. Bonucci, vol. IV, Florence, 1847, pp. 11–86.
2. *Leon Battista Alberti's Kleinere Kunsttheoretische Schriften . . . mit einer Einleitung und Excursen versehen von Dr. H. Janitschek*, Vienna, 1877, pp. 47–163.
3. L. B. Alberti, *Il trattato della pittura e i cinque ordini architettonici*, ed. G. Papini, Lanciano, 1913.
4. *Della Pittura*, ed. Luigi Mallè, Florence, 1950.
[5. *On Painting* by L. B. Alberti, translated from the Italian with an introduction and notes by John R. Spencer, London, 1956, and (with some corrections) New Haven, Conn., 1966 (cfr. *The Art Bulletin*, LI, 1969, pp. 397–399).]

B. *The Latin version*

6. *De pictura praestantissima et nunquam satis laudata arte libri tres absolutissimi Leonis Baptistae de Albertis . . .*, Basle, Th. Venatorius, 1540.
7. *M. Vitruvii Pollionis De Architectura Libri decem*, followed by *Lexicon Vitruvianum* and *De pictura* (title as at n. 6 above), and *Excerpta ex dialogo De Sculptura Pomponii Gaurici*, Amsterdam, L. Elzevirum, 1649.
[8. *La pittura*, translated by Lodovico Domenichi, Venice, 1547.
9. *Della pittura*, in *Opuscoli morali di L. B. Alberti*, translated and edited by Cosimo Bartoli, Venice, 1568.]

C. *Textual problems*

10. GRAYSON, C., 'Studi su L. B. Alberti', in *Rinascimento*, IV, 1953, pp. 54–62 (concerning Mallè's edition, and the relationship between the Italian and Latin versions).

11. WATKINS, R., 'Note on the Parisian MS of L. B. Alberti's vernacular *Della Pittura*', in *Rinascimento*, VI, 1955, pp. 369–372.

12. MICHEL, P. H., 'Le traité *De la peinture* de L. B. Alberti: version latine et version vulgaire', in *Revue des études italiennes*, 1962, pp. 80–91.

13. GRAYSON, C., 'The text of Alberti's *De pictura*', in *Italian Studies*, XXIII, 1968, pp. 71–92.

14. ALBERTI, L. B., *Opere volgari*, ed. C. Grayson, vol. III, Bari, containing, *inter alia*, critical texts of both versions of this work on facing pages, and full examination of MSS and printed editions in the *Nota al Testo* (in the press).

15. MICHEL, P. H., *La pensée de L. B. Alberti*, Paris, 1930, pp. 23–24 contains bibliographical indications concerning translations into other languages than Italian, which stem from Bartoli's version cit. above at n. 9.

(B) DE STATUA

THE precise date of composition is not known. Ten MSS survive of the second half of the fifteenth century or later; none can be dated earlier than 1466, the year in which Giovanandrea de' Bussi became bishop of Aleria, though not all the MSS contain the letter with which Alberti sent the work to this learned ecclesiastic. This does not necessarily mean that the work was not written before that date. The MS tradition does, however, clarify one issue which has bedevilled the question of dating *De statua*, namely, the assumption that it was first written in Italian and even before *De pictura*. There is absolutely no evidence for such an assumption, or for accepting the Italian version published in 1568 by Cosimo Bartoli as a genuine Alberti redaction. The latter is a wordy and inaccurate translation by Bartoli himself. By rendering the phrase in *De statua*: 'verum de pictore alibi', as 'del pittore ne tratteremo altra volta', he gave rise to the supposition that this work must precede *De pictura*. The margin of probability is in favour of the contrary hypothesis. The absence of any reference to a work on sculpture in the so-called *Vita anonima* of Alberti (which lists his works down to about 1437), or among contemporary writers like Filarete (who, however, does mention *De pictura* and *De re aedificatoria*), suggests a late date of composition. For further discussion of this question see Introduction, pp. 18 ff.

Alberti's Latin text remained unpublished until 1877. Before that date Bartoli's Italian translation was published several times, and was included as an authentic text by Bonucci in his edition of Alberti's *Opere volgari*; it also formed the basis for translations into English and French. For his edition of 1877 Janitschek took his text from a Vatican MS: Ott. Lat. 1424, and gave variants from three Florentine MSS, two from the Riccardiana (nos. 767 and 927), and one from the Bibl. Nazionale (formerly P. IV. 39, now Magl. Cl. XVII. 6). Of these only the Vatican MS contains the letter to Bussi, and only the Florence MSS have the additional note added at the end of the text concerning the visible sections of three-dimensional bodies. Janitschek's edition does not pretend to offer a critical text, but the variants in his MSS are few and relatively insignificant, and raise few problems apart from the minor inconsistencies in the tables of measurements. It is regrettable that this edition, on the whole accurate or at least easily emended, has attracted far less attention and fewer readers than the pseudo-Albertian version in Italian.

The present edition is based on MS Canon. Misc. 172 of the Bodleian Library, Oxford, together with the group of MSS used by Janitschek. The Oxford MS is the most important and complete collection known of Alberti's Latin works, put together in the late fifteenth century. A critical edition would need to take account of the other MSS listed here below. Judging from the variants between the MSS already mentioned, and from soundings in the remaining five, I would anticipate few if any changes necessitated by a complete collation. The state of the MSS examined suggests that the author may have made minor amendments. Though this is somewhat contrary to his general habit of revision, it is by no means an isolated case. [As with *De pictura*. I have divided the text into paragraphs.]

Bibliography

A. *Manuscripts*

The following MSS contain *De statua*. Numbers 1, 3, 4, 5, 7, 8 have been consulted for the present edition.

1. Eton College, Bk. 6, 12 (dated 1544).
2. Florence, Biblioteca Nazionale, II. VIII. 58 (late 15th century).
3. Florence, Biblioteca Nazionale, Magl. XVII. 6 (17th century).
4. Florence, Biblioteca Riccardiana, 767 (16th century).
5. Florence, Biblioteca Riccardiana, 927 (16th century).
6. Milan, Biblioteca Ambrosiana, O. 80. sup. (late 15th century).
7. Oxford, Bodleian Library, Canon. Misc. 172 (late 15th century).

8. Rome, Biblioteca Vaticana, Ottobon. Lat. 1424 (late 15th century).

9. Rome, Biblioteca Vaticana, Lat. 5118 (dated 1493).

10. Rome, Biblioteca Vaticana, Arch. Segr. Vaticano, Misc. Arm. II. 81 (16th century).

B. *Editions*

[1. *Della statua*, in *Opuscoli morali di L. B. Alberti*, translated and edited by Cosimo Bartoli, Venice, 1568. This translation has been reprinted and edited recently by O. Morisani, Catania, 1961. For the numerous earlier reprints and translations made from it into English and French, see P. H. Michel, *La pensée de L. B. Alberti*, Paris, 1930, pp. 21–22.]

2. *L. B. Alberti's Kleinere Kunsttheoretische Schriften . . .*, ed. H. Janitschek, Vienna, 1877, pp. 167–205.

C. *Textual and Dating Problems*

I limit reference here to the most recent contributions, where earlier bibliography may be found.

1. FLACCAVENTO, G.,' Per una moderna traduzione del *De Statua* di L. B. Alberti', in *Cronache di Archeologia e Storia dell'Arte*, I, 1962, pp. 50–59, convincingly demonstrates that Bartoli's text is his own translation and not a publication or refurbishing of an original Italian version by Alberti.

2. ——, 'Sulla data del *De Statua* di L. B. Alberti', in *Commentari*, XVI, 1965, 3/4, pp. 216–221, argues persuasively for a late date of composition, but in my opinion too late. He would associate it with Alberti's treatise on cyphers, *De cifris*, of 1466; but he is incorrect in stating that *De statua* is found together with this work in all the known MSS but one. The two are together in five of the ten MSS listed above, and in four of those there is also present at least one other work of Alberti certainly written well before 1466.

For further indications concerning this question of dating see pp. 18 ff of this Introduction, and especially the works there cited of Parronchi and Janson.

II. The Art of Painting

ALBERTI wrote *De pictura* in 1435 in Florence, where he had moved the previous year with the papal entourage from Rome. Whether or not this was his first visit to Florence,—he could have been there any time from 1428, when the ban on the exiled Alberti family was lifted,—there is no doubt that the city and its leading artists made a tremendous impression on him. The well-known dedicatory letter to Brunelleschi of the Italian version of 1436 makes this abundantly clear, and at the same time it suggests that his association with Florentine artists was of more than merely those two years' standing. It is probable that he met Brunelleschi, Ghiberti, Donatello and Masaccio during their visits to Rome in the late 20s and early 30s. It is certain, however, that *De pictura* is not the product of just one year's stay in Florence nor simply of the encounter with Florence and her artists. The place and the people are highly significant for its composition at that particular time, but they do not explain a work whose basic preparation has longer roots in other places and studies, and differs from that of the professional artists.

The measure of this difference may be seen by comparing *De pictura* with the *Libro dell'arte* of Cennini on the one hand, and the *Commentari* of Ghiberti on the other. The first of these works, written early in the fifteenth century, admirably reflects the practice of the Trecento painter-artisan, preoccupied with workshop skills and problems. The second, written or rather put together some time from the late 1440s onwards, shows Ghiberti striving to come to formal and intellectual terms with ideas and theories he could more readily assimilate and express through his hands. The comparison serves, not to belittle either Cennini or Ghiberti, but to throw into sharp relief the extraordinary intellectual grasp and range of Alberti over the entire subject of his treatise. It also serves to underline a fundamental change, for which Alberti was largely responsible, in the concept of the painter and his art: the shift from the artisan to the learned artist creator.

This would not have come about without the assimilation, effected by Alberti, of art into humanist culture. He claims in *De pictura* to have created the theory of painting *ex novo*. He did this in part out of his own experience as a painter and as an observer of Nature, and in part from the study of art, history, literature and mathematics. There is no doubt that within his study of art, the acquaintance with the work and personalities of his Florentine contemporaries played a major role, and that in his treatise Alberti gave form and theoretical validity to certain aspects of their practice. The precedents of Masaccio's paintings, of Donatello's sculptures, of Brunelleschi's experiments in perspective, are certainly highly significant for

Alberti's theories. But he was something more than an able assimilator or codifier of other people's practice or intuitions. He was a learned man who practised the arts himself, and who, unlike the professional artist, could and did take an overall view of the history, purpose and object of art, and see it as a creative and interpretative activity which expresses in a particular way the relationship between Man and his Natural environment, and enriches his cultural and emotional life. He achieved this by bringing painting once more into contact with the classical tradition of art, literature and history.

A general survey of Alberti's sources, in the broad sense of the term, will serve to illuminate the significance of his treatise. His own claim to originality is well founded. As he states, none of the artistic writings of antiquity survived; and no modern writer had hitherto attempted the subject. There were, however, many literary accounts of and references to ancient art, and there were visible, if not Greek, at least Roman remains of monuments and sculptures. From these, and among the writers especially from Pliny, it was possible to reconstruct something of the history, but more important, the basic aesthetics of Greek and Roman art, and to see that it aimed at the representation of Nature in painting and sculpture. Reference to the notes of the present edition will show something of the extent to which Alberti extracted from literary and historical sources, and from some monuments and examples, the objects, procedures and developments of ancient art, and also the foundations of his own theories of imitation of Nature in painting. His historical-literary approach to painting, combining the study of written documents with that of artistic remains and modern examples, is typically humanistic, and characteristic, less of Florence, than of the Rome of Poggio Bracciolini, and later of Flavio Biondo. Yet, although this historical reconstruction of the principles and aims of ancient art is highly original and significant in itself, it is the connection with modern practice and theory that gives the reconstruction real point and constitutes Alberti's major contribution to the understanding and direction of Renaissance art.

It is significant that the only modern artist referred to by Alberti in the text of *De pictura* is Giotto, who is praised for the physical representation of emotional states (§42). There is no mention of developments in art since Giotto, or of the achievements of those contemporaries named in the letter to Brunelleschi. Alberti makes only general allusions to 'modern' painting and painters, and invariably to criticize: for lack of proportion (§39), for failure to realize their purpose (§§12, 56); for abuse of gold (§49). Yet the art of fourteenth- and fifteenth-century Italy is undoubtedly to be considered among his sources, and its sculpture perhaps more than its painting. Between Giotto and Alberti's times the two arts had evolved in

different ways and degrees towards a greater realism and naturalism of represent-
ation. Whatever the reasons for the beginnings of this process, and whatever forces
and traditions directed its development,—individual genius and/or imitation of
particular examples of the antique,—it took place among men who worked on a
practical ad hoc basis and did not conceive or formulate what they were doing in
relation to the aims and objects of art in general and to its past history. It can easily
be conceded that in the later stages of this process a relief or sculpture by Ghiberti
or Donatello is eloquent enough of the assimilation of some classical models or
ideals. But this is something different from a history and theory of art, which
explains the link between modern realistic tendencies and classical antecedents in
terms of the imitation of Nature, and lays the aesthetic, technical and social founda-
tions of painting as an art.

While it is, therefore, correct to insist on recent artistic practice as a principal
source of Alberti's treatise, it is no less important to stress the literary and historical
knowledge and understanding which enabled him to formulate ideas and theories
the professional artists were incapable of expressing. By linking in *De pictura* the
classical past with modern trends and practice, he taught the contemporary artist
his place in history and society, and showed him the nature and purpose of his art.
Indeed, he went beyond this, and beyond current practice to indicate methods and
subjects which had barely been attempted in painting, or not at all, and which were
subsequently to become standard features of Renaissance art.

In this treatise and in *De statua* Alberti is inclined at times to use the term 'pictura'
to embrace both painting and sculpture. Certainly for him they had identical
objects in imitating Nature; and one of the most important aspects of *De pictura*
lies in the assimilation into the art of painting of ideas which he could only have
known and seen to have been practised in sculpture, either in antiquity or among
his contemporaries. Their media were, of course, different, and this difference
involved a representational problem of prime importance for painting, namely,
how to reproduce three-dimensional space and objects on a two-dimensional sur-
face. To introduce the basic question of perspective in painting in this way is, ad-
mittedly, a gross over-simplification. It might imply, for example, a consciousness
of technical affinity between the two arts which we do not know (nor could Alberti
have known) to have been present in classical times; nor does such a consciousness
seem to have been behind the experience of painting and sculpture in the fourteenth
century, which made irregular and at times not dissimilar advances in three-
dimensional space relationships. Available evidence would appear to indicate that,
whereas classical sculpture envisaged and realized in the free-standing figure a
representation corresponding closely to Nature, ancient painting did not arrive at

that rational resolution of space relationships between figures, objects and background, which since Alberti we have come to take for granted. The same may be said, with some reserves, for the art which preceded Alberti, in the sense that sculpture had advanced with the single figure and group, and, perhaps more significantly for its greater nearness to painting, in reliefs, towards a more naturalistic and organized representation of objects in space, without, however, arriving at the perspectival conclusions and justification of them which we find in *De pictura*. Our reserves would relate more to painting, where Masaccio came nearest in practice to representations based on the idea of fixed-point perspective and correct foreshortening, though his works do not show that distribution in deep space which will be possible with Alberti's checker-board construction. In other words, in the early decades of the fifteenth century both painting and sculptural reliefs, especially with Masaccio and Ghiberti, were evolving along similar lines towards the kind of representation which is explained and justified in the theory of vision and fixed-point perspective set out by Alberti.

A great deal has been written on the subject of perspective and on Alberti's theories, especially in recent years; which relieves me of the need, even were it possible in this short introduction, to enter into detail. It is a commonplace in such writings to ascribe the initiative towards fixed-point perspective in painting to Brunelleschi, though there is no real evidence to support this view beyond the experiments described in his *Life* by Manetti. These are difficult to reconstruct exactly, and in any case do not offer or imply instruction on how to represent three-dimensional space on a two-dimensional surface. They are evidently akin to those 'miracles of painting' Alberti says he demonstrated in Rome (*De pictura*, §19). It is another matter to proceed from experiments in optics to a full-grown, mathematically based theory of vision applied to artistic representation, such as we are presented with in *De pictura*. This is founded essentially on a simplified theory of vision, in which rays of light travelling in straight lines convey information from the surfaces of objects to the eye, so that we see, geometrically speaking, in a visual pyramid, containing within it lesser pyramids and triangles that measure individual 'quantities' (i.e. dimensions) in our field of vision. Some of these pyramids and triangles will be larger or smaller according to the relative size of objects at the same or at further distance from the eye, but they will remain proportional to one another and to the main visual pyramid itself if you increase or reduce their distance from the eye. This theory takes no account of binocular vision or of the curvature of the retina; and although it contains allusions to the physiological and philosophical complexities of 'perspectiva', it sets them aside to formulate an empirical, geometrical explanation of monocular vision as a practical basis for pictorial

representation. Whilst it is, therefore, possible to indicate the sources for this in Euclidean optics and geometry and in the late medieval versions of, and commentaries on, Arabic works on optics, this stripping down of those theories to a simple working system, and their transfer from the realm of physiology, philosophy and theology to that of painting is really what constitutes Alberti's originality. His is the first deliberate and rational application of a theory of vision to the art and technique of painting.

This transfer may be seen as the confluence of two traditions: on the one hand, the already mentioned tendencies of the arts towards greater realism of objects and spatial relationships; and on the other, the increasing study and teaching of optics in the fourteenth and early fifteenth centuries. More specifically it may be seen in Alberti as the singular combination of the two interests, in the arts and in mathematics–optics, bridging and closing the traditional gap between the practising artist and the man of learning: a combination going back, in all probability, to his youth and early education in Padua and Bologna, where, according to the *Vita anonima*, he interspersed his legal training with the study of mathematics and physics (and where he could very well have attended lectures on optics). But this marriage of painting and optics could not have come about without the concept, fully developed in Alberti, of Art as imitation of Nature, and painting as the representation on a flat surface of figures and objects in their correct spatial relationships as the human eye would observe them in reality. Hence his famous visualization of painting as a window through which the observer, from a certain fixed viewpoint on this side, looks at the scene 'outside'. The painter's object is to represent on the surface corresponding to that window (the picture surface) the three-dimensional space 'beyond', which is continuous with that in which he himself stands. The window is the intersection of the visual pyramid, and at whatever distance the artist places this intersection, the objects 'beyond' will keep their same proportional size and position. Book I of *De pictura* is primarily concerned with this concept and mathematical basis of painting, with what he regards as the 'rudimenta' of the art. It is not possible to follow him through these in detail here: his text is clear enough except for some controversial passages, for which the reader may refer to the appropriate notes (pp. 108–114). We may simply add that from the date of composition of *De pictura* onwards Italian art was profoundly influenced by Alberti's rationalization of spatial relationships in painting. The mathematics of perspective became more sophisticated in the treatises of the sixteenth century, and its techniques were developed and exploited in unusual ways by the painters of the High Renaissance. In consequence Alberti's original initiative was soon absorbed and more or less forgotten, as the editorial fortune of his treatise suggests. This process

should not, however, be allowed to obscure his importance as the inventor of the theory of fixed-point perspective in painting.

Alberti also specifically claims to have invented a device for executing the correct intersection of the visual pyramid (§31): the 'velum' divided into marked squares, to be placed between the artist and the object(s) to be painted. As a technique it was later developed and much used. It was, of course, applicable only when reproducing from 'life' or from other paintings or sculptures. Although Alberti recommends this sort of activity for training and for studying the outlines and proportions of Nature, he is not, generally speaking, advocating a kind of through-the-window representation as the subject of art. The artist's object is certainly to give the spectator the spatial experience of window-gazing, in which the mathematics of vision and the general appearances and proportions of Nature will dictate basic relationships and attitudes. It does not follow from this methodological realism that the spectator should see a scene of 'real life'. The ideal Albertian painting will have as its subject what he calls a 'historia', inspired most probably by the reading of literature, in common with which it will narrate some action at a certain stage, fixing it in a representation which may also imply its antecedents and its future development. In principle there is nothing novel either in the term or in the idea. The comparison and similarity of poetry and painting go back to antiquity (cfr. Horace, *Ars poetica*, 361; Plutarch, *Moralia*, 18A); Pliny, for example, is full of descriptions of narrative paintings; late medieval art offered plenty of examples of representational painting based mainly on the Bible and on the lives of saints; Dante's *Purgatorio* (canto X) is decorated with 'storie' both classical and biblical; Petrarch's work inspired the decoration by Francesco da Carrara of the Sala virorum illustrium in Padua. What is new is Alberti's insistence on the 'historia' as *the* object of painting, and on the choice of the subject, its organization and execution, as the greatest achievement of the artist.

Alberti envisages the invention of the 'historia' as the free choice of the artist. Although he gives no explicit direction, his choice of examples suggests a bias, though not exclusive, towards secular subjects. As painting is a social art, whose object is to interest and please the public and attract the support of patrons, the artist will pay heed to their tastes and wishes, but such social limitations are far less significant for Alberti than aesthetic considerations. These may be summed up in proportion, harmony, movement, decorum, variety,—those features of organization and execution which for him constitute beauty in the painted 'historia'. It is easy to see that these considerations must inevitably influence the choice of his 'historia' as well as to some extent dictating its form; but it will be such as to permit the painter to explore and exploit, within certain limits, the variety of natural

objects, and especially of human forms and attitudes. For the details the reader is referred to §§35–45. The impression they may give is that Alberti's ideal painting would be a highly dramatic representation, full of action, movement of limbs, hair and clothing, with figures clothed, naked or half-naked, striking attitudes, exhorting or menacing the viewer. At the same time, despite his enthusiasm for variety of things and movements, Alberti is ever conscious of the need (and this is characteristic of the man in all his works) to avoid confusion and excess, to keep within the bounds of natural possibility, of decorum and appropriateness to the subject. Many things in this section of *De pictura* are, as has often been pointed out, among the most interesting and prophetic pronouncements made by any theorist of art, for they were destined to have an immediate effect on Renaissance painting and a long-lasting influence on academic art teaching. It is difficult in consequence not to see some of Alberti's recommendations in terms of later artistic and academic conventions. They were not so, of course, for him. For Alberti and for fifteenth-century artists they were the discovery and opening up of a whole new world of possibilities, not the formulation of rules or techniques to be pursued for their own sakes.

The important thing for Alberti was the 'historia' as a representation and inter-pretation of human life, and especially of human emotions. It is not inappropriate to apply the term 'involvement' to Alberti's artistic theory. His perspectival con-struction, as we have seen, places viewer and 'historia' in the same spatial continuum. His recommendations about the 'historia' all aim to identify the observer with the action of the painting on the emotive plane. Art must move the spectator, excite sympathy or pity or joy, stimulate his imagination either directly by what he sees, or even indirectly by suggestion of what might be implicit within the 'historia'. Hence Alberti's insistence on the external representation or suggestion of inner emotional states that will communicate themselves through the eye to the same basic emotions of the viewer. It is in this context he praises Giotto, and gives examples from classical art, taken mostly from Pliny, of remarkable pictorial realism of this nature. Judging from the examples he refers to, one would conclude that Alberti admitted any emotion into the 'historia' within the bounds of pro-priety, provided that everything in the composition agreed and conspired to the same end; in other words, that the work was both formally and emotionally a unity. He can praise the lifelessness of Meleager, or the grief of Iphigenia's father, or the dismay of the disciples painted by Giotto, whilst also commending in general terms movements and attitudes appropriate only to quite different subjects for painting. This sort of passage from particular examples to abstract consideration of move-ments suggests what were Alberti's own preferences within the open choice of the artist's 'historia', which seem to be for the dignified and optimistic, and for

restrained drama. He says when speaking of colours (§47): 'We all by nature love things that are open and bright'; and certainly the kinds of movements he recommends point rather in this same direction, and condition the significance he ascribes in painting to 'grace and beauty'.

Alberti repeatedly says that the artist must study and imitate Nature to achieve such beauty in his work. On the more elementary level this will teach him to represent bodies in correct proportion, with the right muscles and sinews, and in natural attitudes within the capacities of their structure, to depict properly the movement of hair and clothing, and to avoid all errors that do not correspond to observed experience, and so on. In relation, however, to imitation on a higher level, Alberti asks something more than likeness. The painter is advised to study and note all the varieties of human bodies, faces and limbs, and all their features and postures. But he must not fall into the error of Demetrius by painting things as they really are; he must pursue beauty, and find it, like Zeuxis, by conflating the most excellent parts from many bodies (§§55–56). Whilst observing all kinds of individual men, he will arrive at a kind of ideal representation of Man. Alberti seems to see this 'idea of beauty' as a transcendence of particular reality, a superior goal the painter must aim for. At the same time he recognizes that likeness taken directly from a known example of Nature has powerful attraction; but this is not a comfort, only a warning to the artist that he must go beyond realism if he is to be an excellent painter (§56). There would seem to be no problem here for Alberti of a gap between real and ideal. You learned the latter from study of exemplars of the former; and the object would be to arrive at a representation, not of this or that particular man, but of the perfect image of a given kind of man in a given position or emotion,— an exemplary likeness more convincing and more beautiful than reality itself. The matter is relevant, of course, to the kind of narrative, imaginative painting Alberti had in mind, where the artist is not taking his scene from contemporary life, but constructing his own vision of some 'historia', for which the original actors are not available as models. The artistic reality of the representation must be so complete and unified as to be capable of absorbing without distraction even a figure taken from a known contemporary. This indeed seems to be the import in this context of Alberti's observation that likeness attracts primarily because recognizable, not necessarily because more powerful aesthetically speaking. The painter who aims at beauty will gain recognition of another sort. This question of the relation between the particular and the ideal arises again in *De statua*, and we shall have more to say about it later in this Introduction (see pp. 23–24).

Another main aspect of painting which the artist will learn from Nature is how to make objects appear in relief, even though represented on a flat surface. This

depends on the study of light and shade, which should be properly distributed according to the position of the source or sources of light. Whatever deficiencies there may be in Alberti's theory of colour, he is quite clear and insistent about the use of white and black as determinants of relative light and shade, as moderators, not as colours in themselves. His attempt to identify the major colours with the prime elements of Nature shows a basic concern to bring this aspect of art also into closer contact with observed reality. This is in part the explanation of his antagonism to the use of gold, so characteristic of religious painting, which he rejects as a substitute for the proper use of colours; it is this which enriches painting, not the value of gold. Just as proportions are relative within art, so are colours, and it is the artist's task to explore that relationship, to emphasize its gradations and its reliefs by the subtle use of white and black. At the same time Alberti reveals a strikingly modern aesthetic intuition of the combinations and contrasts of colours, and gives advice on their juxtaposition in order to achieve pleasing variety and harmony and to express the mood of the painter's composition. He is clearly aware that such advice is of more interest and direct practical usefulness to the artist than a theory of colours in the abstract. Alberti prospects this subject, and puts in a theory of his own for what it is worth; but it is of far less importance for him than the aspects we have already identified, namely, the isolation of white and black as light and shade, and the need to understand and exploit the relationships of colours in their effects of agreement and contrast. They are of prime significance because they are intimately bound up in his artistic theory with relief, perspective, proportion, decorum, and imitation of Nature. Alberti took for granted, as we should also take for granted, that the painter would already know something about colour from a practical angle, and he does not descend, therefore, like Cennini, to the problems of finding or mixing pigments. His concern is with the principles governing their use, and the pleasing, three-dimensional effects the artist can achieve by wise combinations of colours and subtle gradations of light and shade.

Most of the principles in *De pictura* concern the understanding and application of methods and techniques that may be learned. There is no reference to inspiration or any kind of artistic 'furor'. Yet it is clear that Alberti's conception of art and artist is that of an exceptional activity and an exceptional man, who, like a god among mortals, recreates and interprets Man and Nature. In order to do this, he must be not only a man of learning, but also of good character, whose person is as socially acceptable as his works are attractive. He must know geometry, study Nature, read literature, observe and understand human life, and especially the relation between emotional states and physical attitudes or movements. His workshop must be open to friends and visitors, and his mind to suggestions and criticism

without compromising his own judgement and independence about the finished work. Seen from Alberti's standpoint, painting is an expression of the whole man and of his ethical and spatial relationship with his environment. It is apparent from the examples Alberti quotes that the models for this conception of the artist are classical and particularly Greek from the pages of Pliny. Yet this conception was beginning to be relevant and applicable to contemporary Italy, and in this respect *De pictura* clearly anticipated and probably helped to determine the idea of the artist and his social relationships that became typical of the later Renaissance.

However, just as it is difficult or indeed impossible to find in preceding or contemporary painting many of the features Alberti describes in this work, so it is difficult to identify among contemporary painters anyone who fulfilled completely the idea he formulates of the excellent artist. Where the classical sources are so evident, it is unnecessary to imagine, as some have done, that this is based on Alberti himself. He was, and knew himself to be, an amateur painter, and we know too little of his work now to have any adequate idea of its quality (see Appendix). But whether he was good or mediocre or bad is irrelevant to the significance of his theory. Unlike any other learned man or professional artist of his own time or for a long time afterwards, he understood and formulated the objects and purposes of art, not because he might be an excellent artist himself, but because he studied history, literature, Nature and art, and saw painting as a rationally organizable representation of human activity in orderly relation to natural environment. With Alberti, painting becomes a humanistic subject and pursuit, the visual projection of a harmonious and balanced interpretation of human life, that both pleases and edifies.

III. The Art of Sculpture

As we have already observed (p. 5), there is a lack of decisive philological evidence for the dating of *De statua*, yet other considerations suggest it was written later than *De pictura*. In comparison with this work, *De statua* is perhaps disappointingly brief, and after a promising general introduction, seems mainly concerned with technical methods and details. This character of the work might in itself suggest that it belongs to the years after Alberti returned to Rome from Florence in 1443. In the decade that followed he wrote several highly technical works which have close affinities with *De statua*, particularly his *Descriptio Urbis Romae* and *Ludi matematici*, in which methods and instruments of measurement similar to those of *De statua* are described. These interests, especially in surveying and related matters, also find expression in his architectural treatise, *De re aedificatoria*, completed by 1452. It might be argued that *De pictura*, especially book I, is also technical, but it does not show that powerful concern with physical measurement evident in his writings in the decade after 1443. It has, however, been held in the past and argued in more recent years that the work on sculpture came before that on painting. Some of the supporting evidence for this view has weakened or disappeared: the passage in *De statua* 'de pictura alibi' misleadingly translated by Bartoli, and the date of *Descriptio Urbis Romae*, now moved from the early 30s to the 40s. There remain considerations of a different kind concerning content, which it will be opportune to review here also for the light they throw on the interpretation of the text and its relationship to *De pictura*.

De statua is obviously a much less ambitious and more limited treatment of sculpture than the parent work on painting. It also has a rather unfinished air. May we infer from this that the shorter work is the earlier, and that in some ways *De pictura* represents a development from, even away from, certain ideas of *De statua*? Professor Janson has recently discussed the originality of Alberti's theory of the beginnings of the arts in the opening paragraphs of the text, suggesting some possible classical sources and contemporary parallels, and at the same time implying that its absence from *De pictura* (where the Narcissus myth is associated with the origins of painting: §26, and note, p. 114) probably means he had then abandoned the earlier theory of *De statua*. Close reading of the first paragraph of this work makes it clear that Alberti is speaking of the origins of the plastic arts and explicitly not of painting, and the two theories are not mutually exclusive. Indeed, it might be argued that the casual reference in *De pictura* (§28) to 'images made by chance' in Nature implies that at the time of writing that passage he did not envisage such

phenomena as the starting point of the plastic arts they later became for him in *De statua*.

A further point, stressed most recently by Professor Parronchi, is the disparity between the two works in the matter of the unit of measurement of the human body. In *De pictura* (§36) Alberti declares a preference for the head, as against the foot (Vitruvius), observing, however, that they are just about the same. In *De statua* the unit of his rule (the 'exempeda') is a 'foot', but this corresponds in the tables of measurements, not to the distance 'from the chin to the top of the head' (as in *De pictura*) but 'from the fork of the throat to the head'. The question is: which way round are these statements chronologically? Alberti's concern with such matters seems far less precise in *De pictura*, where the issue is further complicated by the division of the human body into 'braccia' (arms); and what is really important for his purpose is simply that, whatever unit of the body is taken, the rest should be in proportion and harmony. There is no insistence on exact measurement or on what the proportion of the parts should be. By contrast the measurements and proportions in *De statua* are extremely precise, and, Alberti assures us, based on the mean figures taken from many examples. Rather, therefore, than supposing (with Professor Seymour), along traditional lines of dating, that Alberti adapted the proportions of the earlier *De statua* to the diminished size of human figures in painting in *De pictura*, we might argue conversely that in dealing with painting this sort of problem did not pose itself acutely to Alberti, but that in his later consideration of sculpture of life size or greater, and in three-dimensional form, it became inescapable.

On another technical detail, Professor Parronchi would also see a progression in Alberti's anatomical interests, from a merely passing concern in *De statua* (§13) for bones and sinews and muscles, to the clear advice given in *De pictura* (§36) to the painter to draw these first and then add flesh to the naked body. The difference, as Parronchi himself admits, is slight, and insufficient to decide a matter of priority, which we may help to resolve instead by looking more closely at the character and object of the two treatises, and at the relative interest of the author in their subjects. In the first place, such evidence as we possess suggests that he was more interested in the theory and practice of painting than of sculpture (see Appendix), believing, as he says in *De pictura* (§§26–27), that painting was the superior and more difficult art. This does not mean that he was not very interested in sculpture and did not learn from it many things useful for painting. But if he wrote *De statua* first at the time of his early acquaintance with Donatello and Ghiberti, it is still difficult to understand why he should not then have developed far more the history and aims of sculpture, as he did for painting in *De pictura*. It could hardly be argued that

the achievements of Florentine sculptors by that date made the need to formulate the history and theory of sculpture less obvious or urgent. Yet *De statua* does not appear to respond like *De pictura* to the contemporary scene. The evident enthusiasm Alberti shows for painting, and especially the content and tone of his letter to Brunelleschi, suggest strongly that *De pictura* is his first artistic treatise, in which he is at great pains to explore all the implications of his subject with a lively sense of confidence in his own originality. Most of these attributes are lacking in *De statua*, and it is relevant to seek the reasons for this.

The fact is that *De statua* is not a treatise of the same kind at all as *De pictura* in its structure or aims. Its main subject is the description of instruments and methods of measurement of the human figure, the 'exempeda' and 'squares', and the 'finitorium', with which one can even construct something of colossal size, or in two parts in different places, with unerring accuracy. The introductory part, which promises so well, looks simply like the entry into a disquisition on mathematics applied to the reproduction of three-dimensional forms, designed to give the sculptor the technical advantages possessed by other 'constructors' (builders, naval architects, etc.). Apart from the statement, parallel to that in *De pictura*, that sculpture strives to create bodies similar to the real bodies of Nature, there is no discussion of the aims or other problems of the sculptor. Alberti's concern here seems a comparatively limited and predominantly technical one. Even the important distinction made between portraits of Man or of a particular person, is made to serve the purpose of dividing the functions of the two sets of instruments. So that, when he comes to the end of the mathematical part, Alberti seems somewhat unsure of whether or how to continue the work further, and concludes by referring to questions and needs which he does not attempt to answer or discuss. This 'breve compendium', as it is called in several MSS, stops in mid-air.

This relatively narrow scope of *De statua* might perhaps be explained in two ways: either it was an early work, written even before Alberti's acquaintance with Florentine artists, when he had not yet developed general ideas about the arts; or it was written much later, say between 1443 and 1452, when all the precedents of their work and his own *De pictura* could be taken for granted. The limitations of *De statua*, in other words, are either unconscious or deliberate. The evidence on balance seems to point to the latter. It is difficult to imagine Alberti approaching the arts for the first time with *De statua*; it is far easier to see him later on, in the context of other technical works, applying his practical mathematical talents to a particular aspect of sculpture. Indeed, there is evidence in *De re aedificatoria*, completed in 1452, that he then thought of statuary in the same terms as in *De statua*. The concluding paragraphs of bk. VII, ch. 16, concern statues, and include many examples of

colossal effigies drawn from ancient writers, among them Diodorus Siculus. From this same author Alberti then derives the following statement: '. . . apud Diodorum legimus: statuarios Aegyptios tantum valere solitos arte et ingenio, ut ex variis lapidibus diversis positis locis unum simulacri corpus conficerent, conventu partium adeo perfinito, ut uno loco eodem ab artifice esse perfecta videretur. Miroque hoc ex artificio celebre illud apud Samios Phitii Apollinis simulacrum extitisse praedicant, cuius media fuerit pars Thellesii opus, reliquam vero partem in Epheso Theodorus perfinierit'. Not only does the same preoccupation with 'colossi' appear in *De statua* (and Alberti underlines this as a purpose of the work in his letter to Giovan Andrea de' Bussi), but there is the same obsession with the precision required and obtainable to construct a statue in two parts in different places and make them fit exactly (§§5, 11). In *De statua*, Alberti gives a great deal of emphasis to such problems and the methods of solving them, and it is, therefore, probable that they arose in his mind at the same time as, or soon after he made those observations in *De re aedificatoria*. This would take us to the late 40s or early 50s. Perhaps it is no coincidence that Diodorus Siculus, known in Italy in the Greek text from the 1420s, was translated into Latin by Poggio Bracciolini in 1449.

This is not the only point of contact between *De statua* and *De re aedificatoria*. In his interesting article on 'The image made by chance', already referred to, Professor Janson takes his survey somewhat beyond the intentions and implications of the opening paragraphs of *De statua*. There is no doubt that they do contain a novel explanation of the origins of the plastic arts; for although writers like Pliny cite instances of such images in natural objects, no one before Alberti thought of these as the start of the plastic arts. Yet we should see this as Alberti sees it, and not extend his meaning to identify the theory with that of more modern 'chance' art. There is no element of fantasy in Alberti's statement. He simply says that the beginnings of the arts that make images from natural solid material arose from Man's observation that Nature herself sometimes makes near-images of other things from her own objects. There is little or nothing to suggest he thought of this as a continuing process. Everything points rather in the opposite direction; for Man soon discovered how to make images without that sort of natural start, and it is his control over matter that constitutes art: he can make what he wants, how he wants, once he has learned the principles and techniques. The imaginings of Piero di Cosimo or of Leonardo, which Professor Janson quotes, are not present in Alberti's text. Still further away are the ideas of the eighteenth century and later, of chance images as a method of painting. There is nothing in Alberti's theories of art to suggest he could advocate, literally or metaphorically, 'throwing the sponge at a painting'. Nor does it seem necessary to invoke the Daphne legend, or Mantegna's *Mater Virtutum* to

explain why Alberti should think of tree-trunks as somehow pre-figuring human forms. Wood and earth and stone are Nature's commonest materials, and the tree, according to Alberti's information, was the earliest provider of statues. In *De re aedificatoria*, bk. VII, ch. 17, he writes:

'Prisci—inquit Plutarchus—ex ligno simulacra faciebant, uti in Delo Apollinis, utique in urbe Populonia Iovis ex vite, quod annis incorruptum mansisse multis ferunt, utique Dianae Ephesiae, quod alii ex ebano, Mutianus ex vite fuisse tradit. Peras, qui templum [Junonis] Argolicae condidit et filiam antistitem consecravit, ex trunco piri Iovem effecit'.

This kind of historical information, together with the common experience of similarity between some trees and human form, would be sufficient to back Alberti's reference to tree-trunks in §1 of *De statua*. The idea, in any event, is without further development in that text. His own preferences for materials in statuary are stated in Bk. VII of *De re aedificatoria*; they are for bronze and marble, and they presuppose no help from Nature.

Nothing I have said above is in any way intended to belittle the importance of Alberti's intuition about the origins of the plastic arts, but simply to define its nature and limitations within *De statua*. Nor did I intend, in a passing reference above (p. 20) to the sculptors' aims (§2, that 'the work they have undertaken shall appear to the observer to be similar to the real objects of Nature'), to underestimate the significance for Alberti of the perspective in three dimensions of the freestanding figure. This is apparent, as well as from that brief explicit statement, also from the mathematical methodology of the work. It would be fair to say, on the other hand, that this important aspect is assumed much more than stated and explained; and it is an assumption more likely to have been made at the later date suggested, than the early date hitherto generally accepted. Parronchi sees *De statua* as marking the end of medieval perspective in sculpture, and links the two innovations of fixed-point perspective in painting and multi-point perspective of the freestanding three-dimensional figure. They are indeed closely connected, but whereas *De pictura* has the characteristics of a work consciously new and original for the theory and practice of painting, the same cannot be said in a similar degree of *De statua*, whose range and treatment appear to suppose principles it was unnecessary to explain. It is easier to imagine Alberti proceeding on such a basis circa 1450 in relation to the achievements of contemporary sculptors than at a date some twenty years earlier.

Even at that date *De statua* remains the first theoretical work on sculpture of modern times. Although, as I have said, its scope is somewhat limited, what Alberti has to say of the system of measurement and the three-dimensional proportions of the human body is characteristically original. It is an originality which requires

some explanation, partly because of the structure of the work, but primarily for the fact that Alberti stresses the methods rather than the principles on which he bases himself, and his text is more pregnant with significance than might at first sight appear. The main theme of *De statua* is the measurement of men or statues of men, with the object of reproducing their exact form. The methods he uses represent a complete departure from those of the past; they are untrammelled by the super-imposition of theoretical criteria of harmony, and they involve the third dimension, in contrast with the planimetric proportions of earlier theories. He divides them into two categories: measurements based on the static standing figure, and those representing the redistribution of these proportions in the dynamic moving body. For the former he uses the 'exempeda' and 'normae' (the six 'foot' rule, and squares) that measure heights, widths and depths. The 'exempeda' system, despite the super-ficial resemblance in the relationship of the length of the foot to the height of the body, is not based on Vitruvius, who expressed human proportions in terms of fractions: the head, for example, from chin to the top, is one eighth of the whole body (cf. Alberti's table, §12). For the Vitruvian and later medieval systems based largely on the proportion of the head or face to the body (one to eight or nine), Alberti substitutes a variable ruler related in the first instance strictly to the height of the body to be measured from the sole of the foot upwards. This he divides first into six parts he calls 'feet', and ultimately into 600 lesser parts which permit the accurate recording of all vertical distances. The 'normae', constructed with similar units and divisions, serve to record widths and thicknesses. By this method all resultant measurements can with ease be transferred to any size greater or smaller than the original model. It is a system which, as Panofsky observed, has considerable advantages over the fractional system or one based on particular units of measure-ment. For recording the position of the parts of the dynamic body, Alberti designed an instrument he calls the 'finitorium', similar in part to the astrolabe but nearer to the surveying disc used for *Descriptio Urbis Romae*, with the addition of the radius and plumb-line. This enables him to establish exactly, and in related proportion (by using the same units on the radius as on the 'exempeda'), the position of any given limb.

Consequently both basic methods and instruments, though adapted from other uses, are highly original. They also have important aesthetic implications. The greater part of the text implies that the sculptor's object is the reproduction of Nature by scientific methods. He may do this for the human form in two ways: either by making an effigy of a man or that of a particular man. With this difference of objective Alberti tries to associate, rather artificially and with considerable over-simplification, the two measuring operations he calls 'dimensio' and 'finitio' (the

static and dynamic). As all bodies are susceptible of both, the distinction is not valid, except perhaps in the limited sense that the 'ideal' 'dimensiones' tabulated at the end of the work might seem more applicable to the case of the non-particular. Yet this is almost certainly not their main intention. What in fact are these tables doing at this point? Why does a work hitherto founded on and aimed at the measurement of a given individual pass in its final conclusions to the proportions extracted, after the manner of Zeuxis, from the measurement of many bodies with a view to seeking some ideal of beauty in the human form? The underlying problem is that of the relationship between the particular and the general, adumbrated in §§4–5, and the object of the artist, in imitating Nature, to represent the beautiful. It is the same question already encountered in De pictura (see §§55–56, and Intro-duction, p. 15). In the pages of De statua, however, there is no reference to recogni-tion of a particular individual, and no sense of challenge. Alberti does not seem to see the two as different, but as complementary and mutually integrated exercises. The sculptor, like the painter, works from the study of Nature, which will teach him to see, understand and represent the individual variant as well as the common underlying proportions of the human form. The more he understands the latter, the more effectively he will represent both the individual and the 'type'. In other words, the table of proportions at the end of the text is not a set of norms to which the sculptor *must* adhere, any more than, it would seem, knowledge of the fractional system of proportions inhibited the Greek artist from adjusting himself to the representation of the particular exemplum (see Panofsky). The important fact is that the mean proportions of Alberti's tables represent an aesthetic idea of the human form as a basic guide for the sculptor, extracted from actual examples, and not dictated by philosophical or religious principles. Like the Greek system, his is sound-ly based on anthropometry, not understood as a rigid formula, but as a basic pattern which may be varied according to any particular case.

It is interesting to note that the passage from Diodorus Siculus quoted in De re aedificatoria (see above, p. 21) and evidently present behind Alberti's interest in De statua in making a statue in two different parts and places, has been adapted by him to his own purposes. As Panofsky makes clear, this passage was meant by Diodorus to distinguish between the Egyptian and Greek methods, the highly conventional-ized proportions of the former permitting such independent composition without fear of error. Alberti uses this same possibility as a remarkable proof of the infalli-bility of his own new methods of measurement, which enable any dispositions of the dynamic body to be situated and reproduced exactly. It is the juxtaposition of concern with such precise measurement of the single example, and the establishment of mean proportions in the final tables, that constitutes the most interesting and at

the same time the most puzzling feature of *De statua*. Some explanation is present, but very briefly, in §4, though the constants of the species and the variants in time or between individuals are not sufficient to clarify the relationship in Alberti's artistic theory between general and particular. He is here making assumptions that can only be explained by reference to preceding and later theory, and to contemporary practice.

For that theory before and after Alberti, the fundamental essay of Panofsky on human proportions provides the essential context. It also raises the question of how far *De statua* was known and influential. Among contemporaries only Ghiberti wrote about sculpture, and paradoxically with very different interests from Alberti's. Prof. Krautheimer writes: 'Not by a single word does he (Ghiberti) propose to deal with the technical problems of sculpture or with the sculptor's training in the mechanics of his trade. He writes as a humanist artist and hence with professed disregard of the craftsman's approach'. His interests, unlike Alberti's, were mainly historical and personal. They were also concerned with proportionality in a way which *De statua* is not. There is no trace in *De statua* of any metaphysical meaning ascribed to proportion. Nor does Alberti repeat or refer to, either here or in his architectural work, Vitruvius's identification of the form of the human body with that of the circle and the square, which was so popular with Renaissance theorists, including Leonardo. In any event, it is possible to assume (without, however, agreeing with Parronchi's interpretation of a garbled passage in Ghiberti's *Commentari* apparently referring to his predecessors) that *De statua* was known to Ghiberti and to other friends and contemporaries, even though direct allusion in writing seems to be lacking. Particular attention has recently been focussed on possible allusions to Alberti's theories in the practice of sculpture. Attempts have been made, notably by Parronchi and Seymour, to relate the 'exempeda' proportions to the work of Donatello, in whose figures there is some correspondence to, but also some variation from such norms. It is outside our scope to consider details of such possible influence. There is unfortunately considerable uncertainty about the dating of several of Donatello's works; but it will be clear from our discussion that no reliance can be placed for dating Donatello's sculptures on a supposed date of composition of *De statua* around 1431–32. Instead of discussing the possible influence of *De statua* on practice, it might be more appropriate to try to discover how far the 'exempeda' system in that work, written about 1450, reflects already existing practice and gives it form, bearing in mind always that, as in other fields, Alberti's writings do not necessarily depend so much on what has been done or was being done, as on earlier works of theory and on his own frequently original intuitions.

Judging from the MS tradition, *De statua* did not have a wide circulation, and its fortunes with the press were long delayed. It would not appear to have been known to Leonardo, who makes no mention of the work when writing about human proportions or specifically about sculpture. Leonardo expounds the system of Vitruvius and builds onto it his own more detailed researches into the fractional relationships of the parts of the human body. Here he 'embarked upon a systematic investigation of those mechanical and anatomical processes by which the objective dimensions of the quietly upright human body are altered from case to case' (Panofsky), an enquiry which may be seen as a development of an idea already present in *De statua*. Yet, despite this similarity, and despite Leonardo's acknowledged acquaintance with and dependence on other works of Alberti (*De pictura* and *Ludi matematici*), there is no evidence that he knew this work on sculpture.

A more obvious successor and follower is Dürer, who uses the 'exempeda' system of Alberti in book III of his *Vier Bücher von menschlicher Proportion*, 1528, having evidently come to know it from Francesco Giorgi's *Harmonia mundi totius* of 1525, where it is briefly described with no mention of Alberti's name. Not until the eighteenth century did *De statua* have much editorial success (and then in translation), and in a climate when human proportions were more of an academic and scientific than strictly artistic interest. It would not, however, be fair to judge the true historical and intrinsic value of the work from this brief outline of its fortunes. It remains the first work on sculpture in modern times, and anticipated and helped to determine the anthropometrical interests of the sixteenth century. It may not be the seminal work on sculpture that *De pictura* quite clearly is for painting; and perhaps Alberti, at the date I have suggested, was conscious of this difference in giving *De statua* its peculiar and less developed form. By 1450 Italian sculpture was already well embarked in practice on the kind of naturalistic representation he there envisaged, though his methods, which were perhaps 'too intricate for practical use' as Panofsky suggested, had to await a Dürer to receive their full understanding and application.

IV. Bibliography

THE following bibliography is limited to works referred to or used in the preceding Introduction; with few exceptions, it does not include editions and studies cited elsewhere in this volume for particular purposes (e.g. in pp. 4–7, and in the notes). From these the reader may obtain further detailed references and guidance. Several of the items below (especially those marked with an asterisk) contain extensive bibliographical information on Alberti's life and writings, and on the art and artistic theory of the fifteenth century; others (e.g. on colour, perspective) include detailed indications of studies on particular aspects of Alberti's theory. For ease of reference to the Introduction the bibliography is given separately, in alphabetical order, for *De pictura* and *De statua*, items of general importance, which have relevance for both, being listed under the first of these.

DE PICTURA

[ALBERTI, L. B.], *Vita (anonima)*, in *Opere volgari di L. B. Alberti*, ed. A. Bonucci, vol. I, Florence, 1843, pp. xc–cxviii.

ARGAN, G. C., 'The architecture of Brunelleschi and the origins of perspective theory in the fifteenth century', in *Journal of the Warburg and Courtauld Institutes*, IX, 1946, pp. 96–121.

BIALOSTOCKI, J., 'Ars auro prior', in *Mélanges ... M. Brahmer*, Warsaw, 1966, pp. 56–63.

BLUNT, A., *Artistic theory in Italy 1450–1600*, Oxford, 1940.

[BRUNELLESCHI, F.]; A. Manetti, *Vita di Filippo di Ser Brunellesco*, ed. P. Toesca, Florence, 1927.

CENNINI, Cennino, *Il libro dell'arte*, ed. D. V. Thompson, 2 vols., New Haven, 1932–33.

CLARK, K., *Leon Battista Alberti on painting* (Annual Italian lecture of the British Academy), Proceedings of the British Academy, vol. xxx, Oxford University Press, 1944.

DALAI, M. E., 'La questione della prospettiva 1960–1968', in *L'Arte*, 2, June 1968, pp. 96–105. See also PANOFSKY.

EDGERTON, S. Y., 'Alberti's perspective: a new discovery and a new evaluation', in *The Art Bulletin*, XLVIII, 1966, pp. 367–378.

——, 'Alberti's colour theory: a medieval bottle without Renaissance wine', in *Journal of the Warburg and Courtauld Institutes*, XXXII, 1969, pp. 109–134.

——, review of John R. Spencer (ed. and trans.), *L. B. Alberti On Painting*, New Haven, Conn., Yale U.P., 1966, in *The Art Bulletin*, LI, 1969, pp. 397–399.

*GADOL, J., *L. B. Alberti: Universal Man of the Early Renaissance*, Chicago U.P., 1969.

GHIBERTI, L. *Denkwürdigkeiten* (*I Commentari*), ed. Julius von Schlosser, 2 vols., Berlin, 1912.

GIOSEFFI, D., *Perspectiva Artificialis: per la storia della prospettiva: spigolature e appunti*, Università di Trieste, Istituto di storia dell'arte, n. 7, 1957 (rev. by M. H. Pirenne in *The Art Bulletin*, XLI, 1959, pp. 213–217).

GOMBRICH, E. H., *Art and Illusion*, London, 1960.

——, 'Light, form and texture in XVth-century painting', in the *Journal of the R. Soc. of Arts*, CXII, 1963/1964, pp. 826–849.

*GRAYSON, C., 'Alberti, L. B.', in *Dizionario biografico degli italiani*, vol. I, Rome, 1960, pp. 702 ff.

——, 'L. B. Alberti's "costruzione legittima"', in *Italian Studies*, XIX, 1964, pp. 14–27.

IVINS, W. M., *Art and Geometry*, Harvard U.P., 1946 (reprinted 1964).

KRAUTHEIMER, R., *Lorenzo Ghiberti*, Princeton, 1956.

LEE, R. W., '*Ut pictura poesis*: humanistic theory of painting', in *The Art Bulletin*, XXII, 1940, pp. 197–269.

LEONARDO DA VINCI, *On Painting: a lost book* (*Libro A*), by Carlo Pedretti, Berkeley, Cal., 1964.

*MALLÈ, L., ed. of Alberti's *Della pittura*, Florence, 1950, Introduction, pp. 3–49, and bibliography, pp. 151–160.

*MANCINI, G., *Vita di L. B. Alberti*, 2nd ed., Florence, 1911.

*MICHEL, P-H., *Un idéal humain au xve siècle: L. B. Alberti*, Paris, 1930.

PANOFSKY, E., *La prospettiva come 'forma simbolica'*, ed. G. D. Neri, Milan, 1961 (repr. 1966); with a note in pp. 115–137 by M. Dalai, 'La questione della prospettiva' (up to 1960; see DALAI above).

PARRONCHI, A., 'Le due tavole prospettiche del Brunelleschi', in *Paragone*, n. 107, 1958, and n. 109, 1959; republished in his vol. *Studi sulla dolce prospettiva*, Milan, 1964.

——, 'Il *punctum dolens* della "costruzione legittima"', in *Paragone*, n. 195, 1962; also in his *Studi sulla dolce prospettiva*, cit.

——, 'La "costruzione legittima" è uguale alla "costruzione con punti di distanza"', in *Rinascimento*, anno XV, 1964, pp. 35–40.

——, 'Il Filarete, Francesco di Giorgio e Leonardo su la "costruzione legittima"', in *Rinascimento*, ser. 2, V, 1965, pp. 155–167.

——, 'Sul significato degli *Elementi di pittura* di L. B. Alberti', in *Cronache di Archeologia e di Storia dell'Arte*, 6, 1967, pp. 107–115.

——, 'Due note', in *Rinascimento*, VIII, 1968, pp. 351–363 (note I: 'Postilla alla "costruzione legittima"').

PIRENNE, M. H., *Optics, painting and photography*, Cambridge University Press, 1970.

RICHTER, G. M. A., *Perspective in Greek and Roman art*, London, 1970.

SANTINELLO, G., *L. B. Alberti: una visione estetica del mondo e della vita*, Florence, 1962.

SHEARMAN, J., 'Leonardo's colour and chiaroscuro', in *Zeitschrift für Kunstgeschichte*, 1962, pp. 13–47.

VESCOVINI, G. F., *Studi sulla prospettiva medievale* (Università di Torino, Facoltà di Lettere e Filosofia, vol. XVI, fasc. 1), Torino, 1965.

*WHITE, J., *The birth and rebirth of pictorial space*, London, 1957.

——, 'Paragone: aspects of the relationship between sculpture and painting', in *Art, Science and History in the Renaissance*, ed. by Ch. S. Singleton, Baltimore, 1967, pp. 43–108.

WITTKOWER, R., 'Brunelleschi and "Proportion in Perspective"', in *Journal of the Warburg and Courtauld Institutes*, XVI, 1953, pp. 257–291.

DE STATUA

ALBERTI, L. B., *L'Architettura (De re aedificatoria)*: testo latino e traduzione a cura di G. Orlandi; Introduzione e note di P. Portoghesi, 2 vols., Milan, 1966.

ALBERTI, L. B., *Ludi matematici*, in *Opere volgari di L. B. Alberti*, ed. A. Bonucci, vol. IV, Florence, 1847, pp. 405–440; and more correctly in *Opere volgari*, ed. C. Grayson, vol. III (in the press).

FLACCAVENTO, G., 'Per una moderna traduzione del *De statua* di L. B. Alberti', in *Cronache di Archeologia e Storia dell'Arte*, 1, 1962, pp. 50–59.

——, 'Sulla data del *De statua* di L. B. Alberti', in *Commentari*, XVI, 1965, pp. 216–221.

GRAYSON, C., 'The composition of L. B. Alberti's *Decem libri de re aedificatoria*', in *Münchner Jahrbuch der Bildenden Kunst*, ser. 3, vol. XI, 1960, pp. 152–161.

JANSON, H. W., 'The image made by chance in Renaissance thought', in *Essays in honour of Erwin Panofsky*, ed. M. Meiss, New York, 1961, pp. 254–266.

LEHMANN-BROCKHAUS, O., 'Alberti's "Descriptio Urbis Romae"', in *Kunstchronik*, 13, Dec. 1960, pp. 345–348 (on dating; see also VAGNETTI/ORLANDI).

LEONARDO DA VINCI, *Literary Works*, ed. J. P. Richter, 3rd edition, London, 1970, 2 vols. (see vol. I, pp. 243–270, on proportions of human body).

PANOFSKY, E., 'The history of human proportions as a reflection of style', in *Meaning in the visual arts*, New York, 1957, pp. 55–107.

PARRONCHI, A., 'Sul *Della statua* albertiano', in *Paragone*, 117, 1959, pp. 3–29.

SEYMOUR, C., 'Some aspects of Donatello's methods of figure and space construction: relationships with Alberti's *De statua* and *Della pittura*', in *Donatello e il suo tempo* (Atti dell'VIII convegno internazionale di studi sul Rinascimento), Florence, 1968, pp. 195–206.

——, *Sculpture in Italy 1400–1500*, London, 1966.

SMITH, W., 'Definitions of *statua*', in *The Art Bulletin*, L, 1968, pp. 263–267.

VAGNETTI, L./ORLANDI, G., 'La "Descriptio Urbis Romae" di L. B. ALBERTI', in *Quaderno* No. I, Facoltà di Architettura, Università di Genoa, 1968, pp. 25–88 (text and study with full bibliography).

ADDENDUM (DE PICTURA)

BAXANDALL, Michael, *Giotto and the Orators*, Oxford, 1971, especially chapter III, pp. 121–139.

DE PICTURA : ON PAINTING

For the notes to the texts which follow, see pp. 108 ff.

A Filippo Brunelleschi

Io SOLEA maravigliarmi insieme e dolermi che tante ottime e divine arti e scienze, quali per loro opere e per le istorie veggiamo copiose erano in que' vertuosissimi passati antiqui, ora così siano mancate e quasi in tutto perdute: pittori, scultori, architetti, musici, ieometri, retorici, auguri e simili nobilissimi e maravigliosi intelletti oggi si truovano rarissimi e poco da lodarli. Onde stimai fusse, quanto da molti questo così essere udiva, che già la natura, maestra delle cose, fatta antica e stracca, più non producea come né giuganti così né ingegni, quali in que' suoi quasi giovinili e più gloriosi tempi produsse, amplissimi e maravigliosi. Ma poi che io dal lungo essilio in quale siamo noi Alberti invecchiati, qui fui in questa nostra sopra l'altre ornatissima patria ridutto, compresi in molti ma prima in te, Filippo, e in quel nostro amicissimo Donato scultore, e in quegli altri Nencio e Luca e Masaccio, essere a ogni lodata cosa ingegno da non posporli a qual si sia stato antiquo e famoso in queste arti. Pertanto m'avidi in nostra industria e diligenza non meno che in beneficio della natura e de' tempi stare il potere acquistarsi ogni laude di qual si sia virtù. Confessoti sì a quegli antiqui, avendo quale aveano copia da chi imparare e imitarli, meno era difficile salire in cognizione di quelle supreme arti quali oggi a noi sono faticosissime; ma quinci tanto più el nostro nome più debba essere maggiore, se noi sanza precettori, senza essemplo alcuno, troviamo arti e scienze non udite e mai vedute. Chi mai sì duro o sì invido non lodasse Pippo architetto vedendo qui struttura sì grande, erta sopra e' cieli, ampla da coprire con sua ombra tutti e' popoli toscani, fatta sanza alcuno aiuto di travamenti o di copia di legname, quale artificio certo, se io ben iudico, come a questi tempi era incredibile potersi, così forse appresso gli antichi fu non saputo né conosciuto? Ma delle tue lodi e della virtù del nostro Donato, insieme e degli altri quali a me sono per loro costumi gratissimi, altro luogo sarà da recitarne. Tu tanto persevera in trovare, quanto fai di dì in dì, cose per quali il tuo ingegno maraviglioso s'acquista perpetua fama e nome, e se in tempo t'accade ozio, mi piacerà rivegga questa mia operetta *De pictura* quale a tuo nome feci in lingua toscana. Vederai tre libri: el primo, tutto matematico, dalle radici entro dalla natura fa sorgere questa leggiadra e nobilissima arte. El secondo libro pone l'arte in mano allo artefice, distinguendo sue parti e tutto dimostrando. El terzo instituisce l'artefice quale e come possa e debba acquistare perfetta arte e notizia di tutta la pittura. Piacciati adunque leggermi con diligenza, e se cosa vi ti par da emendarla, correggimi. Niuno scrittore mai fu sì dotto al quale non fussero utilissimi gli amici eruditi; e io in prima da te desidero essere emendato per non essere morso da' detrattori.

To Filippo Brunelleschi

I USED both to marvel and to regret that so many excellent and divine arts and sciences, which we know from their works and from historical accounts were possessed in great abundance by the talented men of antiquity, have now disappeared and are almost entirely lost. Painters, sculptors, architects, musicians, geometers, rhetoricians, augurs and suchlike distinguished and remarkable intellects, are very rarely to be found these days, and are of little merit. Consequently I believed what I heard many say that Nature, mistress of all things, had grown old and weary, and was no longer producing intellects any more than giants on a vast and wonderful scale such as she did in what one might call her youthful and more glorious days.[1] But after I came back here to this most beautiful of cities from the long exile in which we Albertis have grown old, I recognized in many, but above all in you, Filippo, and in our great friend the sculptor Donatello and in the others, Nencio, Luca and Masaccio, a genius for every laudable enterprise in no way inferior to any of the ancients who gained fame in these arts.[2] I then realized that the ability to achieve the highest distinction in any meritorious activity lies in our own industry and diligence no less than in the favours of Nature and of the times. I admit that for the ancients, who had many precedents to learn from and to imitate, it was less difficult to master those noble arts which for us today prove arduous; but it follows that our fame should be all the greater if without preceptors and without any model to imitate we discover arts and sciences hitherto unheard of and unseen. What man, however hard of heart or jealous, would not praise Filippo the architect when he sees here such an enormous construction towering above the skies, vast enough to cover the entire Tuscan population with its shadow, and done without the aid of beams or elaborate wooden supports?[3] Surely a feat of engineering, if I am not mistaken, that people did not believe possible these days and was probably equally unknown and unimaginable among the ancients. But I will speak elsewhere of your praises and the talent of our friend Donatello, and of the others who are dear to me for their virtues. I beg you to go on, as you are doing, finding means whereby your wonderful skill may obtain everlasting fame and renown, and if you should have some leisure, I shall be glad if you will look over this little work of mine on painting, which I did into Tuscan for you.[4] You will see that there are three books. The first, which is entirely mathematical, shows how this noble and beautiful art arises from roots within Nature herself. The second puts the art into the hands of the artist, distinguishes its parts and explains them all. The third instructs the artist how he may and should attain complete mastery and understanding of the art of painting. Please, therefore, read my work carefully, and if anything seems to you to need amendment, correct it. No writer was ever so well informed that learned friends were of no use to him; and I want above all to be corrected by you, so as not to be criticized by detractors.

Ad Johannem Franciscum Illustrissimum Principem Mantuanum

Hos de pictura libros, princeps illustrissime, dono ad te deferri iussi quod intelligebam te maximum in modum his ingenuis artibus delectari, quibus quidem quantum ingenio et industria luminis et doctrinae attulerim ex libris ipsis, cum eos per otium legeris, intelliges. Etenim cum ita pacatam et bene tua virtute constitutam civitatem habeas ut otium tibi quod a republica vacans literarum studiis tua pro consuetudine tribuas interdum non desit, futurum spero ut pro tua solita humanitate, qua non minus quam armorum gloria literarumque peritia caeteros omnes principes longe exuperas, libros nostros minime negligendos ducas. Nam esse eos eiusmodi intelliges ut quae in illis tractentur cum arte ipsa auribus eruditis digna tum rei novitate facile delectare studiosos queant. Sed de libris hactenus. Mores meos doctrinamque si qua est et omnem vitam tum maxime poteris cognoscere cum dederis operam ut possim, prout mea fert voluntas, apud te esse. Denique putabo tibi opus non displicuisse ubi me tibi deditissimum voles annumerare inter familiares tuos et non in postremis commendatum habere.

To Giovan Francesco Illustrious Prince of Mantua

I WISHED to present you with these books on painting, illustrious prince, because I observed that you take the greatest pleasure in these liberal arts; to which you will see from the books themselves, when you have leisure to read them, how much light and learning I have brought with my natural talents and industry. As you rule over a city so peaceful and well governed by your virtue that you do not lack occasional leisure from public affairs to devote to your customary pursuit of the study of letters, I hope, with your usual kindness, in which no less than in the glory of arms and the skill of letters you excel by far all other princes, you will consider my books not unworthy of your attention. You will see they are such that their contents may prove worthy by their art of the ears of learned men, and may also easily please scholars by the novelty of their subject. But I will say no more of them here. You could know my character and learning, and all my qualities best, if you arranged for me to join you, as I indeed desire. And I shall believe my work has not displeased you, if you decide to enrol me as a devoted member among your servants and to regard me as not one of the least.

De Pictura

Liber I

1. De pictura his brevissimis commentariis conscripturi, quo clarior sit nostra oratio, a mathematicis ea primum, quae ad rem pertinere videbuntur, accipiemus. Quibus quidem cognitis, quoad ingenium suppeditabit, picturam ab ipsis naturae principiis exponemus. Sed in omni nostra oratione spectari illud vehementer peto non me ut mathematicum sed veluti pictorem hisce de rebus loqui. Illi enim solo ingenio, omni seiuncta materia, species et formas rerum metiuntur. Nos vero, quod sub aspectu rem positam esse volumus, pinguiore idcirco, ut aiunt, Minerva scribendo utemur. Ac recte quidem esse nobiscum actum arbitrabimur si quoquo pacto in hac plane difficili et a nemine quod viderim alio tradita litteris materia, nos legentes intellexerint. Peto igitur nostra non ut puro a mathematico sed veluti a pictore tantum scripta interpretentur.

2. Itaque principio novisse oportet punctum esse signum, ut ita loquar, quod minime queat in partes dividi. Signum hoc loco appello quicquid in superficie ita insit ut possit oculo conspici. Quae vero intuitum non recipiunt, ea nemo ad pictorem nihil pertinere negabit. Nam ea solum imitari studet pictor quae sub luce videantur. Puncta quidem si continenter in ordine iungantur lineam extendent. Erit itaque apud nos linea signum cuius longitudo sane in partes dividi possit, sed erit usque adeo latitudine tenuissima ut nusquam findi queat. Linearum alia recta dicitur, alia flexa. Recta linea est signum a puncto ad punctum directe in longum protensum. Flexa ea est quae a puncto ad punctum non recto gressu sed facto sinu fluxerit. Lineae plures quasi fila in tela adacta si cohaereant, superficiem ducent. Est namque superficies extrema corporis pars quae non profunditate aliqua sed latitudine tantum longitudineque atque perinde suis qualitatibus cognoscatur. Qualitatum aliae ita superficiei inhaerent ut prorsus nisi alterata superficie minime semoveri aut seiungi queant. Aliae vero qualitates huiusmodi sunt, ut eadem facie superficiei manente, ita sub aspectu tamen iaceant, ut superficies visentibus alterata esse videatur. Perpetuae autem superficierum qualitates geminae sunt. Una quidem quae per extremum illum ambitum quo superficies clauditur notescat, quem quidem ambitum nonnulli horizontem nuncupant; nos, si liceat, latino vocabulo similitudine quadam appellamus oram aut, dum ita libeat, fimbriam. Eritque et ipsa fimbria aut unica linea aut pluribus lineis perfinita, unica ut circulari, pluribus ut altera flexa altera recta, aut etiam quae pluribus rectis aut pluribus flexis lineis ambiatur. Circularis quidem linea est ipsa fimbria quae totum circulum continet. Circulus vero est forma superficiei quam linea veluti corona obambit, quod si in medio aderit punctus, omnes radii ab hoc ipso puncto directe ad coronam ducti longitudine inter

On Painting
Book I

1. In writing about painting in these short books, we will, to make our discourse clearer, first take from mathematicians those things which seem relevant to the subject. When we have learned these, we will go on, to the best of our ability, to explain the art of painting from the basic principles of nature. But in everything we shall say I earnestly wish it to be borne in mind that I speak in these matters not as a mathematician but as a painter. Mathematicians measure the shapes and forms of things in the mind alone and divorced entirely from matter. We, on the other hand, who wish to talk of things that are visible, will express ourselves in cruder terms. And we shall believe we have achieved our purpose if in this difficult subject, which as far as I can see has not before been treated by anyone else, our readers have been able to follow our meaning. I therefore ask that my work be accepted as the product not of a pure mathematician but only of a painter.

2. The first thing to know is that a point is a sign which one might say is not divisible into parts. I call a sign anything which exists on a surface so that it is visible to the eye. No one will deny that things which are not visible do not concern the painter, for he strives to represent only the things that are seen. Points joined together continuously in a row constitute a line. So for us a line will be a sign whose length can be divided into parts, but it will be so slender in width that it cannot be split. Some lines are called straight, others curved. A straight line is a sign extended lengthways directly from one point to another. A curved line is one which runs from point to point not along a direct path but making a bend. If many lines are joined closely together like threads in cloth, they will create a surface. A surface is the outer part of a body which is recognized not by depth but by width and length, and also by its properties. Some of these properties are so much part of the surface that they cannot be removed or parted from it without the surface being changed. Others are ones which may present themselves to the eye in such a way that the surface appears to the beholder to have altered, when in fact the form of the surface remains unchanged. The permanent properties of surfaces are twofold. One of these we know from the outer edge in which the surface is enclosed. Some call this the horizon: we will use a metaphorical term from Latin and call it the brim, or the fringe. This fringe or outline will be composed of one or more lines: of one line as in a circle, or of more than one, for example, one straight and one curved line, or even several straight or curved lines. The circular line is the one which encloses a complete circle. And a circle is that form of surface which a line surrounds like a crown, so that if there were a point in the centre, all radiuses drawn directly from that point to the crown would be equal. This median point is called the centre of the circle.

se equales sunt. Ac is idem medius punctus centrum circuli dicitur. Linea idcirco recta quae bis coronam circuli secuerit perque centrum recta ibit, ea diameter circuli apud mathematicos vocatur. Nos hanc ipsam nominemus centricam. Sitque hoc apud nos loco ab ipsis mathematicis persuasum quod aiunt lineam nullam aequos angulos a corona circuli signare nisi quae recta ipsum centrum attingat.

3. Sed ad superficies redeamus. Ex his enim quae recensui facile intelligi potest ut, tractu fimbriae immutato, ipsa superficies et faciem et nomen quoque pristinum perdat, atque quae triangulus fortasse dicebatur nunc tetrangulus aut plurium deinceps angulorum nuncupabitur. Dicetur quidem fimbria mutata si lineae aut anguli non modo plures sed obtusiores longioresve vel acutiores brevioresve quoquo pacto fiant. Is locus admonet ut de angulis nonnihil recenseamus. Est enim angulus extremitas superficiei a duabus lineis se invicem secantibus confectus. Angulorum tria sunt genera: rectum, obtusum atque acutum. Angulus rectus unus est ex quattuor angulis qui a duabus rectis lineis sese mutuo secantibus ita conscribitur ut cuivis reliquorum trium sit aequalis. Hinc est quod aiunt omnes recti anguli inter se sunt aequales. Obtusus angulus est qui recto maior est. Acutus is est qui recto minor est.

4. Iterum ad superficiem redeamus. Docuimus quo pacto una per fimbriam qualitas superficiei inhaereat. Sequitur ut altera superficierum qualitas referatur, quae est, ut ita loquar, tamquam cutis per totum superficiei dorsum distenta. Ea in tres divisa est, nam alia uniformis et plana, alia tuberosa et sphaerica, alia incurva et concava dicitur. Quarto loco his addendae sunt superficies quae ex duabus harum superficierum compositae sunt. De his postea. Nunc de primis: plana superficies ea est quam in quavis parte sui recta superducta regula aeque contingat. Huic persimilis erit superficies purissimae aquae. Sphaerica superficies dorsum sphaerae imitatur. Sphaeram diffiniunt corpus rotundum in omnes partes volubile cuius in medio punctus inest a quo extremae omnes illius corporis partes aeque distant. Concava superficies ea est quae interius extremum sub ultima, ut ita dixerim, cute sphaerae subiacet, ut sunt in textis ovorum intimae superficies. Composita vero superficies ea est quae una dimensione planitiem, altera aut concavam aut sphaericam superficiem imitetur, quales sunt interiores fistularum et exteriores columnarum superficies.

5. Itaque et ambitu et dorso inhaerentes qualitates cognomenta superficiebus, ut diximus, imposuerunt. At vero qualitates quae non alterata superficie non tamen semper eundem aspectum exhibent, duae item sunt, nam aut loco aut luminibus mutatis tamen variatae intuentibus videntur. De loco prius dicendum, postea de luminibus. Ac perscrutandum quidem est quonam pacto mutato loco ipsae superficiei inhaerentes qualitates immutatae esse videantur. Equidem haec ad vim oculorum spectant. Nam situ mutato aut maiores aut omnino non eiusdem quam hactenus fuerant fimbriae, aut item colore fraudatae superficies appareant necesse est, quas res omnes intuitu metimur. Id quidem qua ratione fiat perscrutemur,

The straight line that cuts the crown of the circle twice and passes through the centre, is called by mathematicians the diameter. Let us call this the centre-line; and let us accept here what mathematicians tell us, that no line makes equal angles at the crown of the circle except the straight line which passes through the centre.

3. But let us come back to surfaces. From what I have said above, it can easily be understood that, if the course of the outline is altered, the surface loses its shape and original description, and what before maybe was called a triangle will now be known as a quadrangle or a figure of several angles. The outline will be said to be altered if the angles or lines in it become, not simply more numerous, but in some way either more obtuse or longer or more acute or shorter. This suggests we ought to say something here about angles. An angle is the boundary of a surface made up of two mutually intersecting lines. There are three kinds of angles: right angle, obtuse angle and acute angle. A right angle is any one of the four which is described by two straight lines intersecting each other in such a way that each angle is equal to the other three. This is why they say that all right angles are equal. An obtuse angle is one which is greater than a right angle. An acute angle is one that is less than a right angle.

4. Let us come back to surfaces again. We explained how one property of a surface is bound up with the outline. We must now speak of the other property of a surface, which, if I might put it this way, is like a skin stretched over the whole extent of the surface. It is divided into three kinds. One is said to be uniform and plane, another raised in the middle and spherical, and the third sunk in and concave. Fourthly there should be added surfaces made up of two of these three. I will speak of them later. I am now concerned with the first three. A plane surface is one which, if you put a straight ruler on it, it touches in every part. A surface like this would be that of clear water. A spherical surface is like the outside of a sphere. A sphere is defined as a circular body, round in every way, at whose centre is a point from which all the outermost parts of that body are equidistant. A concave surface is the one which lies inside, as it were, underneath the last outer layer of a sphere, as for example the inner surfaces of eggshells. A composite surface is one which in one dimension resembles a plane, and in the other either the concave or spherical, as is the case with the inner surfaces of pipes or the outer surfaces of columns.

5. As we have explained, the properties inherent in the periphery and conformation of bodies have determined the names given to surfaces. Now the properties which, even when there is no change in the surface itself, do not always present the same aspect, are of two kinds, for they may seem to the observer to vary according to changes in position and lighting. We must first speak of position, then of lighting. And we must investigate how it is that, with change of position, the properties inherent in a surface appear to be altered. These matters are related to the power of vision; for with a change of position surfaces will appear larger, or of a completely different outline from before, or diminished in colour; all of which we judge by sight. Let us enquire why this is so,

exordiamurque a philosophorum sententia, qui metiri superficies affirmant radiis quibusdam quasi visendi ministris, quos idcirco visivos nuncupant, quod per eos rerum simulacra sensui imprimantur. Nam ipsi idem radii inter oculum atque visam superficiem intenti suapte vi ac mira quadam subtilitate pernicissime congruunt, aera corporaque huiusmodi rara et lucida penetrantes quoad aliquod densum vel opacum offendant, quo in loco cuspide ferientes e vestigio haereant. Verum non minima fuit apud priscos disceptatio a superficie an ab oculo ipsi radii erumpant. Quae disceptatio sane difficilis atque apud nos admodum inutilis pretereatur. Ac imaginari quidem deceat radios, quasi fila quaedam distenta et prorsus tenuissima uno capite quasi in manipulum arctissime colligata, una simul per oculum interius, ubi sensus visus consideat, recipi, quo loco non secus atque truncus radiorum adstent, a quo quidem exeuntes in longum laxati radii veluti rectissima virgulta ad oppositam superficiem effluant. Sed hos inter radios nonnulla differentia est quam tenuisse pernecessarium arbitror. Differunt quidem viribus et officio, nam alii fimbrias superficierum contingentes totas quantitates superficiei metiuntur. Hos autem, quod ultimas partes superficiei libando volitant, extrinsecos radios appellemus. Alii quidem radii ab omni dorso superficiei seu recepti seu fluentes, intra eam pyramidem, de qua paulo post suo loco dicemus, suum quoque officium peragunt, nam coloribus et luminibus imbuuntur iisdem quibus ipsa superficies refulgeat. Hos ergo medios radios nuncupemus. Est quoque ex radiis mediis quidam qui similitudine quadam centricae de qua supra diximus lineae, dicatur centricus, quod in superficie ita perstet ut circa se aequales utrinque angulos reddat. Itaque tres radiorum species repertae sunt: extremorum, mediorum et centrici.

6. Perscrutemur igitur quid quique radii ad visendum conferant; ac primo de extremis, postea de mediis, tum de centrico dicendum erit. Radiis quidem extremis quantitates metiuntur. Est enim quantitas spatium inter duo disiuncta puncta fimbriae transiens per superficiem, quod oculus quasi circino quodam instrumento his extremis radiis metitur. Suntque tot in superficie quantitates quot sunt disiuncta in fimbria sese correspicientia puncta; nam cum proceritatem quae inter supremum et infimum, seu latitudinem quae inter dextrum et sinistrum, seu crassitudinem quae inter propinquius et remotius, seu ceteras quasvis dimensiones aspectu recognoscimus, his tantum radiis extremis utimur. Ex quo illud dici solitum est visum per triangulum fieri cuius basis visa quantitas cuiusve latera sunt iidem ipsi radii qui a punctis quantitatis ad oculum protenduntur. Ac illud quidem certissimum est nisi per hunc ipsum triangulum quantitatem nullam videri. Latera ergo trianguli visivi patent. Anguli quidem in hoc ipso triangulo duo sunt alterutra illa quantitatis capita; tertius vero angulus est is qui basi oppositus intra oculum consistit. Neque hoc loco disputandum est utrum in ipsa iunctura interioris nervi visus, ut aiunt, quiescat, an in superficie oculi quasi in speculo animato imagines figurentur. Sed nec omnia quidem oculorum ad visendum hoc loco munera referenda sunt. Satis enim erit his

and start from the opinion of philosophers who say that surfaces are measured by certain rays, ministers of vision as it were, which they therefore call visual rays, since by their agency the images of things are impressed upon the senses. These rays, stretching between the eye and the surface seen, move rapidly with great power and remarkable subtlety, penetrating the air and rare and transparent bodies until they encounter something dense or opaque where their points strike and they instantly stick. Indeed among the ancients there was considerable dispute as to whether these rays emerge from the surface or from the eye. This truly difficult question, which is quite without value for our purposes, may here be set aside. Let us imagine the rays, like extended very fine threads gathered tightly in a bunch at one end, going back together inside the eye where lies the sense of sight. There they are like a trunk of rays from which, like straight shoots, the rays are released and go out towards the surface in front of them. But there is a difference between these rays which I think it essential to understand. They differ in strength and function, for some reach to the outlines of surfaces and measure all their dimensions. Let us call these extrinsic rays, since they fly out to touch the outer parts of the surface. Other rays, whether received by or flowing from the whole extent of the surface, have their particular function within the pyramid of which we shall presently speak, for they are imbued with the same colours and lights with which the surface itself shines. Let us, therefore, call these median rays. Among them there is one which is called the centric ray, on the analogy of the centric line we spoke of above, because it meets the surface in such a way that it makes equal angles on all sides. So we have found three kinds of rays: extrinsic, median and centric.

6. Let us now investigate what part each of these rays plays in the action of sight; first the extrinsic, then the median, and finally the centric. Quantities are measured by the extrinsic rays. A quantity is the space across the surface between two different points on the outline, which the eye measures with the extrinsic rays rather like a pair of dividers. There are as many quantities in a surface as there are points on the outline that are in some way opposed to one another. We use these extrinsic rays whenever we apprehend by sight the height from top to bottom, or width from left to right, or depth from near to far, or any other dimensions. This is why it is usually said that sight operates by means of a triangle whose base is the quantity seen, and whose sides are those same rays which extend to the eye from the extreme points of that quantity. It is perfectly true that no quantity can be seen without such a triangle. The sides of the visual triangle, therefore, are open. In this triangle two of the angles are at the two ends of the quantity; the third is the one which lies within the eye and opposite the base. This is not the place to argue whether sight rests at the juncture of the inner nerve of the eye, or whether images are created on the surface of the eye, as it were in an animate mirror. I do not think it necessary here to speak of all the functions of the eye in relation to vision. It will be enough in these books to describe briefly those things that are essential to the present purpose. As, then, the visual angle resides in the eye, the following

4

commentariis succincte quae ad rem pernecessaria sint demonstrasse. Cum igitur in oculo consistat angulus visivus, regula deducta est haec: quo videlicet acutior sit in oculo angulus, eo quantitatem breviorem apparere. Ex quo plane discitur cur sit quod multo intervallo quantitas ad punctum usque extenuata esse videatur. Verum haec cum ita sint, fit tamen nonnullis superficiebus ut quo illi propinquior sit visentis oculus eo minorem, quo remotior eo longe plurimam superficiei partem videat. Quod in sphaerica superficie ita esse discitur. Quantitates ergo pro intervallo minores ac maiores intuentibus nonnunquam videntur. Cuius rei qui probe rationem tenuerit minime dubitabit medios aliquos radios aliquando fieri extremos extremosque intervallo mutato item fieri medios; atque idcirco intelliget ubi medii radii sint facti extremi, illico quantitatem breviorem apparere, contraque cum extremi radii intra fimbriam recipiantur, quo magis a fimbria distent, eo maiorem quantitatem videri.

7. Hic solitus sum apud familiares regulam exponere: quo plures radiorum videndo occupentur, eo quantitatem prospectam grandiorem existimari; quo autem pauciores, eo minorem. Ceterum ii radii extremi dentatim universam fimbriam superficiei comprehendentes ipsam totam superficiem quasi cavea circumducunt. Unde illud aiunt visum per pyramidem radiosam fieri. Dicendum idcirco est pyramis quid sit, quove pacto ea radiis construatur. Eam nos nostra Minerva describamus. Pyramis est figura corporis oblongi ab cuius basi omnes lineae rectae sursum protractae ad unicam cuspidem conterminent. Basis pyramidis visa superficies est, latera pyramidis radii ipsi visivi quos extrinsecos nuncupari diximus. Cuspis pyramidis illic intra oculum considet, ubi in unum anguli quantitatum in triangulis conveniunt. Hactenus de extrinsecis radiis ex quibus pyramis concipitur, qua omni ex ratione constat multum interesse quae intervalla inter superficiem et oculum interiaceant. Sequitur ut de mediis radiis dicendum sit. Radii medii sunt ea multitudo radiorum quae ab radiis extrinsecis septa intra pyramidem continetur. Atque hi quidem radii id agunt quod aiunt camaleonta animal et huiusmodi feras metu conterritas solere propinquarum rerum colores suscipere ne a venatoribus facile reperiantur. Hoc ipsum medii radii exequuntur, nam a contactu superficiei usque ad cuspidem pyramidis toto tractu ita colorum et luminum reperta varietate inficiuntur, ut quovis loco rumperentur, eodem loco ipsum inhaustum lumen atque eundem colorem expromerent. Ac de his mediis radiis re primum ipsa cognitum est eos multo intervallo deficere aciemque hebetiorem agere. Demum id cur ita sit ratio reperta est, nam cum iidem ceterique omnes radii visivi luminibus et coloribus imbuti atque graves aerem pervadant sitque aer ipse nonnulla crassitudine suffusus, fit ut multa pars oneris, dum aerem perterebrant, fessis radiis deficiat. Idcirco recte aiunt quo maior distantia sit, eo superficiem subobscuriorem et magis fuscam videri.

8. Restat ut de centrico radio dicamus. Centricum radium dicimus eum qui solus ita quantitatem feriat ut utrinque anguli angulis sibi cohaerentibus respondeant.

rule has been drawn: the more acute the angle within the eye, the less will appear the quantity. From this it can be clearly understood why it is that at a great distance a quantity seems to be reduced to a point. Nonetheless it does happen with some surfaces that the nearer the eye of the observer is to it, the less it sees, and the further away it is, the greater the part of the surface it sees. This is seen to be the case with a spherical surface. Quantities, therefore, sometimes seem to the observer greater or lesser according to their distance. Anyone who has properly understood the theory behind this, will plainly see that some median rays sometimes become extrinsic, and extrinsic ones median, when the distance is changed; and he will appreciate that where the median have become extrinsic, the quantity will appear less, and conversely, when the extrinsic rays fall inside the outline, the further they are from it, the greater the quantity appears.

7. I usually give my friends the following rule: the more rays are employed in seeing, the greater the quantity seen will appear, and the fewer the rays, the smaller the quantity. Furthermore, the extrinsic rays, which hold on like teeth to the whole of the outline, form an enclosure around the entire surface like a cage. This is why they say that vision takes place by means of a pyramid of rays. We must, therefore, explain what a pyramid is, and how it is made up of rays. Let us describe it in our own rough terms. A pyramid is a form of oblong body from whose base all straight lines, prolonged upwards, meet at one and the same point. The base of the pyramid is the surface seen, and the sides are the visual rays we said are called extrinsic. The vertex of the pyramid resides within the eye, where the angles of the quantities in the various triangles meet together. Up to now we have dealt with the extrinsic rays of which the pyramid is composed; from all of which it is evident that it is of considerable importance what distance lies between the surface and the eye. We must now speak of the median rays. These are the mass of rays which is contained within the pyramid and enclosed by the extrinsic rays. These rays do what they say the chameleon and other like beasts are wont to do when struck with fear, who assume the colours of nearby objects so as not to be easily discovered by hunters. These median rays behave likewise; for, from their contact with the surface to the vertex of the pyramid, they are so tinged with the varied colours and lights they find there, that at whatever point they were broken, they would show the same light they had absorbed and the same colour. We know for a fact about these median rays that over a long distance they weaken and lose their sharpness. The reason why this occurs has been discovered: as they pass through the air, these and all the other visual rays are laden and imbued with lights and colours; but the air too is also endowed with a certain density, and in consequence the rays get tired and lose a good part of their burden as they penetrate the atmosphere. So it is rightly said that the greater the distance, the more obscure and dark the surface appears.

8. It remains for us to speak of the centric ray. We call the centric ray the one which alone strikes the quantity in such a way that the adjacent angles on all sides are equal. As for the properties of the centric ray, it is of all the rays undoubtedly the most keen

Equidem et quod ad hunc centricum radium attinet verissimum est hunc esse omnium radiorum acerrimum et vivacissimum. Neque negandum est quantitatem nunquam maiorem videri quam cum centricus in eam radius institerit. Possent plura de centrici radii vi et officio referri. Tantum hoc non praetermittatur, hunc unicum radium quasi unita quadam congressione a ceteris radiis constipatum foveri, ut merito dux radiorum plane ac princeps dici debeat. Reliqua vero, quae ad ostentandum ingenium pertinuissent magis quam ad ea de quibus dicere instituimus, praetereantur. Multa etiam de radiis suis locis accommodatius dicentur. Hoc autem loco sit, quantum commentariorum brevitas postulat, satis ea retulisse ex quibus dubitet nemo hoc ita esse quod quidem satis demonstratum puto: intervallo scilicet centricique radii positione mutatis illico superficiem alteratam videri. Nam ea quidem aut minor aut maior aut denique pro linearum et angulorum inter se concinnitate immutata apparebit. Centrici ergo positio distantiaque ad certitudinem visus plurimum conferunt. Est quoque tertium aliquid ex quo superficies difformes et variae intuentibus exhibeantur. Id quidem est luminum receptio. Nam videre licet in sphaerica atque concava superficie, si unicum tantum adsit lumen, una parte subobscuram alia clariorem esse superficiem, ac eodem intervallo centricaque positione pristina manente, modo ea ipsa superficies diverso quam prius lumine subiaceat, videbis fuscas illic esse partes eas quae sub diverso antea lumine sitae clarebant, atque esse easdem claras quae prius obumbratae erant. Tum etiam si plura circumstent lumina, pro luminum numero et viribus variae suis locis maculae candoris et obscuritatis micabunt. Haec res experimento ipso comprobatur.

9. Sed hic locus admonet ut de luminibus et coloribus aliqua referamus. Colores a luminibus variari palam est, siquidem omnis color non idem conspectu est in umbra ac sub radiis luminum positus. Nam umbra fuscum colorem, lumen vero clarum et apertum exhibet. Dicunt philosophi posse videri nil quod ipsum non sit lumine coloreque vestitum. Maxima idcirco inter colores et lumina cognatio est ad visum agendum, quae quanta sit hinc intelligitur, quod lumine pereunte colores ipsi quoque pereunt, redeunteque luce una et ipsi cum viribus luminum colores restaurantur. Quae res cum ita sit, videndum est ergo de coloribus primo. Dehinc investigabimus quemadmodum colores sub luminibus varientur. Missam faciamus illam philosophorum disceptationem qua primi ortus colorum investigantur. Nam quid iuvat pictorem novisse quonam pacto ex rari et densi aut ex calidi et sicci frigidi humidique permixtione color extet? Neque tamen eos philosophantes aspernandos putem qui de coloribus ita disputant ut species colorum esse numero septem statuant: album atque nigrum duo colorum extrema, unum quidem intermedium, tum inter quodque extremum atque ipsum medium binos, quod alter plus altero de extremo sapiat, quasi de limite ambigentes, collocant. Pictorem sane novisse sat est qui sint colores et quibus in pictura modis iisdem utendum sit. Nolim a peritioribus redargui, qui dum philosophos sectantur, duos tantum esse

and vigorous. It is also true that a quantity will never appear larger than when the centric ray rests upon it. A great deal could be said about the power and function of this ray. One thing should not go unsaid: this ray alone is supported in their midst, like a united assembly, by all the others, so that it must rightly be called the leader and prince of rays. Further comment would be more appropriate to a show of learning than to the things we set out to treat, and may therefore be omitted here. Besides, much will be said about rays more suitably in their proper place. Let it suffice here, as the brevity of these books requires, to have stated those things that will leave no one doubting the truth of what I believe I have adequately shown, namely, if the distance and position of the centric ray are changed, the surface appears to be altered. For it will appear either smaller or larger or changed according to the relative disposition of the lines and angles. So the position of the centric ray and distance play a large part in the determination of sight. There is also a third condition in which surfaces present themselves to the observer as different or of diverse form. This is the reception of light. One can observe in a spherical or concave body, if there is only one source of light present, that the surface is rather dark in one part and lighter in another, whilst at the same distance and with no change of the original centric position, if the same surface lies in a different light from before, you will see as dark the parts which were bright before under the other light, and as light those parts that earlier were in the shadow. Then, if there are several lights around, various patches of brightness and darkness will alternate here and there according to the number and strength of the lights. This can be verified by experiment.

9. At this juncture we ought to say something about lights and colours. It is evident that colours vary according to light, as every colour appears different when in shade and when placed under rays of light. Shade makes a colour look dark, and light makes it bright and clear. Philosophers say that nothing is visible that is not endowed with light and colour. There is, then, a very close relationship between colours and lights in the function of sight; and the extent of this can be observed in the fact that as the light disappears, so also do the colours, and when it returns, the colours come back along with the strength of the light. This being so, we must first take a look at colours. Then we will investigate how colours vary according to light. Let us leave aside the disputes of philosophers regarding the origins of colours. For what help is it to the painter to know how colour is made from the mixture of rare and dense, or hot and dry and cold and wet? Yet I would not regard those philosophers unworthy of respect who maintain that the kinds of colours are seven in number. They set white and black as the two extremes, and another half-way between; then on both sides, between this middle one and each extreme, they put a pair of others, with some uncertainty about their boundaries, though one of each pair is more like the related extreme than the other. It is enough for the painter to know what the colours are, and how they should be used in painting. I would not wish to be contradicted by those more expert than myself, who, while

in rerum natura integros colores asserunt, album et nigrum, ceteros autem omnes ex duorum permixtione istorum oriri. Ego quidem ut pictor de coloribus ita sentio permixtionibus colorum alios oriri colores paene infinitos, sed esse apud pictores colorum vera genera pro numero elementorum quattuor, ex quibus plurimae species educantur. Namque est igneus, ut ita loquar, color quem rubeum vocant, tum et aeris qui celestis seu caesius dicitur, aquaeque color viridis; terra vero cinereum colorem habet. Ceteros omnes colores veluti diaspri et porphyrii lapidis ex permixtione factos videmus. Genera ergo colorum quattuor, quorum pro albi et nigri admixtione sunt species admodum innumerabiles. Nam videmus frondes virentes gradibus deserere viriditatem quoad albescant. Idque ipsum videmus in ipso aere ut circa horizontem plerunque albente vapore suffusus sensim ad proprium colorem redeat. Tum et in rosis hoc videmus ut aliae plenam et incensam purpuram, aliae genas virgineas, aliae candidum ebur imitentur. Terrae quoque color pro albi et nigri admixtione suas species habet.

10. Non igitur albi permixtio genus colorum immutat sed species ipsas creat. Cui quidem persimilem vim niger color habet, nam nigri admixtione multae colorum species oriuntur, quod quidem pulchre ex umbra qua ipse color alteratur patet, siquidem crescente umbra coloris claritas et albedo deficit, lumine vero insurgente clarescit et fit candidior. Ergo pictori satis persuaderi potest album et nigrum minime esse veros colores sed colorum, ut ita dixerim, alteratores, siquidem nihil invenit pictor quo ultimum luminis candorem referat praeter album solumque nigrum quo ultimas tenebras demonstret. Adde his quod album aut nigrum nusquam invenies quod ipsum non sub aliquo genere colorum sit.

11. Sequitur de vi luminum. Lumina alia siderum ut solis et lunae et luciferae stellae, alia lampadum et ignis. At inter haec magna differentia est, nam lumina siderum admodum pares corporibus umbras referunt, ignis vero umbrae maiores quam ipsa corpora sunt. Atqui fit umbra cum radii luminum intercipiuntur. Radii intercepti aut alio flectuntur aut in se ipsos reciprocantur. Flectuntur veluti cum a superficie aquae radii solis in lacunaria exiliunt, fitque omnis radiorum flexio angulis inter se, ut probant mathematici, aequalibus. Sed haec ad aliam partem picturae pertinent. Radii flexi eo colore imbuuntur quem in ea a qua flectuntur superficie invenerint. Hoc ita videmus fieri cum facies perambulantium in pratis subvirides apparent.

12. Dixi ergo de superficiebus. Dixi de radiis. Dixi quo pacto visendo ex triangulis coaedificetur pyramis. Probavimus quam maxime intersit intervallum centricique radii positionem ac luminum receptionem certam esse. Verum cum uno aspectu non unam modo sed et plurimas quoque superficies intueamur, posteaquam de singulis superficiebus non omnino ieiune conscripsimus, nunc investigandum est quemadmodum coniunctae sese superficies efferant. Singulae quidem superficies, ut docuimus, propria pyramide suis coloribus et luminibus referta gaudent. Quod

following the philosophers, nonetheless assert that in the nature of things there are only two true colours, white and black, and all the rest arise from the mixture of these two. My own view about colours, as a painter, is that from the mixture of colours there arises an almost infinite variety of others, but that for painters there are four true kinds of colours corresponding to the number of the elements, and from these many species are produced. There is fire-colour, which they call red, and the colour of air which is said to be blue or blue-gray, and the green of water, and the earth is ash-coloured. We see that all other colours, like jasper and porphyry stone, are made from a mixture. So, there are four kinds of colours, of which there are countless species according to the admixture of white and black. For we see verdant leaves gradually lose their greenness until they become white. We also see the same thing with the air, how, when, as is often the case, it is suffused around the horizon with whitish mist, it gradually changes back to its true colour. Then, with roses we see too that some are a rich bright red, others are like the cheeks of maidens, and others resemble pale ivory. The colour of earth also has its species according to the mixture of white and black.

10. The admixture of white, therefore, does not alter the basic kinds of colours, but creates species. Black has a similar power, for many species of colours arise from the addition of black. This is evident from the effect of shade on colour, for as shade deepens, the clarity and whiteness of a colour become less, and when the light increases, the colour becomes clear and brighter. The painter, therefore, may be assured that white and black are not true colours but, one might say, moderators of colours, for the painter will find nothing but white to represent the brightest glow of light, and only black for the darkest shadows. Furthermore, you will not find any white or black that does not belong to one or other of the kinds of colours.

11. Now we will speak of the effect of lights. Some are of stars, such as the sun and the moon and the morning-star, others of lamps and fire. There is a great difference between them, for the light of stars makes shadows exactly the same size as bodies, while the shadows from fire are larger than the bodies. A shadow is made when rays of light are intercepted. Rays that are intercepted are either reflected elsewhere or return upon themselves. They are reflected, for instance, when they rebound off the surface of water onto the ceiling; and, as mathematicians prove, reflection of rays always takes place at equal angles. But these are matters that concern another aspect of painting. Reflected rays assume the colour they find on the surface from which they are reflected. We see this happen when the faces of people walking about in the meadows appear to have a greenish tinge.

12. I have spoken about surfaces and about rays. I have explained how, in seeing, a pyramid is made up of triangles. We have shown how extremely important it is that the distance, the position of the centric ray, and the reception of light should be determined. But as at one glance we see not merely one but several surfaces together, now that we have dealt in some detail with single surfaces, we must enquire in what way

cum ex superficiebus corpora integantur, totae corporum prospectae quantitates unicam pyramidem referent tot minutis pyramidibus gravidam quot eo prospectu superficies radiis comprehendantur. Haec cum ita sint, dicet tamen quispiam quid tanta indagatio pictori ad pingendum afferet emolumenti. Nempe ut intelligat se futurum artificem plane optimum ubi optime superficierum discrimina et proportiones notarit, quod paucissimi admodum noverunt. Nam si rogentur quid in ea quam tingunt superficie conentur assequi, omnia rectius possunt quam quid ita studeant respondere. Quare obsecro nos audiant studiosi pictores. Quae enim didicisse iuvabit, ea a quovis praeceptore discere nunquam fuit turpe. Ac discant quidem dum lineis circumeunt superficiem, dumque descriptos locos implent coloribus, nihil magis queri quam ut in hac una superficie plures superficierum formae repraesententur, non secus ac si superficies haec, quam coloribus operiunt, esset admodum vitrea et perlucida huiusmodi ut per eam tota pyramis visiva permearet certo intervallo certaque centrici radii et luminis positione cominus in aere suis locis constitutis. Quod ipsum ita esse demonstrant pictores dum sese ab eo quod pingunt ammovent longiusque consistunt natura duce cuspidem pyramidis quaeritantes unde omnia rectius concerni intelligunt. Sed cum haec sit unica seu tabulae seu parietis superficies in quam pictor plures una pyramide comprehensas superficies studet effingere, necesse erit aliquo loco sui pyramidem visivam perscindi, ut istic quales fimbrias et colores intercisio dederit, tales pictor lineis et pingendo exprimat. Quae res cum ita sit, pictam superficiem intuentes intercisionem quandam pyramidis videre videntur. Erit ergo pictura intercisio pyramidis visivae secundum datum intervallum posito centro statutisque luminibus in datam superficiem lineis et coloribus arte repraesentata.

13. Iam vero, quoniam picturam diximus esse intercisionem pyramidis, omnia idcirco perscrutanda sunt ex quibus nobis intercisio sit notissima. Nobis ergo novissimus sermo habendus est de superficiebus a quibus pyramides pictura intercidendas manare demonstratum est. Superficierum aliae prostratae iacent ut pavimenta aedificiorum et ceterae superficies aeque a pavimento distantes, aliae in latus incumbunt ut sunt parietes et ceterae superficies parietibus collineares. Inter se autem aeque distare superficies dicuntur cum intermedia inter eas distantia omni loco eadem est. Collineares superficies illae sunt quas eadem continuata recta linea omni in parte sui aeque contingit, uti sunt superficies quadratarum columnarum quae rectum in ordinem ad porticum adstant. Haec illis quae supra de superficiebus diximus addenda sunt. His vero, quae de radiis cum extrinsecis tum intrinsecis et centrico, atque his quae supra de pyramide visiva recensuimus, addenda est illa mathematicorum sententia ex qua illud probatur quod, si linea recta duo alicuius trianguli latera intersecet, sitque haec ipsa secans et novissime triangulum condens linea alterae lineae prioris trianguli aequedistans, erit tunc quidem is maior triangulus huic minori proportionalis. Haec mathematici.

surfaces that are connected together present themselves. As we have said, individual surfaces enjoy their own pyramid charged with its particular colours and lights. Since bodies are covered in surfaces, all the observed quantities of bodies will make up a single pyramid containing as many small pyramids as there are surfaces embraced by the rays from that point of vision. Even so, someone may ask what practical advantage all this enquiry brings to the painter. It is this: he must understand that he will become an excellent artist only if he knows well the outlines of surfaces and their proportions, which very few do; for if they are asked what they are attempting to do on the surface they are painting, they can answer more correctly about everything else than about what in this sense they are doing. So I beg studious painters to listen to me. It was never shameful to learn from any teacher things that are useful to know. They should understand that, when they draw lines around a surface, and fill the parts they have drawn with colours, their sole object is the representation on this one surface of many different forms of surfaces, just as though this surface which they colour were so transparent and like glass, that the visual pyramid passed right through it from a certain distance and with a certain position of the centric ray and of the light, established at appropriate points nearby in space. Painters prove this when they move away from what they are painting and stand further back, seeking to find by the light of nature the vertex of the pyramid from which they know everything can be more correctly viewed. But as it is only a single surface of a panel or a wall, on which the painter strives to represent many surfaces contained within a single pyramid, it will be necessary for his visual pyramid to be cut at some point, so that the painter by drawing and colouring can express whatever outlines and colours that intersection presents. Consequently the viewers of a painted surface appear to be looking at a particular intersection of the pyramid. Therefore, a painting will be the intersection of a visual pyramid at a given distance, with a fixed centre and certain position of lights, represented artistically with lines and colours on a given surface.

13. Having said that painting represents the intersection of a pyramid, we must now examine all those things that enable us to understand that intersection. We must, therefore, say something further about the surfaces from which, as we have shown, the pyramids to be intersected in the painting arise. Some surfaces lie horizontally before one, like the floors of buildings and other surfaces equidistant from the floor. Others stand perpendicularly, such as walls and other surfaces collinear with them. Surfaces are said to be equidistant from one another when the distance between them is the same at every point. Collinear surfaces are those which a continuous straight line touches equally in every part, like the surfaces of square columns standing in regular succession in an arcade. These remarks should be added to what we said above about surfaces. And to what we said about extrinsic, median and centric rays, and about the visual pyramid, should be added the mathematical proposition that if a straight line intersects two sides of a triangle, and this intersecting line, which forms a new triangle,

14. At nos quo clarior sit nostra oratio, latius hanc propositionem explicabimus. Intelligendum est quid sit hoc loco proportionale pictori. Dicimus proportionales esse triangulos quorum latera et anguli inter se eandem admodum rationem servant, quod si alterum trianguli latus sit in longitudine bis quam basis atque semis et alterum ter, omnes hi eiusmodi trianguli seu sint illi quidem maiores hoc seu minores, modo eandem laterum ad basim, ut ita loquar, convenientiam habeant, erunt inter se apud nos proportionales. Nam quae ratio partis ad partem extat in maiori triangulo, eadem in minori. Ergo trianguli qui ita se habeant omnes inter se proportionales sunt. Hoc quoque ut apertius intelligatur similitudine quadam utemur. Est quidem homo pusillus homini maximo proportionalis, nam eadem fuit proportio palmi ad passum et pedis ad reliquas sui corporis partes in Evandro[1] quae fuit in Hercule, quem Gelius supra alios homines procerum et magnum fuisse coniectatur. Neque tamen fuit alia in membris Herculis proportio quam fuit in Antaei gigantis corpore, siquidem utrisque manus ad cubitum et cubiti ad proprium caput et ceterorum membrorum symmetria pari inter se ordine congruebat. Hoc ipsum in triangulis evenit, ut sit aliqua inter triangulos commensuratio, per quam minor cum maiori ceteris in rebus praeterquam in magnitudine conveniat. Haec autem si satis intelliguntur, statuamus mathematicorum sententia quantum ad rem nostram conducit, omnem intercisionem alicuius trianguli aequedistantem a basi triangulum constituere illi suo maiori triangulo proportionalem. Etenim quae inter se proportionalia sunt, in his omnes partes respondent. In quibus vero diversae et non congruentes partes adsunt, hae minime proportionales sunt.

15. Partes trianguli visivi sunt anguli ipsi et radii, qui quidem erunt in proportionalibus quantitatibus admodum pares ac in non proportionalibus erunt dispares; tum et altera istarum non proportionalium visa quantitas aut pluros occupabit radios aut pauciores. Nosti ergo quemadmodum minor triangulus aliquis maiori proportionalis sit, et meministi ex triangulis pyramidem visivam construi. Ergo omnis noster sermo de triangulis habitus ad pyramidem traducatur, ac persuasum quidem apud nos sit nullas quantitates superficiei, quae aeque ab intercisione sui distent, in pictura alterationem aliquam facere. Nam sunt illae quidem aequedistantes quantitates in omni aequedistanti intercisione suis proportionalibus pares. Quae res cum ita sit, sequitur illud quod non alteratis quantitatibus ex quibus fimbria efficitur nulla fimbriae alteratio in pictura succedit. Itaque illud manifestum est omnem pyramidis visivae intercisionem a visa superficie aequedistantem illi prospectae superficiei esse conproportionalem.

16. Diximus de superficiebus intercisioni proportionalibus, hoc est superficiei pictae aequedistantibus. Verum cum perplurimae pingendae superficies non aequedistantes adsint, de his nobis investigatio diligens habenda est quo omnis ratio

[1] Aul. Gell., *Noct. Att.* I, i, 1–3.

is equidistant from one of the sides of the first triangle, then the greater triangle will be proportional to the lesser. This is what mathematicians affirm.

14. In order to make our argument clearer, we will explain this proposition more fully. Here it is necessary for the painter to know what is meant by proportional. We say that triangles are proportional when their sides and angles stand in the same relationship to each other, because, if one side of a triangle is two and a half times as long as the base and the other three times, then all similar triangles, whether they are larger or smaller, will for us be proportional to one another, provided they have the same correspondence between the sides and the base, since the ratio of one part to another in the greater triangle is the same also in the lesser. Therefore triangles constructed in this way are all proportional. In order that this may be even more clearly understood, we will employ a comparison. A very small man is proportional to a very large one; for there was the same proportion of span to stride, and of foot to the remaining parts of the body in Evander as there was in Hercules, whom Gellius conjectures was taller and bigger than other men. Yet the proportion of the limbs of Hercules was no different from that of the body of the giant Antaeus, since the symmetry from the hand to the elbow, and the elbow to the head, and all the other members, corresponded in both in similar ratio. Similarly in triangles, there can be a certain uniformity between them, whereby the lesser agrees with the greater in all respects except in size. If this is now clear, we may accept the mathematicians' proposition as far as it serves our purpose, and conclude that every intersection of any triangle equidistant from its base will create a triangle proportional to the larger triangle. In things which are proportional to one another, all the parts correspond; but those which have different and incongruous parts are in no sense proportional.

15. The parts of the visual triangle are the angles and the rays, which in proportional quantities will be equal, and in non-proportional quantities unequal; for any one of these non-proportional quantities seen will occupy either more or less rays. You have seen how any lesser triangle may be proportional to a greater, and remember that the visual pyramid is made up of triangles. So all we have said about triangles may be transferred to the pyramid, and we may be sure that no quantities of the surface that are equidistant from the intersection of the pyramid, undergo any change in the painting; for those equidistant quantities are equal, at any equidistant intersection, to those proportional to them. From this it follows that if the quantities that make up the outline of a surface are not changed, there occurs no change in that outline in the painting. And so it is clear that any intersection of the visual pyramid equidistant from the surface seen is proportional to that surface.

16. We have spoken of the surfaces proportional to the intersection, that is, equidistant from the painting surface. But as many surfaces are not equidistant from the painting surface, we must enquire carefully into these, so that the entire system of the intersection may be made clear. Yet it would be a long, difficult, and extremely involved task to

intercisionis explicetur. Etenim longum esset perdifficileque atque obscurissimum in his triangulorum ac pyramidis intercisionibus omnia mathematicorum regula prosequi. Idcirco nostro more ut pictores dicendo procedamus.

17. Referamus brevissime aliqua de quantitatibus non aequedistantibus, quibus perceptis facilis erit omnis non aequedistantis superficiei cognitio. Quantitatum ergo non aequedistantium aliae radiis visivis collineares, aliae radiis aliquibus visivis aequedistantes sunt. Quantitates radiis collineares, quoniam triangulum non efficiant radiorumque numerum non occupent, locum idcirco nullum in intercisione adipiscuntur. At in quantitatibus radiis visivis aequedistantibus quanto qui maior est angulus ad basim trianguli erit obtusior, tanto ea quantitas minus radiorum excipiet atque idcirco in intercisione minus obtinebit spatii. Superficiem quantitatibus contegi diximus; at cum in superficiebus non raro eveniat ut in ea sint quantitates aliquae aeque ab intercisione distantes, caeterae vero eiusdem superficiei quantitates non aeque distent, eam ob rem fit ut quae in superficie adsunt aequedistantes quantitates, hae solae in pictura nullam alterationem faciant. Quae vero quantitates non aequedistant, hae quanto angulum qui in triangulo sit [ad basim] maior obtusiorem habebunt, tanto plus alterationis accipient.

18. Denique his omnibus addenda illa philosophorum[2] opinio est qua affirmant, si coelum, sidera, maria, montes, animantiaque ipsa atque deinceps corpora omnia dimidio quam sint minora, superis ita volentibus, redderentur, fore ut nobis quaeque videantur nulla ex parte ac nunc sint diminuta apparerent. Nam magnum, parvum, longum, breve, altum, infimum, latum, arctum, clarum, obscurum, [luminosum], tenebrosum et huiusmodi omnia, quae cum possint rebus adesse et non adesse, ea philosophi accidentia nuncuparunt, huiusmodi sunt ut omnis earum cognitio fiat comparatione. Aeneam inquit Virgilius[3] totis humeris supra homines extare, at is, si Polyphemo comparetur, pygmaeus videbitur. Euryalum pulcherrimum fuisse tradunt, qui si Ganymedi a diis rapto comparetur, fortassis deformis videatur. Apud Hispanos pleraeque virgines candidae putantur, quae apud Germanos fuscae et atri coloris haberentur. Ebur argentumque colore alba sunt, quae si cigno aut niveis linteis comparentur, subpallentia videantur. Hac ratione in pictura tersissimae ac fulgentissimae quidem superficies apparent, cum illic albi ad nigrum eadem quae est in rebus ipsis luminati ad umbrosum proportio sit. Itaque comparationibus haec omnia discuntur. Inest enim in comparandis rebus vis, ut quid plus, quid minus, quidve aequale adsit, intelligamus. Ex quo magnum esse dicimus quod sit hoc parvo maius, maximum quod sit hoc magno maius, lucidum quod sit obscuro clarius, lucidissimum quod sit hoc claro lucidius. Fit quidem comparatio ad res imprimis notissimas. Sed cum sit homo rerum omnium homini notissimus, fortassis

[2] The philosophers are probably the Sceptics (Mallè, ed. cit. p. 69).

[3] I have failed to trace this statement about Aeneas in Virgil. *Aen.* VI, 668 contains a similar affirmation but not about Aeneas.

pursue all the mathematicians' rules in these intersections of triangles and the pyramid. Let us proceed to deal with the matter as painters.

17. Let us briefly say something about non-equidistant quantities, from an understanding of which it will be easy to learn all about the non-equidistant surface. Of non-equidistant quantities some are collinear to the visual rays, others are equidistant from some visual rays. Quantities collinear to the rays have no room at the intersection, as they make no triangle and occupy no number of rays. But in quantities equidistant from the visual rays, the more obtuse the greater angle is at the base of the triangle, the fewer the rays that quantity will occupy, and consequently the less space it will take up at the intersection. We have said that surfaces were covered in quantities; but as it not infrequently happens in surfaces that there are some quantities equidistant from the intersection, while the rest are not, for this reason only those that are equidistant undergo no change in the painting, and the non-equidistant quantities suffer the more alteration, the more obtuse is the greater angle of their triangle at the base.

18. To all these remarks should be added the belief of philosophers that if the sky, the stars, the seas, the mountains and all living creatures, together with all other objects, were, the gods willing, reduced to half their size, everything that we see would in no respect appear to be diminished from what it is now. Large, small, long, short, high, low, wide, narrow, light, dark, bright, gloomy, and everything of the kind, which philosophers termed accidents, because they may or may not be present in things,—all these are such as to be known only by comparison. Virgil says that Aeneas stands head and shoulders above other men, but if compared with Polyphemus, he will seem a pygmy. They say that Euryalus was most beautiful, but if compared with Ganymede, who was carried off by the gods, he might appear to be ugly. The Spaniards think many young maidens fair, whom the Germans would regard as swarthy and dark. Ivory and silver are white, but compared to the swan or snow-white linen, they appear rather pale. For this reason, surfaces will appear very clear and bright in a painting when there is the same proportion of white to black in it as there is of light to shade in objects themselves. All these things, then, are learned by comparison. There is in comparison a power which enables us to recognize the presence of more or less or just the same. So we call large what is bigger than this small thing, and very large what is bigger than the large, and bright what is lighter than this dark object, and very bright what is brighter than the light. Comparison is made with things most immediately known. As man is the best known of all things to man, perhaps Protagoras, in saying that man is the scale and the measure of all things, meant that accidents in all things are duly compared to and known by the accidents in man. All of which should persuade us that, however small you paint the objects in a painting, they will seem large or small according to the size of any man in the picture. Of all the ancients, the painter Timanthes always seems to me to have observed this force of comparison best. They say that he represented on a small panel a Cyclops asleep, and put in next to him some satyrs

Protagoras,[4] hominem inquiens modum et mensuram rerum omnium esse, hoc ipsum intelligebat rerum omnium accidentia hominis accidentibus recte comparari atque cognosci. Haec eo spectant ut intelligamus in pictura quantulacunque pinxeris corpora, ea pro illic picti hominis commensuratione grandia aut pusilla videri. Hanc sane vim comparationis pulcherrime omnium antiquorum prospexisse Timanthes[5] mihi videri solet, qui pictor, ut aiunt, Cyclopem dormientem parva in tabella pingens fecit iuxta satyros pollicem dormientis amplectentes ut ea satyrorum commensuratione dormiens multo maximus videretur.

19. Hactenus a nobis ferme omnia dicta sunt quae ad visendi vim quaeve ad intercisionem cognoscendam spectant. Sed quia non modo quid sit atque ex quibus constet intercisio, verum etiam quemadmodum eadem fiat, ad rem pertinet, dicendum est de hac intercisione quanam arte pingendo exprimatur. De hac igitur, ceteris omissis, referam quid ipse dum pingo efficiam. Principio in superficie pingenda quam amplum libeat quadrangulum rectorum angulorum inscribo, quod quidem mihi pro aperta finestra est ex qua historia contueatur, illicque quam magnos velim esse in pictura homines determino. Huiusque ipsius hominis longitudinem in tres partes divido, quae quidem mihi partes sunt proportionales cum ea mensura quam vulgus brachium nuncupat. Nam ea trium brachiorum, ut ex symmetria membrorum hominis patet, admodum communis humani corporis longitudo est. Ista ergo mensura iacentem infimam descripti quadranguli lineam in quot illa istiusmodi recipiat partes divido, ac mihi quidem haec ipsa iacens quadranguli linea est proximiori transversae et aequedistanti in pavimento visae quantitati proportionalis. Post haec unicum punctum quo sit visum loco intra quadrangulum constituo, qui mihi punctus cum locum occupet ipsum ad quem radius centricus applicetur, idcirco centricus punctus dicatur. Condecens huius centrici puncti positio est non altius a iacenti linea quam sit illius pingendi hominis longitudo, nam hoc pacto aequali in solo et spectantes et pictae res adesse videntur. Posito puncto centrico, protraho lineas rectas a puncto ipso centrico ad singulas lineae iacentis divisiones, quae quidem mihi lineae demonstrant quemadmodum paene usque ad infinitam distantiam quantitates transversae successivae sub aspectu alterentur. Hic essent nonnulli qui unam ab divisa aequedistantem lineam intra quadrangulum ducerent, spatiumque, quod inter utrasque lineas adsit, in tres partes dividerent. Tum huic secundae aequedistanti lineae aliam item aequedistantem hac lege adderent, ut spatium, quod inter primam divisam et secundam aequedistantem lineam est, in tres partes divisum una parte sui excedat spatium id quod sit inter secundam et tertiam lineam, ac deinceps reliquas lineas adderent ut semper sequens inter lineas esset spatium ad antecedens, ut verbo mathematicorum loquar, superbipartiens. Itaque sic illi quidem facerent, quos etsi optimam quandam pingendi

[4] Protagoras, in H. Diels, *Vorsokr.*,[5] ii, 253–71. Alberti turns Protagoras's comment on the relativity of truth into a criterion of perception and knowledge about the world. [5] Pliny, *N.H.*, xxxv, 74.

embracing his thumb, so that the sleeping figure appeared very large indeed in proportion to the satyrs.

19. Up to now we have explained everything related to the power of sight and the understanding of the intersection. But as it is relevant to know, not simply what the intersection is and what it consists in, but also how it can be constructed, we must now explain the art of expressing the intersection in painting. Let me tell you what I do when I am painting. First of all, on the surface on which I am going to paint, I draw a rectangle of whatever size I want, which I regard as an open window through which the subject to be painted is seen; and I decide how large I wish the human figures in the painting to be. I divide the height of this man into three parts, which will be proportional to the measure commonly called a *braccio*; for, as may be seen from the relationship of his limbs, three *braccia* is just about the average height of a man's body. With this measure I divide the bottom line of my rectangle into as many parts as it will hold; and this bottom line of the rectangle is for me proportional to the next transverse equidistant quantity seen on the pavement. Then I establish a point in the rectangle wherever I wish; and as it occupies the place where the centric ray strikes, I shall call this the centric point. The suitable position for this centric point is no higher from the base line than the height of the man to be represented in the painting, for in this way both the viewers and the objects in the painting will seem to be on the same plane. Having placed the centric point, I draw straight lines from it to each of the divisions on the base line. These lines show me how successive transverse quantities visually change to an almost infinite distance. At this stage some would draw a line across the rectangle equidistant from the divided line, and then divide the space between these two lines into three parts. Then, to that second equidistant line they would add another above, following the rule that the space which is divided into three parts between the first divided (base) line and the second equidistant one, shall exceed by one of its parts the space between the second and third lines; and they would go on to add other lines in such a way that each succeeding space between them would always be to the one preceding it in the relationship, in mathematical terminology, of *superbipartiens*. That would be their way of proceeding, and although people say they are following an excellent method of painting, I believe they are not a little mistaken, because, having placed the first equidistant line at random, even though the other equidistant lines follow with some system and reason, nonetheless they do not know where the fixed position of the vertex of the pyramid is for correct viewing. For this reason quite serious mistakes occur in painting. What is more, the method of such people would be completely faulty, where the centric point were higher or lower than the height of a man in the picture. Besides, no learned person will deny that no objects in a painting can appear like real objects, unless they stand to each other in a determined relationship. We will explain the theory behind this if ever we write about the demonstrations of painting, which our friends marvelled at when we did them, and called them 'miracles

viam sequi affirment, eosdem tamen non parum errare censeo, quod cum casu primam aequedistantem lineam posuerint, tametsi ceterae aequedistantes lineae ratione et modo subsequantur, non tamen habent quo sit certus cuspidis ad bene spectandum locus. Ex quo non modici in pictura errores facile succedunt. Adde his quod istorum ratio admodum vitiosa esset, ubi centricus punctus aut supra aut infra picti hominis longitudinem adstaret. Tum etiam pictas res nullas veris rebus pares, nisi certa ratione distent, videri posse nemo doctus negabit. Cuius rei rationem explicabimus, siquando de his demonstrationibus picturae conscribemus, quas a nobis factas amici dum admirarentur miracula picturae nuncuparunt. Nam ad eam ipsam partem haec quae dixi maxime pertinent. Ergo ad rem redeamus.

20. Haec cum ita sint, ipse idcirco optimum hunc adinveni modum. In caeteris omnibus eandem illam et centrici puncti et lineae iacentis divisionem et a puncto linearum ductionem ad singulas iacentis lineae divisiones prosequor. Sed in successivis quantitatibus transversis hunc modum servo. Habeo areolam in qua describo lineam unam rectam. Hanc divido per eas partes in quas iacens linea quadranguli divisa est. Dehinc pono sursum ab hac linea punctum unicum ad alterum lineae caput perpendicularem tam alte quam est in quadrangulo centricus punctus a iacente divisa quadranguli linea distans, ab hocque puncto ad singulas huius ipsius lineae divisiones singulas lineas duco. Tum quantam velim distantiam esse inter spectantis oculum et picturam statuo, atque illic statuto intercisionis loco, perpendiculari, ut aiunt mathematici, linea intercisionem omnium linearum, quas ea invenerit, efficio. Perpendicularis quidem linea ea est quae aliam rectam lineam dividens angulos utrinque circa se rectos habeat. Igitur haec mihi perpendicularis linea suis percisionibus terminos dabit omnis distantiae quae inter transversas aequedistantes pavimenti lineas esse debeat. Quo pacto omnes pavimenti parallelos descriptos habeo. Est enim parallelus spatium quod intersit inter duas aequedistantes lineas de quibus supra nonnihil tetigimus. Qui quidem quam recte descripti sint inditio erit, si una eademque recta continuata linea in picto pavimento coadiunctorum quadrangulorum diameter sit. Est quidem apud mathematicos diameter quadranguli recta quaedam linea ab angulo ad sibi oppositum angulum ducta, quae in duas partes quadrangulum dividat ita ut ex quandrangulo duos triangulos efficiat. His ergo diligenter absolutis, unam item superduco transversam aeque a ceteris inferioribus distantem lineam, quae duo stantia magni quadrati latera secet, perque punctum centricum permeet. Haec mihi quidem linea est terminus atque limes, quem nulla non plus alta quam sit visentis oculus quantitas excedat. Eaque quod punctum centricum pervadat, idcirco centrica dicatur. Ex quo fit ut qui picti homines in ulteriori parallelo steterint, iidem longe minores sint quam qui in anterioribus adstant, quam rem quidem a natura ipsa ita ostendi palam est. Nam in templis perambulantium hominum capita videmus fere in altum aequalia nutare, pedes vero eorum qui longius absint forte ad genu anteriorum respondere.

of painting'; for the things I have said are extremely relevant to this aspect of the subject. Let us return, therefore, to what we were saying.

20. With regard to the question outlined above, I discovered the following excellent method. I follow in all other respects the same procedure I mentioned above about placing the centric point, dividing the base line and drawing lines from that point to each of the divisions of the base line. But as regards the successive transverse quantities I observe the following method. I have a drawing surface on which I describe a single straight line, and this I divide into parts like those into which the base line of the rectangle is divided. Then I place a point above this line, directly over one end of it, at the same height as the centric point is from the base line of the rectangle, and from this point I draw lines to each of the divisions of the line. Then I determine the distance I want between the eye of the spectator and the painting, and, having established the position of the intersection at this distance, I effect the intersection with what mathematicians call a perpendicular. A perpendicular is a line which at the intersection with another straight line makes right angles on all sides. This perpendicular will give me, at the places it cuts the other lines, the measure of what the distance should be in each case between the transverse equidistant lines of the pavement. In this way I have all the parallels of the pavement drawn. A parallel is the space between two equidistant lines, of which we spoke at some length above. A proof of whether they are correctly drawn will be if a single straight line forms a diameter of connected quadrangles in the pavement. The diameter of a quadrangle for mathematicians is the straight line drawn from one angle to the angle opposite it, which divides the quadrangle into two parts so as to create two triangles from it. When I have carefully done these things, I draw a line across, equidistant from the other lines below, which cuts the two upright sides of the large rectangle and passes through the centric point. This line is for me a limit or boundary, which no quantity exceeds that is not higher than the eye of the spectator. As it passes through the centric point, this line may be called the centric line. This is why men depicted standing in the parallel furthest away are a great deal smaller than those in the nearer ones,—a phenomenon which is clearly demonstrated by nature herself, for in churches we see the heads of men walking about, moving at more or less the same height, while the feet of those further away may correspond to the knee-level of those in front.

21. This method of dividing up the pavement pertains especially to that part of painting which, when we come to it, we shall call composition; and it is such that I fear it may be little understood by readers on account of the novelty of the subject and the brevity of our description. As we can easily judge from the works of former ages, this matter probably remained completely unknown to our ancestors because of its obscurity and difficulty. You will hardly find any 'historia' of theirs properly composed either in painting or modelling or sculpture.

22. I have set out the foregoing briefly and, I believe, in a not altogether obscure

21. Haec omnis dividendi pavimenti ratio maxime ad eam picturae partem pertinet, quam nos compositionem suo loco nominabimus. Et huiusmodi est ut verear ne ob materiae novitatem obque hanc commentandi brevitatem parum a legentibus intelligatur. Nam, ut ex operibus priscis facile intelligimus, eadem fortassis apud maiores nostros, quod esset obscura et difficillima, admodum incognita latuit. Vix enim ullam antiquorum historiam apte compositam, neque pictam, neque fictam, neque sculptam reperies.

22. Qua de re haec a me dicta sunt breviter et, ut existimo, non omnino obscure, sed intelligo qualia sint ut cum in his nullam eloquentiae laudem adipisci queam, tum eadem qui primo aspectu non comprehenderit, vix ullo unquam vel ingenti labore apprehendat. Subtilissimis autem et ad picturam bene pronis ingeniis haec, quoquomodo dicantur, facillima sane et pulcherrima sunt, quae quidem rudibus et a natura parum ad has nobilissimas artes pronis, etiam si ab eloquentissimis dicantur, admodum ingrata sunt. A nobis vero eadem, quod sine ulla eloquentia brevissime recitata sint, fortassis non sine fastidio leguntur. Sed velim nobis dent veniam si, dum imprimis volui intelligi, id prospexi ut clara esset nostra oratio magis quam compta et ornata. Quae vero sequentur minus, ut spero, tedium legentibus afferent.

23. Diximus ergo de triangulis, de pyramide, de intercisione, quae dicenda videbantur, quas res tamen consuevi apud familiares prolixius quadam geometrica ratione cur ea ita essent demonstrare, quod his commentariis brevitatis causa praetermittendum censui. Hic enim sola prima picturae artis rudimenta pictor quidem pictoribus recensui. Eaque idcirco rudimenta nuncupari volumus, quod ineruditis pictoribus prima artis fundamenta iecerint. Sed huiusmodi sunt ut qui eadem probe tenuerit, is cum ad ingenium tum ad cognoscendam picturae definitionem, tum etiam ad ea de quibus dicturi sumus, non minimum profuisse intelligat. Neque sit qui dubitet futurum pictorem nunquam bonum eum, qui quae pingendo conetur non ad unguem intelligat. Frustra enim arcu contenditur, nisi quo sagittam dirigas destinatum habeas. Ac velim quidem apud nos persuasum esse eum solum fore pictorem optimum, qui optime cum fimbrias tum superficierum qualitates omnes notasse didicerit. Contraque eum futurum nunquam bonum arteficem affirmo, qui non diligentissime quae diximus omnia tenuerit.

24. Idcirco nobis haec de superficiebus et intercisione dicta pernecessaria fuere. Sequitur ut pictorem instituamus quemadmodum quae mente conceperit ea manu imitari queat.

fashion, but I realize the content is such that, while I can claim no praise for eloquence in exposition, the reader who does not understand at first acquaintance, will probably never grasp it however hard he tries. To intelligent minds that are well disposed to painting, those things are simple and splendid, however presented, which are disagreeable to gross intellects little disposed to these noble arts, even if expounded by the most eloquent writers. As they have been explained by me briefly and without eloquence, they will probably not be read without some distaste. Yet I crave indulgence if, in my desire above all to be understood, I saw to it that my exposition should be clear rather than elegant and ornate. What follows will, I hope, be less disagreeable to the reader.

23. I have set out whatever seemed necessary to say about triangles, the pyramid and the intersection. I used to demonstrate these things at greater length to my friends with some geometrical explanation. I considered it best to omit this from these books for reasons of brevity. I have outlined here, as a painter speaking to painters, only the first rudiments of the art of painting. And I have called them rudiments, because they lay the first foundations of the art for unlearned painters. They are such that whoever has grasped them properly will see they are of considerable benefit, not only to his own talent and to understanding the definition of painting, but also to the appreciation of what we are going to say later on. Let no one doubt that the man who does not perfectly understand what he is attempting to do when painting, will never be a good painter. It is useless to draw the bow, unless you have a target to aim the arrow at. I want us to be convinced that he alone will be an excellent painter who has learned thoroughly to understand the outlines and all the properties of surfaces. On the other hand, I believe that he who has not diligently mastered all we have said, will never be a good artist.

24. These remarks on surfaces and intersection were, therefore, essential for our purposes. We will now go on to instruct the painter how he can represent with his hand what he has understood with his mind.

Liber II

25. Sed quoniam hoc perdiscendi studium forte nimis laboriosum iuvenibus videri potest, idcirco hoc loco ostendendum censeo quam sit pictura non indigna, in qua omnem operam et studium consumamus. Nam habet ea quidem in se vim admodum divinam non modo ut quod de amicitia dicunt,[6] absentes pictura praesentes esse faciat, verum etiam defunctos longa post saecula viventibus exhibeat, ut summa cum artificis admiratione ac visentium voluptate cognoscantur. Refert Plutarchus[7] Cassandrum unum ex Alexandri ducibus, quod simulacrum iam defuncti Alexandri intueretur, in quo regis maiestatem cognovisset, toto cum corpore trepidasse, Agesilaumque[8] Lacenam, quod se esse admodum deformem intelligeret, suam recusasse a posteris effigiem cognosci, eaque de re neque pingi a quoquam neque fingi voluisse. Itaque vultus defunctorum per picturam quodammodo vitam praelongam degunt. Quod vero pictura deos expresserit quos gentes venerentur, maximum id quidem mortalibus donum fuisse censendum est, nam ad pietatem qua superis coniuncti sumus, atque ad animos integra quadam cum religione detinendos nimium pictura profuit. Phidias[9] in Elide Iovem fecisse dicitur, cuius pulchritudo non parum receptae religioni adiecerit. Iam vero ad delitias animi honestissimas atque ad rerum decus quantum conferat pictura, cum aliunde tum hinc maxime licet videre, quod nullam ferme dabis rem usque adeo pretiosam, quam picturae societas non longe cariorem multoque gratiosissimam efficiat. Ebur, gemmae et istiusmodi cara omnia pictoris manu fiunt pretiosiora. Aurum quoque ipsum picturae arte elaboratum longe plurimo auro penditur. Quin vel plumbum, metallorum vilissimum, si Phidiae aut Praxitelis manu in simulacrum aliquod deductum sit, argento rudi atque inelaborato esse pretiosius fortassis videbitur. Zeuxis[10] pictor suas res donare ceperat, quoniam, ut idem aiebat, pretio emi non possent. Nullum enim pretium existimabat inveniri quod satisfaceret huic qui fingendis aut pingendis animantibus quasi alterum sese inter mortales deum praestaret.

26. Has ergo laudes habet pictura, ut ea instructi cum opera sua admirari videant, tum deo se paene simillimos esse intelligant. Quid, quod omnium artium vel magistra vel sane praecipuum pictura ornamentum est? Nam architectus quidem epistilia, capitula, bases, columnas fastigiaque et huiusmodi ceteras omnes aedificiorum laudes, ni fallor, ab ipso tantum pictore sumpsit. Pictoris enim regula et arte lapicida, sculptor, omnesque fabrorum officinae omnesque fabriles artes diriguntur. Denique nulla paene ars non penitus abiectissima reperietur quae picturam non spectet, ut in rebus quicquid adsit decoris, id a pictura sumptum

[6] Cicero, *De amicitia*, 7, 23. [7] Plutarch, *Alex.*, LXXIV, 4. [8] Plutarch, *Ages.*, II, 2.
[9] Quintilian, *De Inst. Orat.*, 12, 10, 9. [10] Pliny, *N.H.*, XXXV, 62.

Book II

25. As the effort of learning may perhaps seem to the young too laborious, I think I should explain here how painting is worthy of all our attention and study. Painting possesses a truly divine power in that not only does it make the absent present (as they say of friendship), but it also represents the dead to the living many centuries later, so that they are recognized by spectators with pleasure and deep admiration for the artist. Plutarch tells us that Cassandrus, one of Alexander's commanders, trembled all over at the sight of a portrait of the deceased Alexander, in which he recognized the majesty of his king. He also tells us how Agesilaus the Lacedaemonian, realizing that he was very ugly, refused to allow his likeness to be known to posterity, and so would not be painted or modelled by anyone. Through painting, the faces of the dead go on living for a very long time. We should also consider it a very great gift to men that painting has represented the gods they worship, for painting has contributed considerably to the piety which binds us to the gods, and to filling our minds with sound religious beliefs. It is said that Phidias made a statue of Jove in Elis, whose beauty added not a little to the received religion. How much painting contributes to the honest pleasures of the mind, and to the beauty of things, may be seen in various ways but especially in the fact that you will find nothing so precious which association with painting does not render far more valuable and highly prized. Ivory, gems, and all other similar precious things are made more valuable by the hand of the painter. Gold too, when embellished by the art of painting, is equal in value to a far larger quantity of gold. Even lead, the basest of metals, if it were formed into some image by the hand of Phidias or Praxiteles, would probably be regarded as more precious than rough unworked silver. The painter Zeuxis began to give his works away, because, as he said, they could not be bought for money. He did not believe any price could be found to recompense the man who, in modelling or painting living things, behaved like a god among mortals. **26.** The virtues of painting, therefore, are that its masters see their works admired and feel themselves to be almost like the Creator. Is it not true that painting is the mistress of all the arts or their principal ornament? If I am not mistaken, the architect took from the painter architraves, capitals, bases, columns and pediments, and all the other fine features of buildings. The stonemason, the sculptor and all the workshops and crafts of artificers are guided by the rule and art of the painter. Indeed, hardly any art, except the very meanest, can be found that does not somehow pertain to painting. So I would venture to assert that whatever beauty there is in things has been derived from painting. Painting was honoured by our ancestors with this special distinction that, whereas all other artists were called craftsmen, the painter alone was not counted among their number. Consequently I used to tell my friends that the inventor of painting, according to the poets, was Narcissus, who was turned into a flower; for, as painting is the flower

audeam dicere. Sed et hoc in primis honore a maioribus honestata pictura est ut, cum caeteri ferme omnes artifices fabri nuncuparentur, solus pictor in fabrorum numero non esset habitus. Quae cum ita sint, consuevi inter familiares dicere picturae inventorem fuisse, poetarum sententia, Narcissum[11] illum qui sit in florem versus, nam cum sit omnium artium flos pictura, tum de Narcisso omnis fabula pulchre ad rem ipsam perapta erit. Quid est enim aliud pingere quam arte superficiem illam fontis amplecti? Censebat Quintilianus priscos pictores solitos umbras ad solem circumscribere, demum additamentis artem excrevisse.[12] Sunt qui referant Phyloclem quendam Aegyptium et Cleantem nescio quem inter primos huius artis repertores fuisse. Aegyptii affirmant sex millibus annorum apud se picturam in usu fuisse prius quam in Graeciam esset translata. E Graecia vero in Italiam dicunt nostri venisse picturam post Marcelli victorias ex Sicilia.[13] Sed non multum interest aut primos pictores aut picturae inventores tenuisse, quando quidem non historiam picturae ut Plinius sed artem novissime recenseamus, de qua hac aetate nulla scriptorum veterum monumenta quae ipse viderim extant, tametsi ferunt Euphranorem Isthmium nonnihil de symmetria et coloribus scripsisse, Antigonum et Xenocratem de picturis aliqua litteris mandasse, tum et Apellem ad Perseum de pictura conscripsisse.[14] Refert Laertius Diogenes Demetrium[15] quoque philosophum picturam commentatum fuisse. Tum etiam existimo, cum caeterae omnes bonae artes monumentis literarum a maioribus nostris commendatae fuerint, picturam quoque a nostris Italis non fuisse scriptoribus neglectam. Nam fuere quidem antiquissimi in Italia Etrusci pingendi arte omnium peritissimi.

27. Censet Trismegistus[16] vetustissimus scriptor una cum religione sculpturam et picturam exortam: sic enim inquit ad Asclepium: humanitas memor naturae et originis suae deos ex sui vultus similitudine figuravit. Sed quis negabit omnibus in rebus cum publicis tum privatis, profanis religiosisque picturam sibi honestissimas partes vendicasse, ut nullum artificium apud mortales tanti ab omnibus existimatum inveniam? Referuntur de tabulis pictis pretia paene incredibilia.[17] Aristides Thebanus picturam unicam centum talentis vendidit. Rhodum non incensam a Demetrio rege, ne Protogenis tabula periret, referunt. Rhodum ergo unica pictura fuisse ab hostibus redemptam possumus affirmare. Multa praeterea huiusmodi a scriptoribus collecta sunt, quibus aperte intelligas semper bonos pictores in summa laude et honore apud omnes fuisse versatos, ut etiam nobilissimi ac praestantissimi cives philosophique et reges non modo pictis rebus sed pingendis quoque maxime delectarentur. L. Manilius[18] civis Romanus et Fabius homo in urbe nobilissimus pictores fuerunt. Turpilius eques Romanus Veronae pinxit. Sitedius pretorius et proconsularis pingendo nomen adeptus est. Pacuvius poeta tragicus, Ennii poetae

[11] This would seem to be Alberti's own invention. There is no explicit authority of poets to support his statement. On Flemming's claim to have found the source in Plotinus, see E. Panofsky, *Idea*, 2nd ed., Berlin, 1960, p. 93, n. 125(c). [12] Quintilian, *De Inst. Orat.*, 10, 2, 7; cfr. Pliny, *N.H.*, xxxv, 15.

of all the arts, so the tale of Narcissus fits our purpose perfectly. What is painting but the act of embracing by means of art the surface of the pool? Quintilian believed that the earliest painters used to draw around shadows made by the sun, and the art eventually grew by a process of additions. Some say that an Egyptian Philocles and a certain Cleanthes were among the first inventors of this art. The Egyptians say painting was practised in their country six thousand years before it was brought over into Greece. Our writers say it came from Greece to Italy after the victories of Marcellus in Sicily. But it is of little concern to us to discover the first painters or the inventors of the art, since we are not writing a history of painting like Pliny, but treating of the art in an entirely new way. On this subject there exist today none of the writings of the ancients, as far as I have seen, although they say that Euphranor the Isthmian wrote something about symmetry and colours, that Antigonus and Xenocrates set down some works about paintings, and that Apelles wrote on painting to Perseus. Diogenes Laertius tells us that the philosopher Demetrius also wrote about painting. Since all the other liberal arts were committed to writing by our ancestors, I believe that painting too was not neglected by our authors of Italy, for the ancient Etruscans were the most expert of all in Italy in the art of painting.

27. The ancient writer Trismegistus believes that sculpture and painting originated together with religion. He addresses Asclepius with these words: 'Man, mindful of his nature and origin, represented the gods in his own likeness'. Yet who will deny that painting has assumed the most honoured part in all things both public and private, profane and religious, to such an extent that no art, I find, has been so highly valued universally among men? Almost incredible prices are quoted for painted panels. The Theban Aristides sold one painting alone for a hundred talents. They say that Rhodes was not burned down by King Demetrius lest a painting by Protogenes be destroyed. So we can say that Rhodes was redeemed from the enemy by a single picture. Many other similar tales were collected by writers, from which you can clearly see that good painters always and everywhere were held in the highest esteem and honour, so that even the most noble and distinguished citizens and philosophers and kings took great pleasure not only in seeing and possessing paintings, but also in painting themselves. L. Manilius, a Roman citizen, and the nobleman Fabius were painters. Turpilius, a Roman knight, painted at Verona. Sitedius, praetor and proconsul, acquired fame in

[13] Pliny, *N.H.*, xxxv, 16 and 15; Pliny, xxxv, 22 does not mention Marcellus, but states that art treasures were brought from Sicily to Rome by Val. Messala.

[14] Pliny, *N.H.*, xxxv, 129 (Euphranor); ibid. 68 (Antigonus, Xenocrates); ibid. 79 and 111 (Apelles).

[15] Probably the fourth person by name Demetrius, called 'the graphic writer', who was also a painter, in Diog. Laert., v, 83. [16] *Asclepius* III, in W. Scott, *Hermetica*, vol. I, Oxford, 1924, p. 339, para 23b.

[17] Pliny cites many instances of prices paid for paintings; see especially *N.H.*, xxxv, 100 (Aristides), 105 (Protogenes), and cfr. ibid. 55, 70, 130, 132, 136, 156.

[18] Nothing is known of L. Manilius as a painter. Possible confusion with L. Hostilius Mancinus (Pliny, *N.H.*, xxxv, 23; but he was not even a painter) suggested by other commentators, seems very unlikely.

nepos ex filia, Herculem in foro pinxit.[19] Socrates, Plato Metrodorusque Pyrrhoque philosophi pictura claruere.[20] Nero, Valentinianusque atque Alexander Severus imperatores pingendi studiosissimi fuere.[21] Longum esset referre quot principes quotve reges huic nobilissimae arti dediti fuerint. Tum etiam minime decet omnem pictorum veterum turbam recensere, quae quidem quanta fuerit hinc conspici potest quod Demetrio Phalereo,[22] Phanostrati filio, trecentaesexaginta statuae partim equestres partim in curribus et bigis ferme intra quadringentos dies fuere consummatae. Ea vero in urbe, in qua tantus fuerit sculptorum numerus, utrum et pictores non paucos fuisse arbitrabimur? Sunt quidem cognatae artes eodemque ingenio pictura et sculptura nutritae. Sed ipse pictoris ingenium, quod in re longe difficillima versetur, semper praeferam. Verum ad rem redeamus.

28. Ingens namque fuit et pictorum et sculptorum illis temporibus turba, cum et principes et plebei et docti atque indocti pictura delectabantur, cumque inter primas ex provinciis praedas signa et tabulas in theatris exponebant; eoque processit res ut Paulus Aemilius[23] caeterique non pauci Romani cives filios inter bonas artes ad bene beateque vivendum picturam edocerent. Qui mos optimus apud Graecos maxime observabatur, ut ingenui et libere educati adolescentes, una cum litteris, geometria et musica, pingendi quoque arte instruerentur. Quin et feminis etiam haec pingendi facultas honori fuit. Martia,[24] Varronis filia, quod pinxerit apud scriptores celebratur. Ac fuit quidem tanta in laude et honore pictura ut apud Graecos caveretur edicto ne servis picturam discere liceret; neque id quidem iniuria, nam est pingendi ars profecto liberalibus ingeniis et nobilissimis animis dignissima, maximumque optimi et praestantissimi ingenii apud me semper fuit inditium illius quem in pictura vehementer delectari intelligerem. Tametsi haec una ars et doctis et indoctis aeque admodum grata est, quae res nulla fere alia in arte evenit ut quod peritos delectat imperitos quoque moveat. Neque facile quempiam invenies qui non maiorem in modum optet se in pictura profecisse. Ipsam denique naturam pingendo delectari manifestum est. Videmus enim naturam ut saepe in marmoribus hippocentauros regumque barbatas facies effigiet.[25] Quin et aiunt in gemma Pyrrhi novem musas cum suis insignibus distincte a natura ipsa fuisse depictas.[26] Adde his quod nulla ferme ars est in qua perdiscenda ac exercenda omnis aetas et peritorum et imperitorum tanta cum voluptate versetur. Liceat de me ipso profiteri. Si quando me animi voluptatis causa ad pingendum confero, quod facio sane persaepius cum ab aliis negotiis otium suppeditat, tanta cum voluptate in opere perficiendo insisto ut tertiam et quartam quoque horam elapsam esse postea vix possim credere.[27]

[19] The examples of Fabius, Turpilius, Sitedius (Titedius), Pacuvius, all derive from Pliny, *N.H.*, xxxv, 19–20. [20] Pliny, *N.H.*, xxxv, 137, and xxxvi, 32 (Socrates); Diog. Laert., iii, 4–5 (Plato); Pliny, xxxv, 135 (Metrodorus); Diog. Laert., ix, 61 (Pyrrho). [21] Suetonius, *Nero*, 52; Tacitus, *Ann.*, xiii, 3 (Nero); Amm. Marcellinus, xxx, 9, 4 (Valentinianus); Lampridius, *Alex. Sev.*, 27 (Alexander Severus). [22] Pliny, *N.H.*, xxxiv, 27; Diog. Laert., v, 75 (Demetrius).

painting. Pacuvius, the tragedian, nephew of the poet Ennius, painted Hercules in the forum. The philosophers Socrates, Plato, Metrodorus and Pyrrho achieved distinction in painting. The emperors Nero, Valentinianus and Alexander Severus were very devoted to painting. It would be a long story to tell how many princes or kings have devoted themselves to this most noble art. Besides, it is not appropriate to review all the multitude of ancient painters. Its size may be understood from the fact that for Demetrius of Phalerum, son of Phanostratus, three hundred and sixty statues were completed within four hundred days, some on horseback and some in chariots. In a city in which there was so large a number of sculptors, shall we not believe there were also many painters? Painting and sculpture are cognate arts, nurtured by the same genius. But I shall always prefer the genius of the painter, as it attempts by far the most difficult task. Let us return to what we were saying.

28. The number of painters and sculptors was enormous in those days, when princes and people, and learned and unlearned alike delighted in painting, and statues and pictures were displayed in the theatres among the chief spoils brought from the provinces. Eventually Paulus Aemilius and many other Roman citizens taught their sons painting among the liberal arts in the pursuit of the good and happy life. The excellent custom was especially observed among the Greeks that free-born and liberally educated young people were also taught the art of painting together with letters, geometry and music. Indeed the skill of painting was a mark of honour also in women. Martia, Varro's daughter, is celebrated by writers for her painting. The art was held in such high esteem and honour that it was forbidden by law among the Greeks for slaves to learn to paint; and quite rightly so, for the art of painting is indeed worthy of free minds and noble intellects. I have always regarded it as a mark of an excellent and superior mind in any person whom I saw take great delight in painting. Although, this art alone is equally pleasing to both learned and unlearned; and it rarely happens in any other art that what pleases the knowledgeable also attracts the ignorant. You will not easily find anyone who does not earnestly desire to be accomplished in painting. Indeed it is evident that Nature herself delights in painting, for we observe she often fashions in marble hippocentaurs and bearded faces of kings. It is also said that in a gem owned by Pyrrhus the nine Muses were clearly depicted by Nature, complete with their insignia. Furthermore, there is no other art in whose study and practice all ages of learned and unlearned alike may engage with such pleasure. Let me speak of my own experience.

[23] Pliny, *N.H.*, xxxv, 135 (Paul Aem.) 7–9 and 11–13. Ibid., 77 (Greeks).

[24] Martia is not named among women painters by Pliny, *N.H.*, xxxv, 147, and it is not known whether Varro had a daughter of this name. Janitschek suggested that Alberti misunderstood Pliny's text (ibid.): 'Iaia Cyzicena, perpetua virgo, M. Varronis iuventa Romae ... pinxit' (this 'misunderstanding' is confirmed much later by Raffaello Borghini in his *Il Riposo*, Florence, 1584, p. 286); Mallè, ed. cit. p. 80, n. 2, drew attention to the medieval legend of a painter by name Martia.

[25] Cfr. *De Statua*, §1, and Introduction, pp. 18, 21; for images in marble, see Pliny, xxxvi, 5, and bearded kings, Albertus Magnus, *De miner.*, ii, 3, i. [26] Pliny, *N.H.*, xxxvii, 5. [27] See Appendix.

29. Itaque voluptatem haec ars affert dum eam colas, laudem, divitias ac perpetuam famam dum eam bene excultam feceris. Quae res cum ita sit, cum sit pictura optimum et vetustissimum ornamentum rerum, liberis digna, doctis atque indoctis grata, maiorem in modum hortor studiosos iuvenes ut, quoad liceat, picturae plurimam operam dent. Proxime eos moneo, qui picturae studiosissimi sunt, ut omni opera et diligentia prosequantur ipsam perfectam pingendi artem tenere. Sit vobis, qui pictura praestare contenditis, cura in primis nominis et famae, quam veteres assequutos videtis, ac meminisse quidem iuvabit semper adversam laudi et virtuti fuisse avaritiam. Quaestui enim intentus animus raro posteritatis fructum assequetur. Vidi ego plerosque in ipso quasi flore perdiscendi illico decidisse ad quaestum et nec divitias nec laudem ullam inde fuisse adeptos, qui si ingenium studio auxissent, in laude facile conscendissent, quo in loco et divitias et voluptatem nominis accepissent. Itaque de his satis hactenus. Ad institutum redeamus.

30. Picturam in tres partes dividimus, quam quidem divisionem ab ipsa natura compertam habemus. Nam cum pictura studeat res visas repraesentare, notemus quemadmodum res ipsae sub aspectu veniant. Principio quidem cum quid aspicimus, id videmus esse aliquid quod locum occupet. Pictor vero huius loci spatium circumscribet, eamque rationem ducendae fimbriae apto vocabulo circumscriptionem appellabit. Proxime intuentes dignoscimus ut plurimae prospecti corporis superficies inter se conveniant; hasque superficierum coniunctiones artifex suis locis designans recte compositionem nominabit. Postremo aspicientes distinctius superficierum colores discernimus, cuius rei repraesentatio in pictura, quod omnes differentias a luminibus recipiat, percommode apud nos receptio luminum dicetur.

31. Picturam igitur circumscriptio, compositio et luminum receptio perficiunt. De his ergo sequitur ut quam brevissime dicamus. Et primo de circumscriptione. Circumscriptio quidem ea est quae lineis ambitum fimbriarum in pictura conscribit. In hac Parrhasium pictorem eum, cum quo est apud Xenophontem Socratis sermo, pulchre peritum fuisse tradunt, illum enim lineas subtilissime examinasse aiunt.[28] In hac vero circumscriptione illud praecipue servandum censeo, ut ea fiat lineis quam tenuissimis atque admodum visum fugientibus; cuiusmodi Apellem[29] pictorem exerceri solitum ac cum Protogene certasse referunt. Nam est circumscriptio aliud nihil quam fimbriarum notatio, quae quidem si valde apparenti linea fiat, non margines superficierum in pictura sed rimulae aliquae apparebunt. Tum cuperem aliud nihil circumscriptione nisi fimbriarum ambitum prosequi, in qua quidem vehementer exercendum affirmo. Nulla enim compositio nullaque luminum receptio non adhibita circumscriptione laudabitur. At sola circumscriptio plerunque gratissima est. Circumscriptioni igitur opera detur, ad quam quidem bellissime tenendam nihil accomodatius inveniri posse existimo quam id velum quod ipse inter familiares meos sum solitus appellare intercisionem, cuius ego usum nunc

[28] Pliny, *N.H.*, xxxv, 67–8; Xenophon, *Memorabilia*, iii, x. [29] Pliny, ibid., 81–3.

Whenever I devote myself to painting for pleasure, which I very often do when I have leisure from other affairs, I persevere with such pleasure in finishing my work that I can hardly believe later on that three or even four hours have gone by.

29. This art, then, brings pleasure while you practise it, and praise, riches and endless fame when you have cultivated it well. Therefore, as painting is the finest and most ancient ornament of things, worthy of free men and pleasing to learned and unlearned alike, I earnestly beseech young students to devote themselves to painting as much as they can. Next, I would advise those who are devoted to painting to go on to master with every effort and care this perfect art of painting. You who strive to excel in painting, should cultivate above all the fame and reputation which you see the ancients attained, and in so doing it will be a good thing to remember that avarice was always the enemy of renown and virtue. A mind intent on gain will rarely obtain the reward of fame with posterity. I have seen many in the very flower, as it were, of learning, descend to gain and thereafter obtain neither riches nor distinction, who if they had improved their talent with application, would easily have risen to fame and there received both wealth and the satisfaction of renown. But we have said enough on these matters. Let us return to our purpose.

30. We divide painting into three parts, and this division we learn from Nature herself. As painting aims to represent things seen, let us note how in fact things are seen. In the first place, when we look at a thing, we see it as an object which occupies a space. The painter will draw around this space, and he will call this process of sketching the outline, appropriately, circumscription. Then, as we look, we discern how the several surfaces of the object seen are fitted together; the artist, when drawing these combinations of surfaces in their correct relationship, will properly call this composition. Finally, in looking we observe more clearly the colours of surfaces; the representation in painting of this aspect, since it receives all its variations from light, will aptly here be termed the reception of light.

31. Therefore, circumscription, composition and reception of light make up painting; and with these we must now deal as briefly as possible. First circumscription. Circumscription is the process of tracing the outlines in the painting. They say that Parrhasius the painter, with whom Socrates speaks in Xenophon, was very expert in this and studied these lines very closely. I believe one should take care that circumscription is done with the finest possible, almost invisible lines, like those they say the painter Apelles used to practise and vie with Protogenes at drawing. Circumscription is simply the recording of the outlines, and if it is done with a very visible line, they will look in the painting, not like the edges of surfaces, but like cracks. I want only the outlines to be sketched in circumscription; and this should be practised assiduously. No composition and no reception of light will be praised without the presence of circumscription. But circumscription by itself is very often most pleasing. So attention should be devoted to circumscription; and to do this well, I believe nothing more convenient can be found

primum adinveni. Id istiusmodi est: velum filo tenuissimo et rare textum quovis colore pertinctum filis grossioribus in parallelas portiones quadras quot libeat distinctum telarioque distentum. Quod quidem inter corpus repraesentandum atque oculum constituo, ut per veli raritates pyramis visiva penetret. Habet enim haec veli intercisio profecto commoda in se non pauca, primo quod easdem semper immotas superficies referat, nam positis terminis illico pristinam pyramidis cuspidem reperies, quae res absque intercisione sane perdifficillima est. Et nosti quam sit impossibile aliquid pingendo recte imitari quod non perpetuo eandem pingenti faciem servet. Hinc est quod pictas res, cum semper eandem faciem servent, facilius quam sculptas aemulantur. Tum nosti quam, intervallo ac centrici positione mutatis, res ipsa visa alterata esse appareat. Itaque hanc non mediocrem quam dixi utilitatem velum praestabit, ut res semper eadem e conspectu persistat. Proxima utilitas est quod fimbriarum situs et superficierum termini certissimis in pingenda tabula locis facile constitui possint, nam cum istoc in parallelo frontem, in proximo nasum, in propinquo genas, in inferiori mentum, et istiusmodi omnia in locis suis disposita intuearis, itidem in tabula aut pariete suis quoque parallelis divisa illico bellissime omnia collocaris. Postremo hoc idem velum maximum ad perficiendam picturam adiumentum praestat, quandoquidem rem ipsam prominentem et rotundam in istac planitie veli conscriptam et depictam videas. Quibus ex rebus quantam ad facile et recte pingendum utilitatem velum exhibeat, satis et iudicio et experientia intelligere possumus.

32. Nec eos audiam qui dicunt minime conducere pictorem his rebus assuefieri, quae etsi maximum ad pingendum adiumentum afferant, tamen huiusmodi sunt ut absque illis vix quicquam per se artifex possit. Non enim a pictore, ni fallor, infinitum laborem exposcimus, sed picturam expectamus eam quae maxime prominens et datis corporibus persimilis videatur. Quam rem quidem non satis intelligo quonam pacto unquam sine veli adminiculo possit quispiam vel mediocriter assequi. Igitur intercisione hac, idest velo, ut dixi, utantur ii qui student in pictura proficere. Quod si absque velo experiri ingenium delectet, hanc ipsam parallelorum rationem intuitu consequantur, ut semper lineam illic transversam ab altera perpendiculari persectam imaginentur, ubi prospectum terminum in pictura statuant. Sed cum plerunque inexpertis pictoribus fimbriae superficierum dubiae et incertae sint veluti in vultibus, quod non decernunt quo potissimum loco tempora a fronte discriminentur, edocendi idcirco sunt quonam argumento eius rei cognitionem assequantur. Natura id quidem pulchre demonstrat. Nam ut in planis superficiebus intuemur ut suis propriis luminibus et umbris insignes sint, ita et in sphaericis atque concavis superficiebus quasi in plures superficies easdem diversis umbrarum et luminum maculis quadratas videmus. Ergo singulae partes claritate et obscuritate differentes pro singulis superficiebus habendae sunt. Quod si ab umbroso sensim deficiendo ad illustrem colorem visa superficies continuarit, tunc medium, quod inter utrunque

than the veil, which among my friends I call the intersection, and whose usage I was the first to discover. It is like this: a veil loosely woven of fine thread, dyed whatever colour you please, divided up by thicker threads into as many parallel square sections as you like, and stretched on a frame. I set this up between the eye and the object to be represented, so that the visual pyramid passes through the loose weave of the veil. This intersection of the veil has many advantages, first of all because it always presents the same surfaces unchanged, for once you have fixed the position of the outlines, you can immediately find the apex of the pyramid you started with, which is extremely difficult to do without the intersection. You know how impossible it is to paint something which does not continually present the same aspect. This is why people can copy paintings more easily than sculptures, as they always look the same. You also know that, if the distance and the position of the centric ray are changed, the thing seen appears to be altered. So the veil will give you the not inconsiderable advantage I have indicated, namely that the object seen will always keep the same appearance. A further advantage is that the position of the outlines and the boundaries of the surfaces can easily be established accurately on the painting panel; for just as you see the forehead in one parallel, the nose in the next, the cheeks in another, the chin in one below, and everything else in its particular place, so you can situate precisely all the features on the panel or wall which you have similarly divided into appropriate parallels. Lastly, this veil affords the greatest assistance in executing your picture, since you can see any object that is round and in relief, represented on the flat surface of the veil. From all of which we may appreciate by reflection and experience how useful the veil is for painting easily and correctly.

32. I will not listen to those who say it is no good for a painter to get into the habit of using these things, because, though they offer him the greatest help in painting, they make the artist unable to do anything by himself without them. If I am not mistaken, we do not ask for infinite labour from the painter, but we do expect a painting that appears markedly in relief and similar to the objects presented. I do not understand how anyone could ever even moderately achieve this without the help of the veil. So those who are anxious to advance in the art of painting, should use this intersection or veil, as I have explained. Should they wish to try their talents without the veil, they should imitate this system of parallels with the eye, so that they always imagine a horizontal line cut by another perpendicular at the point where they establish in the picture the edge of the object they observe. But as for many inexpert painters the outlines of surfaces are vague and uncertain, as for example in faces, because they cannot determine at what point more particularly the temples are distinguished from the forehead, they must be taught how they may acquire this knowledge. Nature demonstrates this very clearly. Just as we see flat surfaces distinguished by their own lights and shades, so we may see spherical and concave surfaces divided up, as it were, in squares into several surfaces by different patches of light and shade. These individual

spatium est, linea signare oportet, quo omnis colorandi spatii ratio minus dubia sit.
33. Restat ut de circumscriptione aliquid etiam referamus, quod ad compositionem quoque non parum pertinet. Idcirco non ignorandum est quid sit compositio in pictura. Est autem compositio ea pingendi ratio qua partes in opus picturae componuntur. Amplissimum pictoris opus historia, historiae partes corpora, corporis pars membrum est, membri pars est superficies. Etenim cum sit circumscriptio ea ratio pingendi qua fimbriae superficierum designantur, cumque superficierum aliae parvae ut animantium, aliae ut aedificiorum et colossorum amplissimae sint, de parvis superficiebus circumscribendis ea praecepta sufficiant quae hactenus dicta sunt, nam ostensum est ut eadem pulchre velo metiantur. In maioribus ergo superficiebus nova ratio reperienda est. Qua de re quae supra in rudimentis a nobis de superficiebus, radiis pyramideque atque intercisione exposita sunt, ea omnia menti repetenda sunt. Denique meministi quae de pavimenti parallelis et centrico puncto atque linea disserui. In pavimento ergo parallelis inscripto alae murorum et quaevis huiusmodi, quas incumbentes nuncupavimus superficies, coaedificandae sunt. Dicam ergo breviter quid ipse in hac coaedificatione efficiam. Principio ab ipsis fundamentis exordium capio. Latitudinem enim et longitudinem murorum in pavimento describo, in qua quidem descriptione illud a natura animadverti nullius quadrati corporis rectorum angulorum plus quam duas solo incumbentes iunctas superficies uno aspectu posse videri. Ergo in describendis parietum fundamentis id observo ut solum ea latera circumeam quae sub aspectu pateant; ac primo semper a proximioribus superficiebus incipio, maxime ab his quae aeque ab intercisione distant. Itaque has ego ante alias conscribo, atque quam velim esse harum ipsarum longitudinem ac latitudinem ipsis in pavimento descriptis parallelis constituo, nam quot ea velim esse bracchia tot mihi parallelos assumo. Medium vero parallelorum ex utriusque diametri mutua sectione accipio. Nam diametri a diametro intersectio medium sui quadranguli locum possidet. Itaque hac parallelorum mensura pulchre latitudinem atque longitudinem surgentium a solo moenium conscribo. Tum altitudinem quoque superficierum hinc non difficillime assequor. Nam quae mensura est inter centricam lineam et eum pavimenti locum unde aedificii quantitas insurgit, eandem mensuram tota illa quantitas servabit. Quod si voles istanc quantitatem ab solo esse usque in sublime quater quam est hominis picti longitudo, et fuerit linea centrica ad hominis altitudinem posita, erunt tunc quidem ab infimo quantitatis capite usque ad centricam lineam bracchia tria. Tu vero qui istanc quantitatem vis usque ad bracchia xii excrescere, ter tantundem quantum est a centrica usque ad inferius quantitatis caput sursum versus educito. Ergo ex his quae retulimus rationibus pingendi probe possumus omnes angulares superficies circumscribere.
34. Restat ut de circularibus superficiebus suis fimbriis conscribendis enarremus. Circulares quidem ex angularibus extrahuntur. Id ipse sic facio. Areolam quadrangulo rectorum angulorum incircuo, huiusque quadranguli latera in partes

parts, distinguished by light and shade, are therefore to be treated as single surfaces. If the surface seen proceeds from a dark colour gradually lightening to bright, then you should mark with a line the mid-point between the two parts, so that the way in which you should colour the whole area is made less uncertain.

33. It remains for us to say something further about circumscription, which also pertains in no small measure to composition. For this purpose one should know what composition is in painting. Composition is that procedure in painting whereby the parts are composed together in a picture. The great work of the painter is the 'historia'; parts of the 'historia' are the bodies, part of the body is the member, and part of the member is a surface. As circumscription is the procedure in painting whereby the outlines of the surfaces are drawn, and as some surfaces are small, as in living creatures, while others are very large, as in buildings and giant statues, the precepts we have given so far may suffice for drawing the small surfaces, for we have shown that they can be measured with the veil. For the larger surfaces a new method must be found. In this connection one should remember all we said above in our rudiments about surfaces, rays, pyramid and intersection. You will also recall what I wrote about the parallels of the pavement, and the centric point and line. On the pavement that is divided up into parallels, you have to construct the sides of walls and other similar surfaces which we have described as perpendicular. I will explain briefly how I proceed in this construction. I begin first from the foundations. I draw the breadth and length of the walls on the pavement, and in doing this I observed from Nature that more than two connected standing surfaces of any square right-angled body cannot be seen at one glance. So in drawing the foundations of the walls I take care that I outline only those sides that are visible; and I always begin from the nearer surfaces, and particularly from those that are equidistant from the intersection. I draw these before the rest, and I determine what I wish their length and breadth to be by the parallels traced on the pavement, for I take up as many parallels as I want them to be *braccia*. I find the middle of the parallels from the intersection of the two diameters, as the intersection of one diameter by another marks the middle point of a quadrangle. So, from the scale of the parallels I easily draw the width and length of walls that rise from the ground. Then I go on from there without any difficulty to do the heights of the surfaces, since a quantity will maintain the same proportion for its whole height as that which exists between the centre line and the position on the pavement from which that quantity of the building rises. So, if you want this quantity from the ground to the top to be four times the height of a man in the picture, and the centre line has been placed at the height of a man, then it will be three *braccia* from the foot of the quantity to the centre line; but, as you wish this quantity increased to twelve *braccia*, you must continue it upwards three times again the distance from the centre line to the foot of the quantity. Thus, by the methods I have described, we can correctly draw all surfaces containing angles.

34. It remains for us to explain how one draws the outlines of circular surfaces. These

eiusmodi divido in quales partes inferior in pictura quadranguli linea divisa est, lineasque a singulis punctis ad sibi oppositos punctos divisionum ducens parvis quadrangulis aream repleo. Illicque circulum quam velim magnum super inscribo ut mutuo sese circulus et parallelae lineae secent, omnesque sectionum punctos loco adnoto, quae loca in suis parallelis pavimenti descripti in pictura consigno. Sed quia esset extremus labor minutis ac paene infinitis parallelis totum circulum multis ac multis locis percidere, quoad numerosa punctorum consignatione fimbria circuli continuaretur, idcirco ipse cum octo aut quot libuerit percisiones notaro, tum ingenio eum circuli ambitum pingendo ad hos ipsos signatos terminos duco. Fortassis brevior esset via hanc fimbriam ad umbram luminis circumscribere, modo corpus quod umbram efficiat certa ratione suo loco interponeretur. Itaque diximus ut parallelorum adiumentis maiores superficies angulares et circulares circumscribantur. Absoluta igitur omni circumscriptione, sequitur ut de compositione dicendum sit. Repetendum idcirco est quid sit compositio.

35. Est autem compositio ea pingendi ratio qua partes in opus picturae componuntur. Amplissimum pictoris opus non colossus sed historia.[30] Maior enim est ingenii laus in historia quam in colosso. Historiae partes corpora, corporis pars membrum est, membri pars est superficies. Primae igitur operis partes superficies, quod ex his membra, ex membris corpora, ex illis historia, ultimum illud quidem et absolutum pictoris opus perficitur. Ex superficierum compositione illa elegans in corporibus concinnitas et gratia extat, quam pulchritudinem dicunt. Nam is vultus qui superficies alias grandes, alias minimas, illuc prominentes, istuc intus nimium retrusas et reconditas habuerit, quales in vetularum vultibus videmus, erit quidem is aspectu turpis. In qua vero facie ita iunctae aderunt superficies ut amena lumina in umbras suaves defluant, nullaeque angulorum asperitates extent, hanc merito formosam et venustam faciem dicemus. Ergo in hac superficierum compositione maxime gratia et pulchritudo perquirenda est. Quonam vero pacto id assequamur, nulla alia modo mihi visa est via certior quam ut naturam ipsam intueamur, diuque ac diligentissime spectemus quemadmodum natura, mira rerum artifex, in pulcherrimis membris superficies composuerit. In qua imitanda omni cogitatione et cura versari veloque quod diximus vehementer delectari oportet. Dumque sumptas a pulcherrimis corporibus superficies in opus relaturi sumus, semper terminos prius destinemus quo lineas certo loco dirigamus.[31]

36. Hactenus de superficierum compositione. Sequitur ut de compositione membrorum referamus. In membrorum compositione danda in primis opera est ut quaequae inter se membra pulchre conveniant. Ea quidem tunc convenire

[30] For the colossal statues and paintings Alberti evidently has in mind, see Pliny, *N.H.*, xxxiv, 39–46, xxxv, 51. [31] For imitation of Nature in Greek sculpture, see Pliny, *N.H.*, xxxiv, 61; the general concept of art (literature) as imitation of Nature was, of course, widespread in Greek and Roman writings (esp. Aristotle, Horace).

can be derived from angular surfaces. I do this as follows. I draw a rectangle on a drawing board, and divide its sides into parts like those of the base line of the rectangle of the picture. Then, by drawing lines from each point of these divisions to the one opposite, I fill the area with small rectangles. On this I inscribe a circle the size I want, so that the circle and the parallels intersect each other. I note all the points of intersection accurately, and then mark these positions in their respective parallels of the pavement in the picture. But as it would be an immense labour to cut the whole circle at many places with an almost infinite number of small parallels until the rim of the circle were continuously marked with a numerous succession of points, when I have noted eight or some other suitable number of intersections, I draw the outline of the circle in the painting to these indications using my own judgement. Perhaps a quicker way would be to draw this outline from a shadow cast by a light, provided the object making the shadow were interposed correctly at the proper place. We have now explained how the larger angular and circular surfaces are drawn with the aid of the parallels. Having completed circumscription, we must now speak of composition. To this end, we must repeat what composition is.

35. Composition is the procedure in painting whereby the parts are composed together in the picture. The great work of the painter is not a colossus but a 'historia', for there is far more merit in a 'historia' than in a colossus. Parts of the 'historia' are the bodies, part of the body is the member, and part of the member is the surface. The principal parts of the work are the surfaces, because from these come the members, from the members the bodies, from the bodies the 'historia', and finally the finished work of the painter. From the composition of surfaces arises that elegant harmony and grace in bodies, which they call beauty. The face which has some surfaces large and others small, some very prominent and others excessively receding and hollow, such as we see in the faces of old women, will be ugly to look at. But the face in which the surfaces are so joined together that pleasing lights pass gradually into agreeable shadows and there are no very sharp angles, we may rightly call a handsome and beautiful face. So in the composition of surfaces grace and beauty must above all be sought. In order to achieve this there seems to me no surer way than to look at Nature and observe long and carefully how she, the wonderful maker of things, has composed the surfaces in beautiful members. We should apply ourselves with all our thought and attention to imitating her, and take delight in using the veil I spoke of. And when we are about to put into our work the surfaces taken from beautiful bodies, we will always first determine their exact limits, so that we may direct our lines to their correct place.

36. So far we have spoken of the composition of surfaces. Now we must give some account of the composition of members. In the composition of members care should be taken above all that all the members accord well with one another. They are said to accord well with one another when in size, function, kind, colour and other similar respects they correspond to grace and beauty. For, if in a picture the head is enormous,

6

pulchre dicuntur, cum et magnitudine et officio et specie et coloribus et caeteris siquae sunt huiusmodi rebus ad venustatem et pulchritudinem correspondeant. Quod si in simulacro aliquo caput amplissimum, pectus pusillum, manus perampla, pes tumens, corpus turgidum adsit, haec sane compositio erit aspectu deformis. Ergo quaedam circa magnitudinem membrorum ratio tenenda est, in qua sane commensuratione iuvat in animantibus pingendis primum ossa ingenio subterlocare, nam haec, quod minime inflectantur, semper certam aliquam sedem occupant. Tum oportet nervos et musculos suis locis inhaerere, denique extremum carne et cute ossa et musculos vestitos reddere. Sed (video) hoc in loco fortassis aderunt obiicientes quod supra dixerim nihil ad pictorem earum rerum spectare quae non videantur. Recte illi quidem, sed veluti in vestiendo prius nudum subsignare oportet quem postea vestibus obambiendo involuamus, sic in nudo pingendo prius ossa et musculi disponendi sunt, quos moderatis carnibus et cute ita operias, ut quo sint loco musculi non difficile intelligatur. At enim cum has omnes mensuras natura ipsa explicatas in medium exhibeat, tum in eisdem ab ipsa natura proprio labore recognoscendis utilitatem non modicam inveniet studiosus pictor. Idcirco laborem hunc studiosi suscipiant, ut quantum in symmetria membrorum recognoscenda studii et operae posuerint, tantum sibi ad eas res quas didicerint memoria firmandas profuisse intelligant. Unum tamen admoneo, ut in commensurando animante aliquod illius ipsius animantis membrum sumamus, quo caetera metiantur. Vitruvius[32] architectus hominis longitudinem pedibus dinumerat. Ipse vero dignius arbitror si caetera ad quantitatem capitis referantur, tametsi hoc animadverti ferme commune esse in hominibus, ut eadem et pedis et quae est a mento ad cervicem capitis mensura intersit.

37. Itaque uno suscepto membro, huic caetera accommodanda sunt ut nullum in toto animante membrum adsit longitudine aut latitudine caeteris non correspondens. Tum providendum est ut omnia membra suum ad id de quo agitur officium exequantur. Decet currentem manus non minus iactare quam pedes. At philosophum orantem malo in omni membro sui modestiam quam palaestram ostentet. Daemon[33] pictor hoplicitem (*sic*) in certamine expressit, ut illum sudare tum quidem diceres, alterumque arma deponentem, ut plane anhelare videretur. Fuit et qui Ulixem[34] pingeret ut in eo non veram sed fictam et simulatam insaniam agnoscas. Laudatur apud Romam historia in qua Meleager[35] defunctus asportatur, quod qui oneri subsunt angi et omnibus membris laborare videantur; in eo vero qui mortuus sit, nullum adsit membrum quod non demortuum appareat, omnia pendent, manus,

[32] Vitruvius, *De arch.*, III, 1. Cfr. Intro, pp. 19, 23, and *De statua*, para 12.

[33] The painting referred to was by Parrhasius (Pliny, *N.H.*, xxxv, 71); for the origin of the error of attribution, see note 44, p. 81.

[34] The painter of Ulysses here referred to was probably Euphranor (Pliny, ibid., 129).

[35] Various suggestions have been made to identify this representation of Meleager among extant bas-reliefs and sarcophagi. See Mallè, ed. cit., p. 89, n. 2.

the chest puny, the hand very large, the foot swollen and the body distended, this composition will certainly be ugly to look at. So one must observe a certain conformity in regard to the size of members, and in this it will help, when painting living creatures, first to sketch in the bones, for, as they bend very little indeed, they always occupy a certain determined position. Then add the sinews and muscles, and finally clothe the bones and muscles with flesh and skin. But at this point, I see, there will perhaps be some who will raise as an objection something I said above, namely, that the painter is not concerned with things that are not visible. They would be right to do so, except that, just as for a clothed figure we first have to draw the naked body beneath and then cover it with clothes, so in painting a nude the bones and muscles must be arranged first, and then covered with appropriate flesh and skin in such a way that it is not difficult to perceive the positions of the muscles. As Nature clearly and openly reveals all these proportions, so the zealous painter will find great profit from investigating them in Nature for himself. Therefore, studious painters should apply themselves to this task, and understand that the more care and labour they put into studying the proportions of members, the more it helps them to fix in their minds the things they have learned. I would advise one thing, however, that in assessing the proportions of a living creature we should take one member of it by which the rest are measured. The architect Vitruvius reckons the height of a man in feet. I think it more suitable if the rest of the limbs are related to the size of the head, although I have observed it to be well-nigh a common fact in men that the length of the foot is the same as the distance from the chin to the top of the head.

37. Having selected this one member, the rest should be accommodated to it, so that there is no member of the whole body that does not correspond with the others in length and breadth. Then we must ensure that all the members fulfil their proper function according to the action being performed. It is appropriate for a running man to throw his hands about as well as his feet. But I prefer a philosopher, when speaking, to show modesty in every limb rather than the attitudes of a wrestler. The painter Daemon represented an armed man in a race so that you would have said he was sweating, and another taking off his arms, so lifelike that he seemed clearly to be gasping for breath. And someone painted Ulysses in such a way that you could tell he was not really mad but only pretending. They praise a 'historia' in Rome, in which the dead Meleager is being carried away, because those who are bearing the burden appear to be distressed and to strain with every limb, while in the dead man there is no member that does not seem completely lifeless; they all hang loose; hands, fingers, neck, all droop inertly down, all combine together to represent death. This is the most difficult thing of all to do, for to represent the limbs of a body entirely at rest is as much the sign of an excellent artist as to render them all alive and in action. So in every painting the principle should be observed that all the members should fulfil their function according to the action performed, in such a way that not even the smallest limb fails

digiti, cervix, omnia languida decidunt, denique omnia ad exprimendam corporis mortem congruunt. Quod quidem omnium difficillimum est, nam omni ex parte otiosa in corpore membra effingere tam summi artificis est quam viva omnia et aliquid agentia reddere. Ergo hoc ipsum in omni pictura servandum est, ut quaequae membra suum ad id de quo agitur officium ita peragant, ut ne minimus quidem articulus pro re vacet munere, ut mortuorum membra ad unguem usque mortua, viventium vero omnia viva esse videantur. Vivere corpus tum dicitur cum motu quodam sua sponte agatur, mortemque aiunt esse ubi membra vitae officia, hoc est motum et sensum, amplius ferre nequeunt. Ergo quae corporum simulacra pictor viva apparere voluerit, in his efficiet ut omnia membra suos motus exequantur. Sed in omni motu venustas et gratia sectanda est. Ac maxime hi membrorum motus vivaces et gratissimi sunt qui aera in altum petunt. Tum speciem quoque diximus in componendis membris spectandam esse. Nam perabsurdum esset si Helenae aut Iphigeniae manus seniles et rusticanae viderentur, aut si Nestori pectus tenerum et cervix lenis, aut si Ganymedi frons rugosa, crura athletae; aut si Miloni omnium robustissimo latera levia et gracilia adderemus. Tum etiam in eo simulacro, in quo vultus sint solidi et succipleni, ut aiunt, turpe esset lacertos et manus macie absumptas agere. Contraque qui Achaemenidem ab Aenea[36] in insula inventum pingeret facie qua eum fuisse Virgilius refert, nec caetera faciei convenientia sequerentur, esset is quidem pictor perridiculus atque ineptus. Itaque specie omnia conveniant oportet. Tum colore quoque inter se correspondeant velim. Nam quibus sint vultus rosei, venusti, nivei, his pectus ac caetera membra fusca et truculenta minime conveniunt.

38. Ergo in compositione membrorum quae de magnitudine, officio, specie et coloribus diximus tenenda sunt. Tum et pro dignitate omnia subsequantur oportet. Nam Venerem aut Minervam saga indutam esse minime convenit. Iovem aut Martem veste muliebri indecenter vestires. Castorem et Pollucem[37] prisci pictores pingendo curabant ut, cum gemelli viderentur, in altero tamen pugilem naturam, in altero agilitatem discerneres. Tum et Vulcano[38] claudicandi vitium apparere sub vestibus volebant, tantum illis erat studium pro officio, specie et dignitate quod oportet exprimere.

39. Sequitur corporum compositio, in qua omne pictoris ingenium et laus versatur. Quam quidem ad compositionem nonnulla in compositione membrorum dicta pertinent, nam officio et magnitudine corpora omnia in historia conveniant oportet. Si enim centauros in cena tumultuantes pinxeris, ineptum esset in tam efferato tumultu aliquem vino sopitum accubare. Tum etiam vitium esset, si homines pari distantia alii aliis multo maiores, aut si canes equis pares in pictura adessent. Neque parum etiam vituperandum est, quod plerunque video, pictos in aedificio homines quasi in scrinio reclusos, in quo vix sedentes et in orbem coacti recipiantur. Corpora igitur omnia et magnitudine et officio ad eam rem de qua agitur conveniant.

to play its appropriate part, that the members of the dead appear dead down to the smallest detail, and those of the living completely alive. A body is said to be alive when it performs some movement of its own free will. Death, they say, is present when the limbs can no longer carry out the duties of life, that is, movement and feeling. So the painter who wishes his representations of bodies to appear alive, should see to it that all their members perform their appropriate movements. But in every movement beauty and grace should be sought after. Those movements are especially lively and pleasing that are directed upwards into the air. We have also said that regard should be had to similarity of kind in the composition of members, for it would be ridiculous if the hands of Helen or Iphigenia looked old and rustic, or if Nestor had a youthful breast and soft neck, or Ganymede a wrinkled brow and the legs of a prize-fighter, or if we gave Milo, the strongest man of all, light and slender flanks. It would also be unseemly to put emaciated arms and hands on a figure in which the face were firm and plump. Conversely, whoever painted Achaemenides discovered on an island by Aeneas with the face Virgil says he had, and the rest of the body did not accord with that face, would certainly be a ridiculous and inept painter. Therefore, every part should agree in kind. And I would also ask that they correspond in colour too; for to those who have pink, white and agreeable faces, dark forbidding breasts and other parts are completely unsuitable.

38. So, in the composition of members, what we have said about size, function, kind and colour should be observed. Everything should also conform to a certain dignity. It is not suitable for Venus or Minerva to be dressed in military cloaks; and it would be improper for you to dress Jupiter or Mars in women's clothes. The early painters took care when representing Castor and Pollux that, though they looked like twins, you could tell one was a fighter and the other very agile. They also made Vulcan's limp show beneath his clothing, so great was their attention to representing what was necessary according to function, kind and dignity.

39. Now follows the composition of bodies, in which all the skill and merit of the painter lies. Some of the things we said about the composition of members pertain also to this, for all the bodies in the 'historia' must conform in function and size. If you painted centaurs in an uproar at dinner, it would be absurd amid this violent commotion for one of them to be lying there asleep from drinking wine. It would also be a fault if at the same distance some men were a great deal bigger than others, or dogs the same size as horses in your picture. Another thing I often see deserves to be censured, and that is men painted in a building as if they were shut up in a box in which they can hardly fit sitting down and rolled up in a ball. So all the bodies should conform in size and function to the subject of the action.

[36] *Aen.*, III, 588 ff.

[37] I have been unable to find the source of this reference to portraits of Castor and Pollux.

[38] Cicero, *De nat. deorum*, I, xxx, 83 (Vulcan).

40. Historia vero, quam merito possis et laudare et admirari, eiusmodi erit quae illecebris quibusdam sese ita amenam et ornatam exhibeat, ut oculos docti atque indocti spectatoris diutius quadam cum voluptate et animi motu detineat. Primum enim quod in historia voluptatem afferat est ipsa copia et varietas rerum. Ut enim in cibis atque in musica semper nova et exuberantia cum caeteras fortassis ob causas tum nimirum eam ob causam delectant quod ab vetustis et consuetis differant, sic in omni re animus varietate et copia admodum delectatur. Idcirco in pictura et corporum et colorum varietas amena est. Dicam historiam esse copiosissimam illam in qua suis locis permixti aderunt senes, viri, adolescentes, pueri, matronae, virgines, infantes, cicures, catelli, aviculae, equi, pecudes, aedificia, provinciaeque; omnemque copiam laudabo modo ea ad rem de qua illic agitur conveniat. Fit enim ut cum spectantes lustrandis rebus morentur, tum pictoris copia gratiam assequatur. Sed hanc copiam velim cum varietate quadam esse ornatam, tum dignitate et verecundia gravem atque moderatam. Improbo quidem eos pictores, qui quo videri copiosi, quove nihil vacuum relictum volunt, eo nullam sequuntur compositionem sed confuse et dissolute omnia disseminant, ex quo non rem agere sed tumultuare historia videtur. Ac fortassis qui dignitatem in primis in historia cupiet, huic solitudo admodum tenenda erit. Ut enim in principe maiestatem affert verborum paucitas, modo sensa et iussa intelligantur, sic in historia competens corporum numerus adhibet dignitatem. Odi solitudinem in historia, tamen copiam minime laudo quae a dignitate abhorreat. Atque in historia id vehementer approbo quod a poetis tragicis atque comicis observatum video, ut quam possint paucis personatis fabulam doceant. Meo quidem iudicio nulla erit usque adeo tanta rerum varietate referta historia, quam novem aut decem homines non possint condigne agere, ut illud Varronis huc pertinere arbitror, qui in convivio tumultum evitans non plus quam novem accubantes admittebat.[39] Sed in omni historia cum varietas iocunda est, tamen in primis omnibus grata est pictura, in qua corporum status atque motus inter se multo dissimiles sint. Stent igitur alii toto vultu conspicui, manibus supinis et digitis micantibus, alterum in pedem innixi, aliis adversa sit facies et demissa bracchia, pedesque iniuncti, singulisque singuli flexus et actus extent; alii consideant, aut in flexo genu morentur, aut prope incumbant. Sintque nudi, si ita deceat, aliqui, nonnulli mixta ex utrisque arte partim velati partim nudi assistant. Sed pudori semper et verecundiae inserviamus. Obscoenae quidem corporis et hae omnes partes quae parum gratiae habent, panno aut frondibus aut manu operiantur. Appelles[40] Antigoni imaginem ea tantum parte vultus pingebat qua oculi vitium non aderat. Periclem[41] referunt habuisse caput oblongum et deforme; idcirco a pictoribus et sculptoribus, non ut caeteros inoperto capite, sed casside vestito eum formari solitum. Tum antiquos pictores refert Plutarchus solitos in pingendis regibus, si quid vitii aderat formae, non id praetermissum videri velle, sed quam

[39] Aul. Gell., *Noct. Att.*, XIII, xi, 2–3. [40] Pliny, *N.H.*, XXXV, 90. [41] Plutarch, *Pericles*, III, 2.

40. A 'historia' you can justifiably praise and admire will be one that reveals itself to be so charming and attractive as to hold the eye of the learned and unlearned spectator for a long while with a certain sense of pleasure and emotion. The first thing that gives pleasure in a 'historia' is a plentiful variety. Just as with food and music novel and extraordinary things delight us for various reasons but especially because they are different from the old ones we are used to, so with everything the mind takes great pleasure in variety and abundance. So in painting variety of bodies and colours is pleasing. I would say a picture was richly varied if it contained a properly arranged mixture of old men, youths, boys, matrons, maidens, children, domestic animals, dogs, birds, horses, sheep, buildings and provinces; and I would praise any great variety, provided it is appropriate to what is going on in the picture. When the spectators dwell on observing all the details, then the painter's richness will acquire favour. But I would have this abundance not only furnished with variety, but restrained and full of dignity and modesty. I disapprove of those painters who, in their desire to appear rich or to leave no space empty, follow no system of composition, but scatter everything about in random confusion with the result that their 'historia' does not appear to be doing anything but merely to be in a turmoil. Perhaps the artist who seeks dignity above all in his 'historia', ought to represent very few figures; for as paucity of words imparts majesty to a prince, provided his thoughts and orders are understood, so the presence of only the strictly necessary numbers of bodies confers dignity on a picture. I do not like a picture to be virtually empty, but I do not approve of an abundance that lacks dignity. In a 'historia' I strongly approve of the practice I see observed by the tragic and comic poets, of telling their story with as few characters as possible. In my opinion there will be no 'historia' so rich in variety of things that nine or ten men cannot worthily perform it. I think Varro's dictum is relevant here: he allowed no more than nine guests at dinner, to avoid disorder. Though variety is pleasing in any 'historia', a picture in which the attitudes and movements of the bodies differ very much among themselves, is most pleasing of all. So let there be some visible full-face, with their hands turned upwards and fingers raised, and resting on one foot; others should have their faces turned away, their arms by their sides, and feet together, and each one of them should have his own particular flexions and movements. Others should be seated, or resting on bended knee, or almost lying down. If suitable, let some be naked, and let others stand around, who are halfway between the two, part clothed and part naked. But let us always observe decency and modesty. The obscene parts of the body and all those that are not very pleasing to look at, should be covered with clothing or leaves or the hand. Apelles painted the portrait of Antigonus only from the side of his face away from his bad eye. They say Pericles had a rather long, misshapen head, and so he used to have his portrait done by painters and sculptors, not like other people with head bare, but wearing his helmet. Plutarch tells how the ancient painters, when painting kings who had some physical defect, did not wish this to appear to have been

maxime possent, servata similitudine, emendabant. Hanc ergo modestiam et verecundiam in universa historia observari cupio ut foeda aut praetereantur aut emendentur. Denique, ut dixi, studendum censeo ut in nullo ferme idem gestus aut status conspiciatur.

41. Animos deinde spectantium movebit historia, cum qui aderunt picti homines suum animi motum maxime prae se ferent. Fit namque natura, qua nihil sui similium rapacius inveniri potest,[42] ut lugentibus conlugeamus, ridentibus adrideamus, dolentibus condoleamus. Sed hi motus animi ex motibus corporis cognoscuntur. Nam videmus ut tristes, quod curis astricti et aegritudine obsessi sint, totis sensibus ac viribus torpeant, interque pallentia et admodum labantia membra sese lenti detineant. Est quidem maerentibus pressa frons, cervix languida, denique omnia veluti defessa et neglecta procidunt. Iratis vero, quod animi ira incendantur, et vultus et oculi intumescunt ac rubent, membrorumque omnium motus pro furore iracundiae in eisdem acerrimi et iactabundi sunt. Laeti autem et hilares cum sumus, tum solutos et quibusdam flexionibus gratos motus habemus. Laudatur Euphranor[43] quod in Alexandro Paride et vultus et faciem effecerit, in qua illum et iudicem dearum et amatorem Helenae et una Achillis interfectorem possis agnoscere. Est et Daemonis quoque pictoris mirifica laus, quod in eius pictura adesse iracundum, iniustum, inconstantem, unaque et exorabilem et clementem, misericordem, gloriosum, humilem ferocemque facile intelligas.[44] Sed inter caeteros referunt Aristidem Thebanum[45] Apelli aequalem probe hos animi motus expressisse, quos certum quidem est et nos quoque, dum in ea re studium et diligentiam quantum convenit posuerimus, pulchre assequemur.

42. Pictori ergo corporis motus notissimi sint oportet, quos quidem multa solertia a natura petendos censeo. Res enim perdifficilis est pro paene infinitis animi motibus corporis quoque motus variare. Tum quis hoc, nisi qui expertus sit, crediderit usque adeo esse difficile, cum velis ridentes vultus effigiare, vitare id ne plorabundi magis quam alacres videantur? Tum vero et quis poterit sine maximo labore, studio et diligentia vultus exprimere, in quibus et os et mentum et oculi et genae et frons et supercilia in unum ad luctum aut hilaritatem conveniant? Idcirco diligentissime ex ipsa natura cuncta perscrutanda sunt, semperque promptiora imitanda, eaque potissimum pingenda sunt, quae plus animis quod excogitent relinquant, quam quae oculis intueantur.[46] Sed nos referamus nonnulla quae de motibus partim fabricavimus nostro ingenio, partim ab ipsa natura didicimus. Primum reor oportere ut omnia inter se corpora, ad eam rem de qua agitur, concinnitate quadam moveantur. Tum placet in historia adesse quempiam qui earum quae gerantur rerum spectatores admoneat, aut manu ad visendum advocet, aut quasi id negotium secretum esse velit, vultu ne eo proficiscare truci et torvis oculis minitetur, aut periculum remve aliquam illic admirandam demonstret, aut ut una adrideas aut ut simul deplores suis te gestibus invitet. Denique et quae illi cum spectantibus et

overlooked, but they corrected it as far as possible while still maintaining the likeness. Therefore, I would have decency and modesty observed in every 'historia', in such a way that ugly things are either omitted or emended. Lastly, as I said, I think one should take care that the same gesture or attitude does not appear in any of the figures.

41. A 'historia' will move spectators when the men painted in the picture outwardly demonstrate their own feelings as clearly as possible. Nature provides—and there is nothing to be found more rapacious of her like than she,—that we mourn with the mourners, laugh with those who laugh, and grieve with the grief-stricken. Yet these feelings are known from movements of the body. We see how the melancholy, pre-occupied with cares and beset by grief, lack all vitality of feeling and action, and remain sluggish, their limbs unsteady and drained of colour. In those who mourn, the brow is weighed down, the neck bent, and every part of their body droops as though weary and past care. But in those who are angry, their passions aflame with ire, face and eyes become swollen and red, and the movements of all their limbs are violent and agitated according to the fury of their wrath. Yet when we are happy and gay, our movements are free and pleasing in their inflexions. They praise Euphranor because in his portrait of Alexander Paris he did the face and expression in such a way that you could recognize him simultaneously as the judge of the goddesses, the lover of Helen and the slayer of Achilles. The painter Daemon's remarkable merit is that you could easily see in his painting the wrathful, unjust and inconstant, as well as the exorable and clement, the merciful, the proud, the humble and the fierce. They say the Theban Aristides, the contemporary of Apelles, represented these emotions best of all; and we too will certainly do the same, provided we dedicate the necessary study and care to this matter.

42. The painter, therefore, must know all about the movements of the body, which I believe he must take from Nature with great skill. It is extremely difficult to vary the movements of the body in accordance with the almost infinite movements of the heart. Who, unless he has tried, would believe it was such a difficult thing, when you want to represent laughing faces, to avoid their appearing tearful rather than happy? And who, without the greatest labour, study and care, could represent faces in which the mouth and chin and eyes and cheeks and forehead and eyebrows all accord together in grief or hilarity? All these things, then, must be sought with the greatest diligence from Nature. The more visible things should always be imitated, and those preferred in painting which leave more for the mind to imagine than is seen by the eye. Let me

[42] The expression is Cicero's in *De amicitia*, 14, 50. [43] Pliny, *N.H.*, XXXIV, 77.

[44] Alberti has evidently here misinterpreted his source in Pliny, *N.H.*, XXXV, 69, where, continuing the description of the works of Parrhasius, the text reads: 'pinxit demon Atheniensium argumento quoque ingenioso. ostendebat namque varium, iracundum, iniustum, inconstantem, etc. . . .' Alberti has taken 'demon' to be the name of an artist (on Daemon the sculptor see Pliny, XXXIV, 87) and changed the sense of the passage. Cfr. the same error in n. 33, p. 74.

[45] Pliny, XXXV, 98 ff.

[46] For the same idea, cfr. Pliny, ibid., 68.

quae inter se picti exequentur, omnia ad agendam et docendam historiam congruant necesse est. Laudatur Timanthes Cyprius in ea tabula qua Colloteicum vicit,[47] quod cum in Iphigeniae immolatione tristem Calchantem, tristiorem fecisset Ulixem, inque Menelao maerore affecto omnem artem et ingenium exposuisset, consumptis affectibus, non reperiens quo digno modo tristissimi patris vultus referret, pannis involuit eius caput, ut cuique plus relinqueret quod de illius dolore animo meditaretur, quam quod posset visu discernere. Laudatur et navis apud Romam ea, in qua noster Etruscus pictor Giottus undecim metu et stupore percussos ob socium, quem supra undas meantem videbant, expressit, ita pro se quemque suum turbati animi inditium vultu et toto corpore praeferentem, ut in singulis singuli affectionum motus appareant.[48] Sed decet hunc totum locum de motibus brevissime transigere.

43. Sunt namque motus alii animorum, quos docti affectiones nuncupant, ut ira, dolor, gaudium, timor, desiderium et eiusmodi. Sunt et alii corporum, nam dicuntur moveri corpora plerisque modis, siquidem cum crescunt aut minuuntur, cumque valentes in aegritudinem cadunt, cumque a morbo in valetudinem surgunt, cumque locum mutant et huiusmodi causis corpora moveri dicuntur. Nos autem pictores, qui motibus membrorum volumus animos affectos exprimere, caeteris disputationibus omissis, de eo tantum motu referamus, quem tum factum dicunt, cum locus mutatus sit. Res omnis quae loco movetur, septem habet movendi itinera,[49] nam aut sursum versus aut deorsum aut in dexteram aut in sinistram aut illuc longe recedendo aut contra nos redeundo. Septimus vero movendi modus est is qui in girum ambiendo vehitur. Hos igitur omnes motus cupio esse in pictura. Adsint corpora nonnulla quae sese ad nos porrigant, alia abeant horsum, dextrorsum et sinistrorsum. Tum ex ipsis corporibus nonnullae partes adversus conspectantes ostententur, aliquae retrocedant, aliae sursum tollantur, aliquae in infimum tendantur. Sed cum in his expingendis motibus ratio plerunque et modus transgrediatur, iuvat hoc loco de statu et motibus membrorum referre nonnulla quae ex ipsa natura collegi, unde plane intelligatur qua moderatione his motibus utendum sit. Perspexi quidem in homine quam in omni statu sui totum substituat corpus capiti, membro omnium ponderosissimo. Tum si toto corpore idem in unum pedem institerit, semper is pes tamquam columnae basis est ad perpendiculum capiti subiectus, ac ferme semper eo stantis vultus porrectus est quo sit pes ipse directus. Capitis vero

[47] The description is taken almost verbatim from Quintilian, *De inst. orat.*, 2, 13, 13 (where Timanthes is 'Cythnius' not 'Cyprius'); cfr. also Pliny, xxxv, 73, Cicero, *Orator*, xxii, 74. Alberti evidently means to refer to Colotes, and has perhaps arrived at Colloteicum (or all copyists of his work have done so) by conflating Quintilian's Coloten Teium. Alternatively one should read Collote teicum (assuming the loss of the duplicated syllable *te*).

[48] Giotto's famous 'Navicella' in St. Peter's, destroyed in the 17th century (cfr. W. Oakeshott, *The mosaics of Rome*, London, 1967, pp. 328–332).

[49] The seven movements are in Quintilian, *De inst. orat.*, 11, 3, 105.

here, however, speak of some things concerning movements, partly made up from my own thoughts, and partly learned from Nature. First, I believe that all the bodies should move in relation to one another with a certain harmony in accordance with the action. Then, I like there to be someone in the 'historia' who tells the spectators what is going on, and either beckons them with his hand to look, or with ferocious expression and forbidding glance challenges them not to come near, as if he wished their business to be secret, or points to some danger or remarkable thing in the picture, or by his gestures invites you to laugh or weep with them. Everything the people in the painting do among themselves, or perform in relation to the spectators, must fit together to represent and explain the 'historia'. They praise Timanthes of Cyprus for the painting in which he surpassed Colotes, because, when he had made Calchas sad and Ulysses even sadder at the sacrifice of Iphigenia, and employed all his art and skill on the grief-stricken Menelaus, he could find no suitable way to represent the expression of her disconsolate father; so he covered his head with a veil, and thus left more for the onlooker to imagine about his grief than he could see with the eye. They also praise in Rome the boat in which our Tuscan painter Giotto represented the eleven disciples struck with fear and wonder at the sight of their colleague walking on the water, each showing such clear signs of his agitation in his face and entire body that their individual emotions are discernible in every one of them. We must, however, deal briefly with this whole matter of movements.

43. Some movements are of the mind, which the learned call dispositions, such as anger, grief, joy, fear, desire and so on. Others are of the body, for bodies are said to move in various ways, as when they grow or diminish, when they fall ill and recover from sickness, and when they change position, and so on. We painters, however, who wish to represent emotions through the movements of limbs, may leave other arguments aside and speak only of the movement that occurs when there is a change of position. Everything which changes position has seven directions of movement, either up or down or to right or left, or going away in the distance or coming towards us; and the seventh is going around in a circle. I want all these seven movements to be in a painting. There should be some bodies that face towards us, and others going away, to right and left. Of these some parts should be shown towards the spectators, and others should be turned away; some should be raised upwards and others directed downwards. Since, however, the bounds of reason are often exceeded in representing these movements, it will be of help here to say some things about the attitude and movements of limbs which I have gathered from Nature, and from which it will be clear what moderation should be used concerning them. I have observed how in every attitude a man positions his whole body beneath his head, which is the heaviest member of all. And if he rests his entire weight on one foot, this foot is always perpendicularly beneath his head like the base of a column, and the face of a person standing is usually turned in the direction in which his foot is pointing. But I have noticed that the movements

motus animadverti vix unquam ullam in partem esse tales, ut non semper aliquas reliqui corporis partes sub se positas habeat, quo immane pondus regatur, aut certe in adversam partem tamquam alteram lancem aliquod membrum protendit quod ponderi correspondeat. Namque idem videmus, dum quis manu extensa pondus aliquod sustentat, ut altero pede tamquam asse bilancis firmato alia tota corporis pars ad coaequandum pondus contrasistatur. Intellexi etiam stantis caput non plus verti sursum quam quo oculi coelum medium contueantur, neque in alterum latus plus diverti quam usque quo mentum scapulam attigerit; in ea parte vero corporis qua incingimur, vix unquam ita intorquemur ut humerum supra umbilicum ad rectam lineam super astituamus. Tibiarum et bracchiorum motus liberiores sunt, modo caeteras corporis honestas partes non impediant. At in his illud a natura perspexi, manus ferme nunquam supra caput neque cubitum supra humeros elevari, neque supra genu pedem in altum attolli, neque pedem a pede plus distare quam quantum pedis unius spatium intersit. Tum spectavi, si quam in altum protendamus manum, eum motum caeteras omnes eius lateris partes ad pedem usque subsequi, ut etiam ipsius pedis calcaneus eiusdem bracchii motu a pavimento levetur.

44. Sunt his simillima perplurima quae diligens artifex animadvertet, et fortasse quae ipse hactenus retuli, usque adeo in promptu sunt ut superflua videri possint. Sed ea idcirco non negleximus, quod plerosque in ea re vehementer errare noverimus. Motus enim nimium acres exprimunt, efficiuntque ut in eodem simulacro et pectus et nates uno sub prospectu conspiciantur, quod quidem cum impossibile factu, tum indecentissimum visu est. Sed hi, quo audiunt eas imagines maxime vivas videri, quae plurimum membra agitent, eo histrionum motus, spreta omni picturae dignitate, imitantur. Ex quo non modo gratia et lepore eorum opera nuda sunt, sed etiam artificis nimis fervens ingenium exprimunt. Suaves enim et gratos atque ad rem de qua agitur condecentes habere pictura motus debet. Sint in virginibus motus et habitudo venusta simplicitate compta atque amena, quae statum magis sapiat dulcem et quietem quam agitationem, tametsi Homero, quem Zeuxis[50] sequutus est, etiam in feminis forma validissima placuit. Sint in adolescente motus leviores, iocundi cum quadam significatione valentis animi et virium. Sint in viro motus firmiores et status celeri palaestra admodum ornati. Sint in senibus omnes motus tardi, sintque ipsi status defessi, ut corpus non pedibus modo ambobus sustineant, sed et manibus aliquo haereant. Denique pro dignitate cuique sui motus corporis ad eos quos velis exprimere motus animi referantur. Tum denique maximarum animi perturbationum maximae in membris significationes adsint necesse est. Atqui haec de motibus ratio in omni animante admodum comunis est. Non enim convenit bovem aratorem his motibus uti quibus Bucephalum generosum Alexandri equum. At celebrem illam Inachi filiam, quae in vaccam conversa sit, fortassis currentem, erecta cervice, levatis pedibus, intorta cauda, perapte pingemus.

[50] Quintilian, ibid., 12, 10, 5.

of the head in any direction are hardly ever such that he does not always have some other parts of the body positioned beneath to sustain the enormous weight, or at least he extends some limb in the opposite direction like the other arm of a balance, to correspond to that weight. When someone holds a weight on his outstretched hand, we see how, with one foot fixed like the axis of a balance, the rest of the body is counterpoised to balance the weight. I have also seen that the head of a man when standing does not turn upwards further than the point at which the eye can see the centre of the sky, nor sideways further than where the chin touches the shoulder; and at the waist we hardly ever turn so far that we get the shoulder directly above the navel. The movements of the legs and arms are freer, provided they do not interfere with the other respectable parts of the body. But in these movements I have observed from Nature that the hands are very rarely raised above the head, or the elbow above the shoulders, or the foot lifted higher than the knee, and that one foot is usually no further from the other than the length of a foot. I have also seen that, if we stretch our hand upwards as far as possible, all the other parts of that side follow that movement right down to the foot, so that with the movement of that arm even the heel of the foot is lifted from the ground.

44. There are many other things of this kind which the diligent artist will notice, and perhaps those I have mentioned so far are so obvious as to seem superfluous. But I did not leave them out, because I have known many make serious mistakes in this respect. They represent movements that are too violent, and make visible simultaneously in one and the same figure both chest and buttocks, which is physically impossible and indecent to look at. But because they hear that those figures are most alive that throw their limbs about a great deal, they cast aside all dignity in painting and copy the movements of actors. In consequence their works are not only devoid of beauty and grace, but are expressions of an extravagant artistic temperament. A painting should have pleasing and graceful movements that are suited to the subject of the action. In young maidens movements and deportment should be pleasing and adorned with a delightful simplicity, more indicative of gentleness and repose than of agitation, although Homer, whom Zeuxis followed, liked a robust appearance also in women. The movements of a youth should be lighter and agreeable, with some hint of strength of mind and body. In a man the movements should be more powerful, and his attitudes marked by a vigorous athletic quality. In old men all the movements should be slow and their postures weary, so that they not only hold themselves up on their two feet, but also cling to something with their hands. Finally, each person's bodily movements, in keeping with dignity, should be related to the emotions you wish to express. And the greatest emotions must be expressed by the most powerful physical indications. This rule concerning movements is common to all living creatures. It is not suitable for a plough-ox to have the same movements as Alexander's noble horse Bucephalus. But we might appropriately paint the famous daughter of Inachus, who was turned into a cow, running with head high, feet in the air, and twisted tail.

45. Haec de animantium motu breviter excursa sufficiant. Nunc vero, quoniam et rerum inanimatarum eos omnes quos dixi motus in pictura necessarios esse arbitror, quonam illa pacto moveantur dicendum censeo. Sane et capillorum et iubarum et ramorum et frondium et vestium motus in pictura expressi delectant. Ipse quidem capillos cupio eos omnes quos retuli septem motus agere; etenim vertantur in girum nodum conantes, atque undent in aera flammas imitantes, modoque sub aliis crinibus serpant, modo sese in has atque has partes attollant. Sintque item ramorum flexus et curvationes partim in sublime arcuati, partim inferius tracti, partim emineant, partim introcedant, partim ut funis intorqueantur. Idque ipsum in plicis pannorum observetur, ut veluti trunco arboris rami in omnes partes emanent, sic ex plica succedant plicae utputa in suos ramos. In hisque idem quoque omnes motus expleantur ut nullius panni extensio adsit, in qua non idem ferme omnes motus reperiantur. Sed sint motus omnes, quod saepius admoneo, moderati et faciles, gratiamque potius quam admirationem laboris exhibeant. Iam vero cum pannos motibus aptos esse volumus, cumque natura sui panni graves et assiduo in terram cadentes omnes admodum flexiones refugiant, pulchre idcirco in pictura Zephiri aut Austri facies perflans inter nubes ad historiae angulum ponetur, qua panni omnes adversi pellantur. Ex quo gratia illa aderit ut quae corporum latera ventus feriat, quod panni vento ad corpus imprimantur, ea sub panni velamento prope nuda appareant. A reliquis vero lateribus panni vento agitati perapte in aera inundabunt. Sed in hac venti pulsione illud caveatur ne ulli pannorum motus contra ventum surgant, neve nimium refracti, neve nimium porrecti sint. Haec igitur de motibus animantium et rerum inanimatarum dicta valde a pictore servanda sunt. Tum etiam ea omnia diligenter exequenda, quae de superficierum, membrorum, corporumque compositione recensuimus.

46. Itaque duae a nobis partes picturae absolutae sunt: circumscriptio et compositio. Restat ut de luminum receptione dicendum sit. In rudimentis satis demonstravimus quam vim lumina ad variandos colores habeant. Nam manentibus colorum generibus, modo apertiores, modo restrictiores colores pro luminum umbrarumque pulsu fieri edocuimus; albumque et nigrum colores eos esse quibus lumina et umbras in pictura exprimamus; caeteros vero colores tamquam materiam haberi, quibus luminis et umbrae alterationes adigantur. Ergo, caeteris omissis, explicandum est quonam pacto sit pictori albo et nigro utendum. Veteres pictores Polygnotum et Timanthem quattuor coloribus tantum usos fuisse, tum Aglaophon simplici colore delectatum admirantur,[51] ac si in tanto quem putabant esse colorum numero, modicum sit eosdem optimos pictores tam paucos in usum delegisse, copiosique artificis putent omnem colorum multitudinem ad opus congerere. Sane ad gratiam

[51] Cicero, *Brutus*, XVIII, 70, mentions Zeuxis, Polygnotus, Timanthes, and others who used four colours (cfr. Pliny, *N.H.*, XXXV, 50). For Aglaophon (and Polygnotus), who use one colour only, see Quintilian, 12, 10, 3.

45. These brief comments must suffice regarding the movement of living creatures. Now I must speak of the way in which inanimate things move, since I believe all the movements I mentioned are necessary in painting also in relation to them. The movements of hair and manes and branches and leaves and clothing are very pleasing when represented in painting. I should like all the seven movements I spoke of to appear in hair. Let it twist around as if to tie itself in a knot, and wave upwards in the air like flames, let it weave beneath other hair and sometimes lift on one side and another. The bends and curves of branches should be partly arched upwards, partly directed downwards; some should stick out towards you, others recede, and some should be twisted like ropes. Similarly in the folds of garments care should be taken that, just as the branches of a tree emanate in all directions from the trunk, so folds should issue from a fold like branches. In these too all the movements should be done in such a way that in no garment is there any part in which similar movements are not to be found. But, as I frequently advise, let all the movements be restrained and gentle, and represent grace rather than remarkable effort. Since by nature clothes are heavy and do not make curves at all, as they tend always to fall straight down to the ground, it will be a good idea, when we wish clothing to have movement, to have in the corner of the picture the face of the West or South wind blowing between the clouds and moving all the clothing before it. The pleasing result will be that those sides of the bodies the wind strikes will appear under the covering of the clothes almost as if they were naked, since the clothes are made to adhere to the body by the force of the wind; on the other sides the clothing blown about by the wind will wave appropriately up in the air. But in this motion caused by the wind one should be careful that movements of clothing do not take place against the wind, and that they are neither too irregular nor excessive in their extent. So, all we have said about the movements of animate and inanimate things should be rigorously observed by the painter. He should also diligently follow all we have said about the composition of surfaces, members and bodies.

46. We have dealt with two parts of painting: circumscription and composition. It remains for us to speak of the reception of light. In the rudiments we said enough to show what power lights have in varying colours. We explained that, while the kinds of colours remain the same, they become lighter or darker according to the incidence of lights and shades; that white and black are the colours with which we express lights and shades in painting; and that all the other colours are, as it were, matter to which variations of light and shade can be applied. Therefore, leaving other considerations aside, we must explain how the painter should use white and black. Some people express astonishment that the ancient painters Polygnotus and Timanthes used only four colours, while Aglaophon took pleasure in one alone, as if it were a mean thing for those fine painters to have chosen to use so few from among the large number of colours they thought existed, and as if they believed it the duty of an excellent artist to employ the entire range of colours. Indeed, I agree that a wide range and variety of

et leporem picturae affirmo copiam colorum et varietatem plurimum valere. Sed sic velim pictores eruditi existiment summam industriam atque artem in albo tantum et nigro disponendo versari, inque his duobus probe locandis omne ingenium et diligentiam consummandam. Nam veluti luminum et umbrae casus id efficit ut quo loco superficies turgeant, quove in cavum recedant, quantumve quaeque pars declinet ac deflectat [appareat], sic albi et nigri concinnitas efficit illud quod Niciae[52] pictori Atheniensi laudi dabatur quodve artifici in primis optandum est: ut suae res pictae maxime eminere videantur. Zeuxim[53] nobilissimum vetustissimumque pictorem dicunt quasi principem ipsam hanc luminum et umbrarum rationem tenuisse. Caeteris vero ea laus minime attributa est. Ego quidem pictorem nullum vel mediocrem putabo eum qui non plane intelligat quam vim umbra omnis et lumina in quibusque superficiebus habeant. Pictos ego vultus, et doctis et indoctis consentientibus, laudabo eos qui veluti exsculpti extare a tabulis videantur, eosque contra vituperabo quibus nihil artis nisi fortassis in lineamentis eluceat. Bene conscriptam, optime coloratam compositionem esse velim. Ergo ut vituperatione careant, utque laudem mereantur, in primis lumina et umbrae diligentissime notanda sunt, atque animadvertendum quam in eam superficiem in quam radii luminum feriant, color ipse insignior atque illustrior sit, tum ut dehinc sensim deficiente vi luminum idem color subfuscus reddatur. Denique animadvertendum est quo pacto semper umbrae luminibus ex adverso respondeant, ut nullo in corpore superficies lumine illustretur, in quo eodem contrarias superficies umbris obtectas non reperias. Sed quantum ad lumina albo et umbras nigro imitandas pertinet, admoneo ut praecipuum studium adhibeas ad superficies eas cognoscendas quae lumine aut umbra pertactae sint. Id quidem a natura et rebus ipsis pulchre perdisces. Eas demum cum probe tenueris, tum levissimo albo quam parcissime suo loco intra fimbrias colorem alteres, suoque contrario loco pariter nigrum illico adiunges. Nam hac nigri et albi conlibratione, ut ita dicam, surgens prominentia fit perspicacior. Dehinc pari parsimonia additamentis prosequere quoad quid satis sit assequutum te sentias. Erit quidem ad eam rem cognoscendam iudex optimus speculum. Ac nescio quo pacto res pictae in speculo gratiam habeant, si vitio careant. Tum mirum est ut omnis menda picturae in speculo deformior appareat. A natura ergo suscepta speculi iudicio emendentur.

47. Sed liceat hic nonnulla, quae a natura hausimus, referre. Animadverti quidem ut planae superficies uniformem omni loco sui colorem servent, sphaericae vero et concavae colores variant, nam istic clarior, illic obscurior est, alio vero loco medii coloris species servatur. Haec autem coloris in non planis superficiebus alteratio difficultatem exhibet ignavis pictoribus. Sed si, ut docuimus, recte fimbrias superficierum pictor conscripserit luminumque sedes discriminarit, facilis tum quidem

[52] Pliny, *N.H.*, xxxv, 131: Nicias 'ut eminerent e tabulis picturae maxime curavit'.
[53] Quintilian, 12, 10, 5 (Zeuxis).

colours contribute greatly to the beauty and attraction of a painting. But I would prefer learned painters to believe that the greatest art and industry are concerned with the disposition of white and black, and that all skill and care should be used in correctly placing these two. Just as the incidence of light and shade makes it apparent where surfaces become convex or concave, or how much any part slopes and turns this way or that, so the combination of white and black achieves what the Athenian painter Nicias was praised for, and what the artist must above all desire: that the things he paints should appear in maximum relief. They say that Zeuxis, the most eminent ancient painter, was like a prince among the rest in understanding this principle of light and shade. Such praise was not given to others at all. I would consider of little or no virtue the painter who did not properly understand the effect every kind of light and shade has on all surfaces. In painting I would praise—and learned and unlearned alike would agree with me—those faces which seem to stand out from the pictures as if they were sculpted, and I would condemn those in which no artistry is evident other than perhaps in the drawing. I would like a composition to be well drawn and excellently coloured. Therefore, to avoid condemnation and earn praise, painters should first of all study carefully the lights and shades, and observe that the colour is clearer and brighter on the surface on which the rays of light strike, and that this same colour turns darker where the force of the light gradually grows less. It should also be observed how shadows always correspond on the side away from the light, so that in no body is a surface illuminated without your finding surfaces on its other side covered in shade. But as regards the representation of light with white and of shadow with black, I advise you to devote particular study to those surfaces that are clothed in light or shade. You can very well learn from Nature and from objects themselves. When you have thoroughly understood them, you may change the colour with a little white applied as sparingly as possible in the appropriate place within the outlines of the surface, and likewise add some black in the place opposite to it. With such balancing, as one might say, of black and white a surface rising in relief becomes still more evident. Go on making similar sparing additions until you feel you have arrived at what is required. A mirror will be an excellent guide to knowing this. I do not know how it is that paintings that are without fault look beautiful in a mirror; and it is remarkable how every defect in a picture appears more unsightly in a mirror. So the things that are taken from Nature should be emended with the advice of the mirror.

47. Let me relate here some things I have learned from Nature. I observed that plane surfaces keep a uniform colour over their whole extent, while spherical and concave vary their colours, and here it is lighter, there darker, and elsewhere a kind of in-between colour. This variation of colour in other than plane surfaces presents some difficulty to not very clever painters. But if, as I explained, the painter has drawn the outlines of the surfaces correctly and clearly sketched the border-line between lighter and darker, the method of colouring will then be easy. He will first begin to modify the colour of the

7

erit colorandi ratio. Nam levissimo quasi rore primum usque ad discriminis lineam albo aut nigro eam superficiem, ut oporteat, alterabit. Dehinc aliam, ut ita loquar, irrorationem citra lineam, post hanc aliam citra hanc, et citra eam aliam super- addendo assequetur, ut cum illustrior locus apertiori colore pertinctus sit, tum idem deinceps color quasi fumus in contiguas partes diluatur. At meminisse oportet nullam superficiem usque adeo dealbandam esse ut eandem multo ac multo candidiorem nequeas efficere. Ipsas quoque niveas vestes exprimendo citra ultimum candorem longe residendum est. Nam habet pictor aliud nihil quam album colorem quo ultimos tersissimarum superficierum fulgores imitetur, solumque nigrum invenit quo ultimas noctis tenebras referat. Idcirco in albis vestibus pingendis unum ex quattuor generibus colorum suscipere opus est, quod quidem apertum et clarum sit. Idque ipsum contra in nigro fortassis pallio pingendo alium extremum quod non longe ab umbra distet, veluti profundi et nigrantis maris colorem sumemus. Denique vim tantam haec albi et nigri compositio habet, ut arte et modo facta aureas argenteasque et vitreas splendidissimas superficies demonstret in pictura. Ergo vehementer vituperandi sunt pictores qui albo intemperanter et nigro indiligenter utuntur. Quam ideo ipse vellem apud pictores album colorem longe carius quam pretiosissimas gemmas coemi! Conduceret quidem album et nigrum ex illis unionibus Cleopatrae quos aceto colliquabat, constare quo eorum avarissimi redderentur, nam et lepidiora opera et ad veritatem proximiora essent. Neque facile dici potest quantam esse oporteat distribuendi albi in pictura parsimoniam atque modum. Hinc solitus erat Zeuxis pictores redarguere, quod nescirent quid esset nimis.[53a] Quod si vitio indulgendum est, minus redarguendi sunt qui nigro admodum profuse, quam qui albo paulum intemperanter utantur. Natura enim ipsa indies atrum et horrendum opus usu pingendi odisse discimus, continuoque quo plus intelligimus, eo plus ad gratiam et venustatem manum delinitam reddi- mus. Ita natura omnes aperta et clara amamus. Ergo qua in parte facilior peccato via patet, eo arctius obstruenda est.

48. Haec de albi et nigri usu dicta hactenus. De colorum vero generibus etiam ratio quaedam adhibenda est. Sequitur ergo ut de colorum generibus nonnulla referamus, non id quidem quemadmodum Vitruvius[54] architectus quo loco rubrica optima et probatissimi colores inveniantur, sed quonam pacto selecti et valde pertriti colores in pictura componendi sint. Ferunt Euphranorem[55] priscum pictorem de coloribus nonnihil mandasse litteris. Ea scripta non extant hac tempe- state. Nos autem qui hanc picturae artem seu ab aliis olim descriptam ab inferis repetitam in lucem restituimus, sive nunquam a quoquam tractatam a superis deduximus, nostro ut usque fecimus ingenio, pro instituto rem prosequamur. Velim genera colorum et species, quoad id fieri possit, omnes in pictura quadam

[53a] Cicero, *Orator*, XXII, 73 (Apelles not Zeuxis). [54] Vitruvius, *De arch.*, VII, vii. [55] Pliny, XXV, 129 (Euphranor).

surface with white or black, as necessary, applying it like a gentle dew up to the border-line. Then he will go on adding another sprinkling, as it were, on this side of the line, and after this another on this side of it, and then another on this side of this one, so that not only is the part receiving more light tinged with a clearer colour, but the colour also dissolves progressively like smoke into the areas next to each other. But you have to remember that no surface should be made so white that you cannot make it a great deal whiter still. Even in representing snow-white clothing you should stop well on this side of the brightest white. For the painter has no other means than white to express the brightest gleams of the most polished surfaces, and only black to represent the deepest shadows of the night. And so in painting white clothes we must take one of the four kinds of colours which is bright and clear; and likewise in painting, for instance, a black cloak, we must take the other extreme which is not far from the deepest shadow, such as the colour of the deep and darkening sea. This composition of white and black has such power that, when skilfully carried out, it can express in paint-ing brilliant surfaces of gold and silver and glass. Consequently, those painters who use white immoderately and black carelessly, should be strongly condemned. I would like white to be purchased more dearly among painters than precious stones. It would be a good thing if white and black were made from those pearls Cleopatra dissolved in vinegar, so that painters would become as mean as possible with them, for their works would then be both more agreeable and nearer the truth. It is not easy to express how sparing and careful one should be in distributing white in a painting. On this point Zeuxis used to condemn painters because they had no idea what was too much. If some indulgence must be given to error, then those who use black extravagantly are less to be blamed than those who employ white somewhat intemperately; for by nature, with experience of painting, we learn as time goes by to hate work that is dark and horrid, and the more we learn, the more we attune our hand to grace and beauty. We all by nature love things that are open and bright. So we must the more firmly block the way in which it is the easier to go wrong.

48. We have spoken so far about the use of white and black. But we must give some account also of the kinds of colours. So now we shall speak of them, not after the manner of the architect Vitruvius as to where excellent red ochre and the best colours are to be found, but how selected and well compounded colours should be arranged together in painting. They say that Euphranor, a painter of antiquity, wrote something about colours. This work does not exist now. However, whether, if it was once written about by others, we have rediscovered this art of painting and restored it to light from the dead, or whether, if it was never treated before, we have brought it down from the heavens, let us go on as we intended, using our own intelligence as we have done up to now. I should like, as far as possible, all the kinds and species of colours to appear in painting with a certain grace and amenity. Such grace will be present when colours are placed next to others with particular care; for, if you are painting Diana leading

cum gratia et amenitate spectari. Gratia quidem tunc extabit cum exacta quadam diligentia colores iuxta coloribus aderunt; quod si Dianam agentem chorum pingas, huic nymphae virides, illi propinquae candidos, proximae huic purpureos, alteri croceos amictus dari convenit, ac deinceps istiusmodi colorum diversitate caeterae induantur ut clari semper colores aliquibus diversi generis obscuris coloribus coniungantur. Nam ea quidem coniugatio colorum et venustatem a varietate et pulchritudinem a comparatione illustriorem referet. Atqui est quidem nonnulla inter colores amicitia ut iuncti alter alteri gratiam et venustatem augeat. Rubeus color si inter coelestem et viridem medius insideat, mutuum quoddam utrisque suscitat decus. Niveus quidem color non modo inter cinereum atque croceum positus, sed paene omnibus coloribus hilaritatem praestat. Obscuri autem colores inter claros non sine insigni dignitate assident, parique ratione inter obscuros clari belle collocantur. Ergo quam dixi varietatem colorum in historia pictor disponet.
49. At sunt qui auro inmodice utantur, quod aurum putent quandam historiae afferre maiestatem. Eos ipse plane non laudo. Quin et si eam velim Didonem Virgilii expingere, cui pharetra ex auro, in aurumque crines nodabantur, aurea cui fibula vestem subnectebat, aureisque frenis vehebatur, dehinc omnia splendebant auro, eam tamen aureorum radiorum copiam, quae undique oculos visentium perstringat, potius coloribus imitari enitar quam auro. Nam cum maior in coloribus sit artificis admiratio et laus, tum etiam videre licet ut in plana tabula auro posito pleraeque superficies, quas claras et fulgidas repraesentare oportuerat, obscurae visentibus appareant, aliae fortassis quae umbrosiores debuerant esse, luminosiores porrigantur. Caetera quidem fabrorum ornamenta quae picturae adiiciuntur, ut sunt circumsculptae columnae et bases et fastigia, non sane vituperabo si ex ipso argento atque auro solido vel admodum purissimo fuerint. Nam et gemmarum quoque ornamentis perfecta et absoluta historia dignissima est.
50. Hactenus picturae partes tres brevissime transactae a nobis sunt. Diximus de circumscriptione minorum et maiorum superficierum. Diximus de compositione superficierum, membrorum atque corporum. Diximus de coloribus quantum ad pictoris usum pertinere arbitrabamur. Omnis igitur pictura a nobis exposita est, quam quidem in tribus his rebus consistere praediximus, circumscriptione, compositione et luminum receptione.

her band, it is appropriate for this nymph to be given green clothes, the one next to her white, and the next red, and another yellow, and the rest should be dressed successively in a variety of colours, in such a way that light colours are always next to dark ones of a different kind. This combining of colours will enhance the attractiveness of the painting by its variety, and its beauty by its comparisons. There is a kind of sympathy among colours, whereby their grace and beauty is increased when they are placed side by side. If red stands between blue and green, it somehow enhances their beauty as well as its own. White lends gaiety, not only when placed between gray and yellow, but almost to any colour. But dark colours acquire a certain dignity when between light colours, and similarly light colours may be placed with good effect among dark. So the painter in his 'historia' will arrange this variety of colours I have spoken of.

49. There are some who make excessive use of gold, because they think it lends a certain majesty to painting. I would not praise them at all. Even if I wanted to paint Virgil's Dido with her quiver of gold, her hair tied up in gold, her gown fastened with a golden clasp, driving her chariot with golden reins, and everything else resplendent with gold, I would try to represent with colours rather than with gold this wealth of rays of gold that almost blinds the eyes of the spectators from all angles. Besides the fact that there is greater admiration and praise for the artist in the use of colours, it is also true that, when done in gold on a flat panel, many surfaces that should have been presented as light and gleaming, appear dark to the viewer, while others that should be darker, probably look brighter. Other ornaments done by artificers that are added to painting, such as sculpted columns, bases and pediments, I would not censure if they were in real silver and solid or pure gold, for a perfect and finished painting is worthy to be ornamented even with precious stones.

50. So far we have dealt briefly with the three parts of painting. We spoke of the circumscription of smaller and larger surfaces. We spoke of the composition of surfaces, members and bodies. With regard to colours we have explained what we considered applicable to the painter's use. We have, therefore, expounded the whole of painting, which we said earlier on consisted in three things: circumscription, composition and the reception of light.

Liber III

51. Sed cum ad perfectum pictorem instituendum ut omnes quas recensuimus laudes assequi possit, nonnulla etiam supersint, quae his commentariis minime praetereunda censeo, ea quam brevissime referamus.

52. Pictoris officium est quaevis data corpora ita in superficie lineis et coloribus conscribere atque pingere, ut certo intervallo, certaque centrici radii positione constituta, quaeque picta videas, eadem prominentia et datis corporibis persimillima videantur. Finis pictoris laudem, gratiam et benivolentiam vel magis quam divitias ex opere adipisci. Id quidem assequetur pictor dum eius pictura oculos et animos spectantium tenebit atque movebit. Quae res quonam argumento fieri possint diximus cum de compositione atque luminum receptione supra disceptavimus. Sed cupio pictorem, quo haec possit omnia pulchre tenere, in primis esse virum et bonum et doctum bonarum artium. Nam nemo nescit quantum probitas vel magis quam omnis industriae aut artis admiratio valeat ad benivolentiam civium comparandam. Tum nemo dubitat benivolentiam multorum artifici plurimum conferre ad laudem atque ad opes parandas. Siquidem ex ea fit ut cum non nunquam divites benivolentia magis quam artis peritia moveantur, tum lucra ad hunc potissimum modestum et probum deferant, spreto alio peritiore sane, sed fortassis intemperanti. Quae cum ita sint, moribus egregie inserviendum erit artifici, maxime humanitati et facilitati, quo et benivolentiam, firmum contra paupertatem praesidium, et lucra, optimum ad perficiendam artem auxilium, assequatur.

53. Doctum vero pictorem esse opto, quoad eius fieri possit, omnibus in artibus liberalibus, sed in eo praesertim geometriae peritiam desidero. Assentior quidem Pamphilo[56] antiquissimo et nobilissimo pictori, a quo ingenui adolescentes primo picturam didicere. Nam erat eius sententia futurum neminem pictorem bonum qui geometriam ignorarit. Nostra quidem rudimenta, ex quibus omnis absoluta et perfecta ars picturae depromitur, a geometra facile intelliguntur. Eius vero artis imperitis neque rudimenta neque ullas picturae rationes posse satis patere arbitror. Ergo geometricam artem pictoribus minime negligendam affirmo. Proxime non ab re erit se poetis atque rhetoribus delectabuntur. Nam hi quidem multa cum pictore habent ornamenta communia. Neque parum illi quidem multarum rerum notitia copiosi litterati ad historiae compositionem pulchre constituendam iuvabunt, quae omnis laus praesertim in inventione consistit. Atqui ea quidem hanc habet vim, ut etiam sola inventio sine pictura delectet. Laudatur, dum legitur, illa Calumniae descriptio quam ab Apelle pictam refert Lucianus.[57] Eam quidem

[56] Pliny, xxxv, 76–7 (Pamphilus).　　[57] Lucian, *De calumnia*, 5; cfr. R. Altrocchi, 'The Calumny of Apelles in the literature of the Quattrocento', in *PMLA*, 36, 1921, pp. 454–91; also E. Panofsky, *Studies in Iconology*, New York, 1962, pp. 158–159.

Book III

51. Several things, which I do not think should be omitted from these books, still remain to complete the instruction of the painter, so that he may attain all the praise-worthy objects of which we have spoken. Let me now explain them very briefly.

52. The function of the painter is to draw with lines and paint in colours on a surface any given bodies in such a way that, at a fixed distance and with a certain, determined position of the centric ray, what you see represented appears to be in relief and just like those bodies. The aim of the painter is to obtain praise, favour and good-will for his work much more than riches. The painter will achieve this if his painting holds and charms the eyes and minds of spectators. We explained how this may be done when talking above about composition and the reception of light. But in order that he may attain all these things, I would have the painter first of all be a good man, well versed in the liberal arts. Everyone knows how much more effective uprightness of character is in securing people's favour than any amount of admiration for someone's industry and art. And no one doubts that the favour of many people is very useful to the artist for acquiring reputation and wealth. It so happens that, as rich men are often moved by kindness more than by expert knowledge of art, they will give money to one man who is especially modest and good, and spurn another who is more skilled but perhaps intemperate. For this reason it behoves the artist to be particularly attentive to his morals, especially to good manners and amiability, whereby he may obtain both the good-will of others, which is a firm protection against poverty, and money, which is an excellent aid to the perfection of his art.

53. I want the painter, as far as he is able, to be learned in all the liberal arts, but I wish him above all to have a good knowledge of geometry. I agree with the ancient and famous painter Pamphilus, from whom young nobles first learned painting; for he used to say that no one could be a good painter who did not know geometry. Our rudiments, from which the complete and perfect art of painting may be drawn, can easily be understood by a geometer, whereas I think that neither the rudiments nor any principles of painting can be understood by those who are ignorant of geometry. Therefore, I believe that painters should study the art of geometry. Next, it will be of advantage if they take pleasure in poets and orators, for these have many ornaments in common with the painter. Literary men, who are full of information about many subjects, will be of great assistance in preparing the composition of a 'historia', and the great virtue of this consists primarily in its invention. Indeed, invention is such that even by itself and without pictorial representation it can give pleasure. The description that Lucian gives of Calumny painted by Apelles, excites our admiration when we read it. I do not think it is inappropriate to tell it here, so that painters may be advised of the need to take particular care in creating inventions of this kind. In the painting there was

enarrare minime ab instituto alienum esse censeo, quo pictores admoneantur eiusmodi inventionibus fabricandis advigilare oportere. Erat enim vir unus, cuius aures ingentes extabant, quem circa duae adstabant mulieres, Inscitia et Suspitio, parte alia ipsa Calumnia adventans, cui forma mulierculae speciosae sed quae ipso vultu nimis callere astu videbatur, manu sinistra facem accensam tenens, altera vero manu per capillos trahens adolescentem qui manus ad coelum tendit. Duxque huius est vir quidam pallore obsitus, deformis, truci aspectu, quem merito compares his quos in acie longus labor confecerit. Hunc esse Livorem merito dixere. Sunt et aliae duae Calumniae comites mulieres, ornamenta dominae componentes, Insidiae et Fraus. Post has pulla et sordidissima veste operta et sese dilanians adest Poenitentia, proxime sequente pudica et verecunda Veritate. Quae plane historia etiam si dum recitatur animos tenet, quantum censes eam gratiae et amoenitatis ex ipsa pictura eximii pictoris exhibuisse?

54. Quid tres illae iuvenculae sorores, quibus Hesiodus imposuit nomina Egle,[58] Euphronesis atque Thalia, quas pinxere implexis inter se manibus ridentes, soluta et perlucida veste ornatas, ex quibus liberalitatem demonstratam esse voluere, quod una sororum det, alia accipiat, tertia reddat beneficium; qui quidem gradus in omni perfecta liberalitate adesse debent. Vides quam huiusmodi inventa magnam artifici laudem comparent. Idcirco sic consulo poetis atque rhetoribus caeterisque doctis litterarum sese pictor studiosus familiarem atque benivolum dedat, nam ab eiusmodi eruditis ingeniis cum ornamenta accipiet optima, tum in his profecto inventionibus iuvabitur, quae in pictura non ultimam sibi laudem vendicent. Phidias[59] egregius pictor fatebatur se ab Homero didicisse qua potissimum maiestate Iovem pingeret. Nostris sic arbitror nos etiam poetis legendis et copiosiores et emendatiores futuros, modo discendi studiosiores fuerimus quam lucri.

55. Sed plerunque non minus studiosos quam cupidos, quod viam perdiscendae rei ignorent, magis quam discendi labor frangit. Idcirco quonam pacto in hac arte nos eruditos fieri oporteat ordiamur. Caput sit omnes discendi gradus ab ipsa natura esse petendos; artis vero perficiendae ratio diligentia, studio et assiduitate comparetur. Velim quidem eos qui pingendi artem ingrediuntur, id agere quod apud scribendi instructores observari video.[60] Nam illi quidem prius omnes elementorum characteres separatim edocent, postea vero syllabas atque perinde dictiones componere instruunt. Hanc ergo rationem et nostri in pingendo sequantur. Primo ambitum superficierum quasi picturae elementa, tum et superficierum connexus, dehinc membrorum omnium formas distincte ediscant, omnesque quae in membris possint esse differentias memoriae commendent. Nam sunt illae quidem neque

[58] I have kept the form Egle (for Aglaia) common to the MS tradition. For the allegorical explanation, see Seneca, *De beneficiis*, I, 3, 2–7.

[59] Strabo, *Geogr.*, VIII, 3, 30 (C354) (Phidias). [60] Quintilian, I, I, 24–31; cfr. also Alberti's own short work *Elementa picturae* (in *Op. volgari*, III) and cfr. Parronchi, 'Sul significato degli *Elementi di pittura*', cit.

a man with enormous ears sticking out, attended on each side by two women, Ignorance and Suspicion; from one side Calumny was approaching in the form of an attractive woman, but whose face seemed too well versed in cunning, and she was holding in her left hand a lighted torch, while with her right she was dragging by the hair a youth with his arms outstretched towards heaven. Leading her was another man, pale, ugly and fierce to look upon, whom you would rightly compare to those exhausted by long service in the field. They identified him correctly as Envy. There are two other women attendant on Calumny and busy arranging their mistress's dress; they are Treachery and Deceit. Behind them comes Repentance clad in mourning and rending her hair, and in her train chaste and modest Truth. If this 'historia' seizes the imagination when described in words, how much beauty and pleasure do you think it presented in the actual painting of that excellent artist?

54. What shall we say too about those three young sisters, whom Hesiod called Egle, Euphronesis and Thalia? The ancients represented them dressed in loose transparent robes, with smiling faces and hands intertwined; they thereby wished to signify liberality, for one of the sisters gives, another receives and the third returns the favour, all of which degrees should be present in every act of perfect liberality. You can appreciate how inventions of this kind bring great repute to the artist. I therefore advise the studious painter to make himself familiar with poets and orators and other men of letters, for he will not only obtain excellent ornaments from such learned minds, but he will also be assisted in those very inventions which in painting may gain him the greatest praise. The eminent painter Phidias used to say that he had learned from Homer how best to represent the majesty of Jupiter. I believe that we too may be richer and better painters from reading our poets, provided we are more attentive to learning than to financial gain.

55. Very often, however, ignorance of the way to learn, more than the effort of learning itself, breaks the spirit of men who are both studious and anxious to do so. So let us explain how we should become learned in this art. The fundamental principle will be that all the steps of learning should be sought from Nature: the means of perfecting our art will be found in diligence, study and application. I would have those who begin to learn the art of painting do what I see practised by teachers of writing. They first teach all the signs of the alphabet separately, and then how to put syllables together, and then whole words. Our students should follow this method with painting. First they should learn the outlines of surfaces, then the way in which surfaces are joined together, and after that the forms of all the members individually; and they should commit to memory all the differences that can exist in those members, for they are neither few nor insignificant. Some people will have a crook-backed nose; others will have flat, turned-back, open nostrils; some are full around the mouth, while others are graced with slender lips, and so on: every part has something particular which considerably alters the whole member when it is present in greater or lesser degree. Indeed

modicae neque non insignes. Aderunt quibus sit nasus gibbosus; erunt qui gerant
simas nares, recurvas, patulas: alii buccas fluentes porrigunt, alios labiorum gracilitas
ornat, ac deinceps quaeque membra aliquid praecipuum habent, quod cum plus aut
minus affuerit, tunc multo totum membrum variet. Quin etiam videmus ut eadem
membra pueris nobis rotunda et, ut ita dicam, tornata atque levia, aetatis vero accessu
asperiora et admodum angulata sint. Haec igitur omnia picturae studiosus ab ipsa
natura excipiet, ac secum ipse assiduo meditabitur quonam pacto quaeque extent,
in eaque investigatione continuo oculis et mente persistet. Spectabit namque
sedentis gremium et tibias ut dulce in proclivum labantur. Notabit stantis faciem
totam atque habitudinem, denique nulla erit pars cuius officium et symmetriam, ut
Graeci aiunt, ignoret. At ex partibus omnibus non modo similitudinem rerum,
verum etiam in primis ipsam pulchritudinem diligat. Nam est pulchritudo in
pictura res non minus grata quam expetita. Demetrio[61] pictori illi prisco ad sum-
mam laudem defuit quod similitudinis exprimendae fuerit curiosior quam pulchri-
tudinis. Ergo a pulcherrimis corporibus omnes laudatae partes eligendae sunt.
Itaque non in postremis ad pulchritudinem percipiendam, habendam atque
exprimendam studio et industria contendendum est. Quae res tametsi omnium
difficillima sit, quod non uno loco omnes pulchritudinis laudes comperiantur sed
rarae illae quidem ac dispersae sint, tamen in ea investiganda ac perdiscenda omnis
labor exponendus est. Nam qui graviora apprehendere et versare didicerit, is facile
minora poterit ex sententia, neque ulla est usque adeo difficilis res quae studio et
assiduitate superari non possit.[62]

56. Sed quo sit studium non futile et cassum, fugienda est illa consuetudo non-
nullorum qui suopte ingenio ad picturae laudem contendunt, nullam naturalem
faciem eius rei oculis aut mente coram sequentes. Hi enim non recte pingere discunt
sed erroribus assuefiunt. Fugit enim imperitos ea pulchritudinis idea quam peritis-
simi vix discernunt. Zeuxis, praestantissimus et omnium doctissimus et peritissimus
pictor, facturus tabulam quam in templo Lucinae apud Crotoniates publice dicaret,
non suo confisus ingenio temere, ut fere omnes hac aetate pictores, ad pingendum
accessit, sed quod putabat omnia quae ad venustatem quaereret, ea non modo
proprio ingenio non posse, sed ne a natura quidem petita uno posse in corpore
reperiri, idcirco ex omni eius urbis iuventute delegit virgines quinque forma
praestantiores, ut quod in quaque esset formae muliebris laudatissimum, id in pictura
referret.[63] Prudenter is quidem, nam pictoribus nullo proposito exemplari quod
imitentur, ubi ingenio tantum pulchritudinis laudes captare enituntur, facile evenit
ut eo labore non quam debent aut quaerunt pulchritudinem assequantur, sed plane
in malos, quos vel volentes vix possunt dimittere, pingendi usus dilabantur.[64] Qui
vero ab ipsa natura omnia suscipere consueverit, is manum ita exercitatam reddet
ut semper quicquid conetur naturam ipsam sapiat. Quae res in picturis quam sit
optanda videmus, nam in historia si adsit facies cogniti alicuius hominis, tametsi

we see that those same members which in our boyhood were rounded, and, one might say, well turned and smoothed, are become rough and angular with the advance of age. All these things, therefore, the student of painting will take from Nature, and assiduously meditate upon the appearance of each part; and he will persist continually in such enquiry with both eye and mind. In a seated figure he will observe the lap, and how the legs hang gently down. In a standing person he will note the whole appearance and posture, and there will be no part whose function and symmetry, as the Greeks call it, he will not know. But, considering all these parts, he should be attentive not only to the likeness of things but also and especially to beauty, for in painting beauty is as pleasing as it is necessary. The early painter Demetrius failed to obtain the highest praise because he was more devoted to representing the likeness of things than to beauty.[61] Therefore, excellent parts should all be selected from the most beautiful bodies, and every effort should be made to perceive, understand and express beauty. Although this is the most difficult thing of all, because the merits of beauty are not all to be found in one place, but are dispersed here and there in many, every endeavour should nonetheless be made to investigate and understand it thoroughly. The man who has learned to grasp and handle more serious matters, will in my view easily manage the less troublesome, and there is nothing so difficult that cannot be overcome by application and persistent effort.[62]

56. Yet, in order that our effort shall not be vain and futile, we must avoid the habit of those who strive for distinction in painting by the light of their own intelligence without having before their eyes or in their mind any form of beauty taken from Nature to follow. They do not learn to paint properly, but simply make habits of their mistakes. The idea of beauty, which the most expert have difficulty in discerning, eludes the ignorant. Zeuxis, the most eminent, learned and skilled painter of all, when about to paint a panel to be publicly dedicated in the temple of Lucina at Croton, did not set about his work trusting rashly in his own talent like all painters do now; but, because he believed that all the things he desired to achieve beauty not only could not be found by his own intuition, but were not to be discovered even in Nature in one body alone, he chose from all the youth of the city five outstandingly beautiful girls, so that he might represent in his painting whatever feature of feminine beauty was most praiseworthy in each of them.[63] He acted wisely, for to painters with no model before them to follow, who strive by the light of their own talent alone to capture the qualities of beauty, it easily happens that they do not by their efforts achieve the beauty they seek or

[61] Quintilian, 12, 10, 9 (Demetrius).

[62] A typical assertion of confidence in human ability; cfr. Alberti's *Famiglia*, proem, in *Op. volg.*, ed. Grayson, I, pp. 4–10.

[63] Cfr. *De statua*, §12, and see Introduction, pp. 15, 23–24. For the source, see Cicero, *De inventione*, II, I, 1–3, and also Pliny, *N.H.*, xxxv, 64 (with slight differences of detail).

[64] Cicero, *De orat.*, I, 33, 149–50.

aliae nonnullae praestantioris artificii emineant, cognitus tamen vultus omnium
spectantium oculos ad se rapit, tantam in se, quod sit a natura sumptum, et gratiam
et vim habet.[65] Ergo semper quae picturi sumus, ea a natura sumamus, semperque
ex his quaeque pulcherrima et dignissima deligamus.

57. Sed cavendum ne, quod plerique faciunt, ea minimis tabellis pingamus.
Grandibus enim imaginibus te velim assuefacias, quae quidem quam proxime
magnitudine ad id quod ipse velis efficere, accedant. Nam in parvis simulacris maxi-
ma vitia maxime latent, in magna effigie etiam minimi errores conspicui sunt.
Scripsit Galenus vidisse se in anulo sculptum Phaethontem quattuor equis vectum,
quorum frena et omnes pedes et pectora distincte videbantur.[66] Concedant pictores
hanc laudem sculptoribus gemmarum; ipsi vero maioribus in campis laudis versen-
tur. Nam qui magnas figuras fingere aut pingere noverit, is perfacile atque optime
unico tractu eiusmodi minuta poterit. Qui vero pusillis his monilibus manum et
ingenium assuefecerit, facile in maioribus aberrabit.

58. Sunt qui aliorum pictorum opera emulentur, atque in ea re sibi laudem quae-
rant; quod Calamidem[67] sculptorem fecisse ferunt, qui duo pocula caelavit in
quibus Zenodorum ita emulatus est ut nulla in operibus differentia agnosceretur.
At pictores maximo in errore versantur, si non intelligunt eos qui pinxerint conatos
fuisse tale simulacrum repraesentare, quale nos ab ipsa natura depictum in velo
intuemur. Vel si iuvat opera aliorum imitari, quod ea firmiorem quam viventes
patientiam ad se ostendenda praestent, malo mediocriter sculptam quam egregie
pictam rem tibi imitandam proponas, nam ex pictis rebus solum ad aliquam
similitudinem referendam manum assuefacimus, ex rebus vero sculptis et similitu-
dinem et vera lumina deducere discimus. In quibus quidem luminibus colligendis
plurimum confert pilis palpebrarum aciem intuitus subopprimere, quo illic lumina
subfusca et quasi intercisione depicta videantur. Ac fortassis conducet fingendo
exerceri quam penniculo. Certior enim et facilior est sculptura quam pictura.
Neque unquam erit quispiam qui recte possit eam rem pingere, cuius omnes
prominentias non cognoscat. Prominentiae vero facilius reperiuntur sculptura
quam pictura. Etenim sit hoc ad rem non mediocre argumentum, quod videre
liceat quam omni fere in aetate mediocres aliquos fuisse sculptores invenias,
pictores vero paene nullos non irridendos ac prorsus imperitos reperias.

59. Denique vel picturae studeas vel sculpturae, semper tibi proponendum est
elegans et singulare aliquod exemplar, quod et spectes et imiteris, in eoque imitando
diligentiam celeritati coniunctam ita adhiberi oportere censeo, ut nunquam penni-
culum aut stilum ad opus admoveat pictor, quin prius mente quid facturus et
quomodo id perfecturus sit, optime constitutum habeat. Tutius est enim errores
mente levare quam ex opere abradere. Tum etiam dum ex composito agere omnia

[65] See Introduction, p. 15. [66] Galen, *De usu partium*, XVII, 1 (cit. Edgerton, 'Alberti's colour theory',
cit., p. 125, n. 39). [67] Pliny, *N.H.*, XXXIV, 47 (Alberti has reversed the names).

ought to create; they simply fall into bad habits of painting, which they have great difficulty in relinquishing even if they wish. But the painter who has accustomed himself to taking everything from Nature, will so train his hand that anything he attempts will echo Nature. We can see how desirable this is in painting when the figure of some well-known person is present in a 'historia', for although others executed with greater skill may be conspicuous in the picture, the face that is known draws the eyes of all spectators, so great is the power and attraction of something taken from Nature. So, let us always take from Nature whatever we are about to paint, and let us always choose those things that are most beautiful and worthy.

57. We must beware, however, not to paint on very small panels, as many do. I would have you get used to making large pictures, which are as near as possible in size to the actual object you wish to represent. In small pictures the greatest mistakes are most easily concealed; in a large one even the smallest errors are obvious. Galen wrote that he had seen carved on a ring Phaethon driving four horses, with their reins and feet and breasts clearly visible. But painters should leave this distinction to the sculptors of precious stones, and occupy themselves instead in larger fields of fame. The man who has learned to make or paint large figures would at once do small things of this kind easily and well; whereas the man who has accustomed his hand and talent to these tiny jewels, will easily go wrong in larger works.

58. There are some who imitate the work of other painters and thereby aspire to fame. They say that the sculptor Calamis did this: he engraved two cups in which he so closely copied Zenodorus that no difference could be recognized between their works. But painters are gravely mistaken if they do not understand that those who painted in the past endeavoured to represent a likeness such as we see depicted by Nature on our veil. If it is a help to imitate the works of others, because they have greater stability of appearance than living things, I prefer you to take as your model a mediocre sculpture rather than an excellent painting, for from painted objects we train our hand only to make a likeness, whereas from sculptures we learn to represent both likeness and correct incidence of light. In studying such light it is very useful to dim your vision by half closing your eyelashes, so that the light appears less strong and almost as if depicted on an intersection. It will probably help also to practise at sculpting rather than painting, for sculpture is easier and surer than painting. No one will ever be able to paint a thing correctly if he does not know its every relief, and relief is more easily found by sculpture than by painting. No mean proof of this lies in the observation that in almost all ages you will find there were some mediocre sculptors, but scarcely any painters who were not ridiculous and completely incompetent.

59. Whether you practise painting or sculpture, you should always have before you some fine and remarkable model which you observe and copy; and in copying it I believe that diligence should be combined with speed of execution, but in such a way that the painter will never apply his brush or style to his work before he has clearly

consueverimus, fit ut Asclepiodoro[68] longe promptiores artifices reddamur, quem quidem omnium velocissimum pingendo fuisse ferunt. Nam redditur ad rem peragendam promptum, accinctum expeditumque ingenium id quod exercitatione agitatum calet, eaque manus velocissima sequitur, quam certa ingenii ratio duxerit. Si qui vero sunt pigri artifices, hi profecto idcirco ita sunt quod lente et morose eam rem tentent quam non prius menti suae studio perspicuam effecere, dumque inter eas erroris tenebras versantur, meticulosi ac veluti obcaecati, penniculo, ut caecus bacillo, ignotas vias et exitus praetentant ac perquirunt. Ergo nunquam, nisi praevio ingenio atque eodem bene erudito, manum ad opus admoveat.

60. Sed cum sit summum pictoris opus historia, in qua quidem omnis rerum copia et elegantia adesse debet, curandum est ut non modo hominem, verum et equum et canem et alia animantia et res omnes visu dignissimas pulchre pingere, quoad per ingenium id liceat, discamus, quo varietas et copia rerum, sine quibus nulla laudatur historia, in nostris rebus minime desideretur. Magnum id quidem atque nulli antiquorum concessum, ut omni in re, non dico praestaret, sed vel mediocriter esset doctus. Tamen omni studio enitendum censeo, ne nobis negligentia nostra ea deficiant, quae et laudem afferunt permagnam si assequantur, et vituperationem si negligantur. Nicias[69] Atheniensis pictor diligentissime pinxit mulieres. At Zeuxim[70] muliebri in corpore pingendo plurimum aliis praestitisse ferunt. Eraclides[71] navibus pingendis claruit. Serapion nequibat hominem pingere, caeteras plane res pulcherrime pingebat. Dionysius nihil nisi hominem poterat.[72] Alexander[73] is qui Pompeii porticum pinxit, quadrupedes omnes, maximeque canes, egregie faciebat. Aurelius, quod semper amaret, solum deas, in earumque simulacris amatos vultus exprimere gaudebat. Phidias in deorum maiestate demonstranda quam in hominum pulchritudine elaborabat. Euphranori[74] dignitatem heroum simulari cordi admodum erat, in eaque caeteros antecelluit. Itaque cuique non aequa facultas affuit. Proprias enim dotes natura singulis ingeniis elargita est, quibus non usque adeo contenti esse debemus, ut quid ultra possimus intentatum relinquamus. Sed et naturae dotes industria, studio atque exercitatione colendae, augendaeque sunt, et praeterea nihil quod ad laudem pertineat, negligentia praetermissum a nobis videri decet.

61. Caeterum cum historiam picturi sumus, prius diutius excogitabimus quonam ordine et quibus modis eam componere pulcherrimum sit. Modulosque in chartis conicientes, tum totam historiam, tum singulas eiusdem historiae partes commentabimur, amicosque omnes in ea re consulemus. Denique omnia apud nos ita

[68] Pliny, *N.H.*, xxxv, 109, attributes this speed to Nicomachus. Probably an oversight of Alberti, as Pliny mentions Asclepiodorus, ibid., 107. [69] Pliny, *N.H.*, xxxv, 129 (Nicias). [70] For Zeuxis, see n. 63. [71] Pliny, ibid., 135 (Eraclides). [72] Ibid., 113 (Serapion, Dionysius). [73] I have failed to identify this Alexander (it has been suggested that Alberti misunderstood Pliny, xxxv, 132, but there is no mention of dogs there). [74] Pliny, xxxv, 119 (Arellius); ibid., 54, and xxxvi, 18–19 (Phidias); xxxv, 128 (Euphranor).

decided in his own mind what he is going to do and how he will do it. It is safer to remove errors with the mind than to erase them from one's work. Besides, when we have acquired the habit of doing everything in orderly fashion, we shall become faster workers by far than Asclepiodorus, who they say was the fastest painter of all. Talent roused and stimulated by practice turns easily and readily to work, and the hand swiftly follows when guided by sure judgement. If there are slow artists, they are so because they try slowly and lingeringly to do something which they have not first thought out clearly in their own minds; as they wander, fearful and virtually sightless, in the darkness of their error, like the blind man with his stick they with their brush test and investigate unknown paths and exits. Therefore he should never put his hand to work without the guidance of well-informed judgement.

60. As the most important part of the painter's work is the 'historia', in which there should be every abundance and beauty of things, we should take care to learn to paint well, as far as our talent allows, not only the human figure but also the horse, the dog and other living creatures, and every other object worthy to be seen. In this way, variety and abundance, without which no 'historia' merits praise, will not be lacking in our works. It is a tremendous gift, and one not granted to any of the ancients, for a man to be, I will not say outstanding, but even moderately learned in everything. Yet I think every effort should be made to see that we do not lack through our own negligence those things which bring high praise if they are achieved, and blame if they are neglected. The Athenian painter Nicias painted women very well; but they say that Zeuxis far excelled all others in painting the female body. Heraclides was famous for painting ships. Serapion was incapable of painting men, but he did all other things splendidly. Dionysius could not do anything but men. The Alexander who painted the portico of Pompeius, was excellent at doing all the quadrupeds and especially dogs. Because he was always in love, Aurelius delighted only in painting goddesses and giving their portraits the faces of his mistresses. Phidias endeavoured to represent the majesty of the gods rather than the beauty of men. The representation of the dignity of illustrious men most pleased Euphranor, and in this he excelled all others. And so each one had a different ability. Nature gave to each mind its own gifts; but we should not be so content with these that we leave unattempted whatever we can do beyond them. The gifts of Nature should be cultivated and increased by industry, study and practice, and nothing which pertains to glory ought to be overlooked and neglected by us.

61. When we are about to paint a 'historia', we will always ponder at some length on the order and the means by which the composition might best be done. We will work out the whole 'historia' and each of its parts by making sketch models on paper, and take advice on it with all our friends. We will endeavour to have everything so well worked out beforehand that there will be nothing in the picture whose exact collocation we do not know perfectly. In order that we may know this with greater certainty,

praemeditata esse elaborabimus, ut nihil in opere futurum sit, quod non optime qua id sit parte locandum intelligamus. Quove id certius teneamus, modulos in parallelos dividere iuvabit, ut in publico opere cuncta, veluti ex privatis commentariis ducta, suis sedibus collocentur. In opere vero perficiendo eam diligentiam adhibebimus quae sit coniuncta celeritati agendi, quam neque taedium a prosequendo deterreat, neque cupiditas perficiendi praecipitet. Interlaxandus interdum negotii labor est recreandusque animus, neque id agendum quod plerique faciunt, ut plura opera assumant, hoc ordiantur, hoc inchoatum atque imperfectum abiciant. Sed quae coeperis opera, ea omni ex parte perfecta reddenda sunt. Cuidam,[75] cum imaginem ostenderet, dicenti: hanc modo pinxi, respondit Apelles: te quidem tacente id sane perspicuum est, quin et miror non plures huiuscemodi abs te esse pictas. Vidi ego aliquos tum pictores atque sculptores, tum rhetores et poetas, si qui nostra aetate aut rhetores aut poetae appellandi sunt, flagranti studio aliquod opus aggredi, qui postea, dum ardor ille ingenii deferbuit, inchoatum ac rude opus deserunt, novaque cupiditate aliud agendi ad novissima sese conferunt. Quos ego homines profecto vitupero. Nam omnes qui sua posteris grata et accepta fore opera cupiunt, multo ante meditari opus oportet, quod multa diligentia perfectum reddant. Siquidem non paucis in rebus ipsa diligentia grata non minus est quam omne ingenium. Sed vitanda est superflua illa, ut ita loquar, superstitio eorum qui, dum omni vitio sua penitus carere et nimis polita esse volunt, prius contritum opus vetustate efficiunt quam absolutum sit. Protogenem[76] soliti erant vituperare antiqui pictores quod nesciret manum a tabula amovere. Merito id quidem, nam conari sane oportet ut pro ingenii viribus quantum sat sit diligentia rebus adhibeatur, sed in omni re plus velle quam vel possis vel deceat, pertinacis est non diligentis.

62. Ergo moderata diligentia rebus adhibenda est, amicique consulendi sunt, quin et in ipso opere exequendo omnes passim spectatores recipiendi et audiendi sunt. Pictoris enim opus multitudini gratum futurum est. Ergo multitudinis censuram et iudicium tum non aspernetur, cum adhuc satisfacere opinionibus liceat. Apellem[77] aiunt post tabulam solitum latitare, quo et visentes liberius dicerent, et ipse honestius vitia sui operis recitantes audiret. Nostros ergo pictores palam et audire saepius et rogare omnes quid sentiant volo, quandoquidem id cum ad caeteras res tum ad gratiam pictori aucupandam valet. Nemo enim est qui non sibi decorum putet suam in alienis laboribus sententiam proferre. Tum minime verendum est ne vituperatorum et invidorum iudicium laudibus pictoris quicquam possit decerpere. Perspicua enim ac celeberrima est pictoris laus, dicacemque testem ipsum bene pictum opus habet. Ergo omnes audiat, secumque ipse rem prius pensitet atque emendet; deinde cum omnes audiverit, peritioribus pareat.

63. Haec habui quae de pictura his commentariis referrem. Ea si eiusmodi sunt ut pictoribus commodum atque utilitatem aliquam afferant, hoc potissimum

[75] Plutarch, *De lib. educ.*, 7. [76] Pliny, xxxv, 80. [77] Ibidem, 84–85.

it will help to divide our models into parallels, so that everything can then be transferred, as it were, from our private papers and put in its correct position in the work for public exhibition. In carrying out our work we will employ the necessary diligence combined with speed, so that tedium does not prevent us from going on, nor eagerness to complete make us rush the job. From time to time we should interrupt our work and refresh our minds, and not do what many do, and take on several works at once, starting on one and setting another on one side unfinished. Whatever works you begin should be completed in every respect. When someone showed him a picture, saying: 'I painted this just now', Apelles replied: 'That is obvious without your saying so; I am only surprised you did not manage several more like it.' I have seen some painters and sculptors, and rhetoricians and poets as well (if in our day and age there are any worth calling rhetoricians or poets), begin some work with great enthusiasm, and then when their ardour cooled, abandon it in a rough and unfinished state, and under impulse to do something different, devote themselves to fresh enterprises. I certainly disapprove of such people. All who wish their works to be pleasing and acceptable to posterity, should first think well about what they are going to do, and then carry it out with great diligence. Indeed diligence is no less welcome than native ability in many things. But one should avoid the excessive scruple of those who, out of desire for their work to be completely free from all defect and highly polished, have it worn out by age before it is finished. The ancient painters used to criticize Protogenes because he could not take his hand off his painting. And rightly so, for we should certainly strive to employ every care needed in our work, as far as our talents permit, but wanting to achieve in every particular more than is possible or suitable is characteristic of a stubborn, not of a diligent man.

62. Therefore, a moderate diligence should be employed. Friends should be consulted, and while the work is in progress, any chance spectators should be welcomed and their opinion heard. The painter's work is intended to please the public. So he will not despise the public's criticism and judgement when he is still in a position to meet their opinion. They say that Apelles used to hide behind his painting, so that the viewers could speak more freely, and he could more decently listen to them enumerating the defects of his work. So I want our painters openly and often to ask and listen to everybody's opinion, since it helps the painter, among other things, to acquire favour. There is no one who does not think it an honour to express his opinion on someone else's work. Nor is there any need to fear that the judgement of censorious and envious critics can in any way detract from the merit of the painter. His fame is open and known to all, and his own good painting is eloquent witness to it. So he should listen to everyone, and first reflect on the matter for himself, making any necessary amendments; then, when he has heard everybody, he should follow the advice of the more expert.

63. This is all I had to say about painting in these books. If it is such as to be of some use and convenience to painters, I would especially ask them as a reward for my

laborum meorum premium exposco ut faciem meam in suis historiis pingant,[78] quo illos memores beneficii et gratos esse ac me artis studiosum fuisse posteris praedicent. Si vero expectationibus eorum minime satisfeci, non tamen quod tantam aggredi rem ausi fuerimus vituperent. Nam si quod laudis est conari id perficere nostrum ingenium nequivit, meminerint tamen solere in maximis rebus laudi esse id voluisse quod difficillimum esset. Aderunt fortasse qui nostra vitia emendent et in hac praestantissima et dignissima re longe magis quam nos possint esse pictoribus adiumento. Quos ego, si qui futuri sunt, etiam atque etiam precor ut hoc munus alacri animo ac prompto suscipiant, in quo et ipsi ingenium exerceant suum et hanc nobilissimam artem excultissimam reddant. Nos tamen hanc palmam praeripuisse ad voluptatem ducimus, quandoquidem primi fuerimus qui hanc artem subtilissimam litteris mandaverimus. Quod quidem sane difficillimum inceptum, si pro expectatione legentium perficere nequivimus, in eo natura magis quam nos inculpanda est, quae hanc legem rebus imposuisse visa est, ut nulla sit ars quae non a mendosis admodum initiis exordium sumpserit. Simul enim ortum atque perfectum nihil esse aiunt.[79] Qui vero nos sequentur, si qui aderunt studio et ingenio quam nos praestantiores, hi fortasse artem picturae perfectam atque absolutam reddent.

[78] A suggestion not, as far as is known, followed by any of his readers.
[79] Cicero, *Brutus*, XVIII, 71: 'Nihil est enim simul et inventum et perfectum'.

labours to paint my portrait in their 'historiae', and thereby proclaim to posterity that I was a student of this art and that they are mindful of and grateful for this favour. If, however, I have not fulfilled their expectations, they should not censure me for having dared to attempt such an important subject. For, if my ability was unequal to completing what was praiseworthy to attempt, they should remember that in matters of great importance the very desire to achieve what was most difficult is usually regarded as worthy of praise. There will probably be some who will correct my mistakes and who will be of far greater assistance to painters than me in this excellent and honourable art. I implore them, should they in future exist, to take up this task eagerly and readily, to exercise their talents on it, and perfect this most noble art. I consider it a great satisfaction to have taken the palm in this subject, as I was the first to write about this most subtle art. If I have not succeeded in accomplishing this undoubtedly difficult task to the satisfaction of the reader, Nature is more to blame than me, as she imposed the law that no art exists that did not begin from faulty origins. Nothing, they say, was born perfect. If they are superior to me in ability and application, my successors will probably make the art of painting complete and perfect.

Notes to De Pictura

References to the text of *De pictura* are to paragraphs.

Full details of works referred to in the notes may be found in the preceding bibliographies, pp. 4–5 and 27–29.

Letters

The dedicatory letter to Brunelleschi is found in only one MS (II. IV. 38 of the Bibl. Naz., Florence), where it precedes the Italian version of *De pictura* (dated 1436) done by the author for the famous architect. It is included here, and translated into English, because of its obvious historical and artistic importance, and in particular to illustrate the significance Alberti attached to his encounter with Florence and her famous artists.

1. On this *topos* see E. H. Gombrich, in *Journal of the Warburg and Courtauld Institutes*, xx, 1/2, 1957, p. 173.

2. The Albertis were exiled from Florence in 1387, and readmitted from 1428. We do not know for certain whether Leon Battista came to Florence before his visit with the papal court from 1434, though this may be inferred from the reference here to Masaccio—if Masaccio did indeed die in 1430, as is commonly supposed. It is just a little difficult to understand in the circumstances why there is no reference made to this sad event. Some have wished to see this as an allusion to Maso di Bartolommeo; but the hypothesis seems unlikely, given the association here with Donatello, Ghiberti (Nencio) and Luca della Robbia.

3. The allusion is to the dome of S. Maria del Fiore, designed and constructed in those years by Brunelleschi.

4. I render thus the Italian phrase 'quale a tuo nome feci in lingua toscana'. For the question of the priority of the Latin version see above, pp. 4–5.

Giovan Francesco Gonzaga, Lord of Mantua (1407–1444). Alberti probably met him in 1438. He later designed several buildings for his son, Ludovico (1444–1478): the choir of SS. Annunziata in Florence, and the churches of S. Andrea and S. Sebastiano in Mantua.

De pictura

Book I

2. Here and in what follows Alberti (like all the medieval writers on optics) owes an obvious debt to Euclid; but his approach to the problems of vision in relation to painting is empirical and in a sense materialistic. On the point and line, and later regarding the importance of distance (not visual angle) in determining the size of objects seen, Alberti is close to Alkindi's optical theories and to the anonymous commentator on Euclid's *Optics* in the Florentine MS discussed by Vescovini, op. cit., ch. III, especially pp. 47 ff., and ch. XI, especially pp. 225 ff.

5. The philosophers referred to are the writers on optics from Euclid onwards, and in particular those medieval Arab thinkers like Alkindi and Alhazen who had challenged and modified the theories of the Greeks. The problem of whether visual rays originate from the eye or from

the objects seen, was resolved by Alhazen in his *De aspectibus*, translated by Witelo into Latin in the 13th century, (contrary to Galen and others) in favour of the operation of luminous bodies upon the eye by light travelling from them in straight lines. Alberti here states the question and claims to leave it open, though it can be inferred immediately from what follows and also from his later discussion of light that he followed Alhazen's explanation.

6. I have kept to a literal translation of the technical term 'quantitas'. The visual triangle is found in Euclid and all later writers on optics. The dispute, referred to and set aside, about the seat of vision on or within the eye, occurs especially among the Arab physiologist-philosophers, especially in Alhazen (cfr. Vescovini, op. cit., ch. VI–VII). In speaking of the angle within the eye in relation to the apparent size of objects, and of the effect of proximity in reducing the area of the surface seen, in this case of a sphere, Alberti would seem to be following Euclid (see *Optica*, Lipsia, 1895, pp. 37 ff.). But the emphasis in Alberti's treatise is upon distance, not upon the visual angle, in relation to size. For the significance of this difference as the basis of linear 'perspectiva artificialis', see E. Panofsky, *La prospettiva*, cit., pp. 42 ff.

7. Euclid's *Optica* speaks of the visual 'cone'. This is more explicitly stated in the so-called 'recensio Theonis' of Euclid (ed. cit., pp. 167 ff.), where it is used as the explanation why rectangles seen at a distance seem round, i.e. the tangential angles are not seen. Arab writers, Alkindi and Alhazen, and later theorists, however, speak of the pyramid. Cfr. also Diog. Laert., VII, 157, cited by Spenser, ed. cit., p. 103 (but Spenser's comment on cone and pyramid is unacceptable). Nicola Oresme (d. 1328) attributed the weakening of light and colour over a distance to the density of the air (*De visione stellarum*, cit. Vescovini, ch. IX, p. 202), which corresponds more closely to Alberti's statement than the passage from Aristotle's *Meteorologica*, cit. by Edgerton, 'Alberti's colour theory', p. 119. Edgerton, ibid., pp. 132 ff., believes Alberti is ambiguous in using the term 'fuscus' in relation to colours seen at a distance. I think he over-complicates the matter by including considerations that were not in Alberti's mind. The term and its meaning are quite clear; for Alberti colour and light are intimately associated, and both diminish (darken) with distance, which as a general principle (and this is all he is enunciating here) is quite valid. It may be considered a limitation that Alberti did not envisage dark brown hills appearing light blue in the distance in certain conditions, but he is not ambiguous in what he does say.

8. Much emphasis is laid on the centric ray by Alhazen, *Optica*, I, 18 (Vescovini, ch. VI, pp. 121 ff.). For painting its importance is crucial, since it is the point on the intersection of the pyramid (i.e. the painting surface) which determines the position of all the others, primarily the height of the horizon and the angle from which the picture is seen and represented. Reception of light will be dealt with at greater length in Bk. II.

9. See Edgerton, 'Alberti's colour theory'. The seven-colour theory is Aristotle's (*De sensu et sensibili*). Alberti sets it aside, but not 'because the philosophers "seemed undecided about the [colour] boundaries" ' (Edgerton, p. 117): this is merely a detail of his description of the pairs 2/3 and 5/6 in relation to 1 and 7. Alberti prefers his own view of four colours corresponding to the elements, which, as Edgerton says, probably derives from Galen; and despite its inadequacy as a theory, it does at least indicate a greater approximation to observed colours in Nature, the object of the painter's imitation. Yet his attention is focussed, rather than on theories, on the practical implications of the wide range of colours produced by mixing, and the infinite

grading of these by addition of white or black (light or shade). It is in this precise context we must read the passage about the colour of the sky, which Edgerton assumes to be an observation on atmospheric perspective: 'he was only pointing out that the blue sky increases in blackness or dark-blueness towards the top and in whiteness towards the bottom' (p. 128). I see it as a far more bland statement (and have translated accordingly): when there is white mist on the horizon, the sky looks pale; when the mist disperses, the sky appears blue again. No need to add anything to the text to interpret it, nor to imagine any implied scientific explanation, as it is merely an instance in Nature, among three others, of how the addition of white changes colours.

11. These are merely preliminary technical observations on light, shadow and reflection, including colour. The pictorial implications are discussed later on, in Bk. II, under reception of light (§§46 ff.). At this point in the Italian version is a first reference to the 'miracula picturae', of which Alberti speaks in §19 (see relevant note below).

12–17. These are the central paras for the understanding of Alberti's perspective and perspectival construction in painting. Some explanation of his terminology is necessary. He uses the term 'equidistant' here with reference to objects and surfaces which are in a plane at right angles to the observer's view, i.e. parallel to his painting surface; and 'collinear' for those that are in line with the visual rays to the eye. His rather over-complicated explanation of proportional triangles (§§13–14) is aimed at showing how all equidistant quantities in the field of vision will have the same proportional size at the intersection of the visual pyramid, as the following figure illustrates. The problems arise with non-equidistant quantities, or with col-

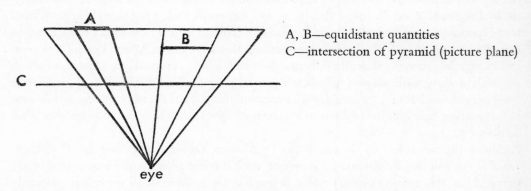

A, B—equidistant quantities
C—intersection of pyramid (picture plane)

eye

linear quantities. The latter, Alberti says, make no triangle, and therefore have no room at the intersection; so, for example, the side of a wall in line with the visual rays is not seen or represented, as strictly speaking it has no 'quantity' at all; one might perhaps see the line of the corner or the end of the wall which has thickness (in which case this may be an equidistant quantity; see next fig.). It will only emerge later that lines *parallel to the spectator's vision* will appear to converge towards the centric point, e.g. like train lines going off into the distance. It is important to avoid confusion between the mathematics of vision in space and the practical transfer to the *plane* surface of data so observed. Alberti does not altogether succeed in doing this himself, and he is aware of the complications (§16). A prime example is the woolliness of §17, where he uses 'equidistant' in relation to quantities, not parallel to the picture plane, but equidistant,

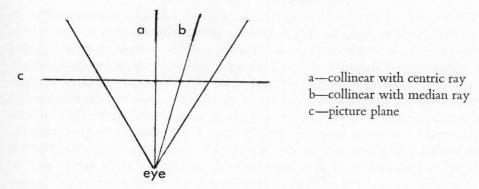

a—collinear with centric ray
b—collinear with median ray
c—picture plane

as he puts it, from some visual rays, as e.g. in the following figure. Such quantities are certainly

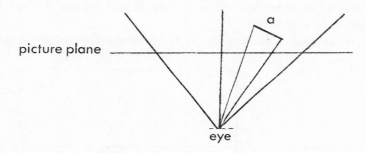

non-equidistant in the earlier sense of the term, and they cease in fact immediately to be equidistant even in the new sense when he speaks of the increase in the greater angle of the base of the triangle. Allowing for this, we have the following type of situation. In his discussion

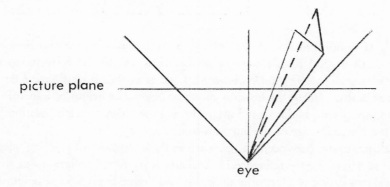

of the application of this visual geometry to painting in §§19–20, the problem of executing these non-equidistant quantities in practice is not dealt with.

19. For the illustration and elucidation of the processes of construction here described see the bibliographical items on perspective of Panofsky, Parronchi, Edgerton, Grayson (also ch. 1 in Gadol). I leave untranslated the term 'braccio', which in Florence was a measure of just

under 23 inches. The sentence immediately after the division of the base line has given inter-preters considerable difficulty, but there is nothing wrong with the text. In earlier paras Alberti has explained at length the similarity of triangles to show the proportional relation between quantities seen and the space they will occupy at the intersection of the visual pyramid. Here he is merely reaffirming this principle, as the base of his rectangle is in effect that same intersection,—with the added qualification that, by virtue of the division of this base line into 'braccia' (proportional to the size of a man's body), he has established the further relation with human proportion. This seems borne out by the pattern of his statements. First he divides the height of his figure into 'braccia': this is proportional to real human measurement (and it will ultimately establish relatively all proportions in the painting); then he divides the base line into these same 'braccia', and this is proportional to the equidistant quantities seen 'through the window' of the painting. He has unnecessarily (for us) complicated the matter by speaking of the 'next' equidistant quantity; he could have said all. He certainly means within and 'beyond' the picture area, as he speaks of the 'pavement' (and also later in §20, where he writes of the 'parallels of the pavement').

The procedure described in this para may be represented as follows. The dotted lines repre-

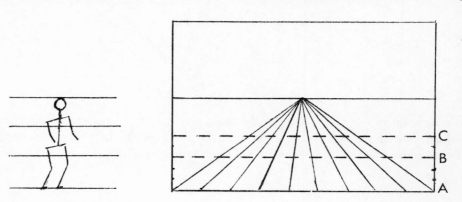

sent the rule-of-thumb practice of establishing the recession of equidistant lines criticized by Alberti. In mathematical terminology 'superbipartiens' means the relationship of 3:5 (cfr. Boethius, De inst. arithm., I, 28; De inst. mus., I, 4), as in the above figure AB:AC. Alberti rightly observes that placing the horizon above or below the height of a man in the picture would upset this system, as this would mean altering the viewer's height relationship with the pavement and hence the size of the intervals seen.

In the Italian version there occurs a reference to these 'miracles of painting' also in §11 (see note). Here in §19 (the only reference in the Latin text) Alberti relates them to the correct mathematical correlation of objects in a painting established from a fixed point of view. The 'demonstrations' are described in some detail in the anonymous life of Alberti (in Opere volgari, ed. Bonucci, vol. I, pp. CII–CIII), though their precise technical character has not been clarified. The description suggests they involved some form of 'camera obscura' ('Scripsit libellos de pictura, tum et opera ex ipsa arte pingendi effecit inaudita, et spectatoribus incredi-bilia, quae quidem parva in capsa conclusa pusillum per foramen ostenderet'), in which life-

like scenes were visible. The association of these demonstrations with reflection in §11 of the Italian text, and indeed the whole of Alberti's theory of optics applied to painting, suggest the use of mirrors. There is, therefore, a certain resemblance to Brunelleschi's experiments described by Manetti, for these consisted in looking from behind through a hole in a painted panel at the image in a mirror held in front of it. Whatever the detail of Alberti's 'demonstrations', it seems feasible to suppose that his mathematical representation of three-dimensional objects in space on a two-dimensional painting surface derives from experiments with mirrors, which precisely perform this sort of function. It is noteworthy that he ascribes the invention of painting to Narcissus (see §26), and also recommends the mirror as a test for effects of relief and beauty in painting (see §46). See also note to §23; and cfr. Pirenne, *Optics, painting and photography*, p. 11, n. 1.

20. This para, which contains Alberti's own method for establishing the correct recession of equidistant transverse quantities, has been much discussed in recent years. Since the restoration to the text of the words 'directly over one end of it' (line 7), most of the difficulties have been removed (cfr. my art. in *Ital. Studies*, XIX, 1964); some still remain, but may, I think, be solved. For example, there seems no doubt whatever that the construction of the 'profile' of the plane was carried out by Alberti on a drawing surface (an 'areola') quite separate from the painting surface and not necessarily of smaller dimensions. Considerable misunderstanding has been caused by the fact that at this point the Italian version reads 'uno picciolo spazio' (for 'areola'). The proper corrective lies further on in §34 where Alberti again uses the 'areola' (this time

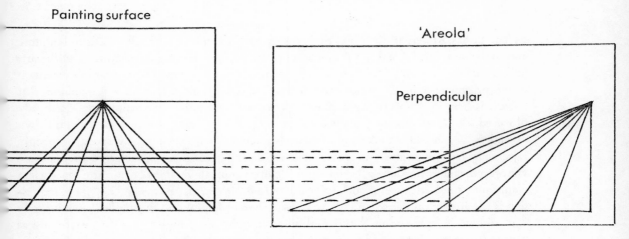

rendered in the corresponding Italian merely as 'lo spazzo') which is undoubtedly separate from and larger than the painting surface. This disposes of the problem of size and clearly points to a drawing board for rough preparatory work, from which the results were transferred to the painting. Some scholars believe that the placing of the point over one end of the line prejudices the issue of the distance of the viewer. But it should be pointed out that Alberti does *not* say he draws a line on his drawing board the *same length* as his picture base line: he simply draws a line and divides it into similar divisions ('braccia'), and as we now know his 'areola' was not really small, there is no difficulty in imagining this line as of greater length than the base line.

The establishing of the distance and the dropping of the perpendicular at that point follow logically (and not arbitrarily, nor through the centric point of the picture plane); and the points of intersection indicate the relative distances (the 'terminos') of the receding transverse quantities. There is no difficulty in supposing the transfer of these to the painting surface behind the phrase: 'Quo pacto omnes pavimenti parallelos descriptos habeo'. The sentence is in any event elliptical and ambiguous in its tense: he has up to this point drawn no parallels at all. The operations described in this para may be represented by the figures on p. 113.

21. I take the use of 'prisci', 'maiores nostri', and 'antiqui' in this para to refer to the medieval Italian tradition, rather than to classical antiquity.

23. For comment on Alberti's perspective and the 'geometrical explanations' here referred to, see Spenser's long note, ed. cit., pp. 113–116, where he relates Alberti's procedures to the practice of surveying with an instrument similar to that used in his *Descriptio Urbis Romae* (which was not, however, written at that time, but some years later; see Introduction, pp. 18, 29–30, and cfr. Gadol, op. cit., pp. 70 ff. for a development of Spenser's ideas). There are many points of contact between Alberti's perspective and his surveying methods (also in *Ludi Matematici* and *De re aedificatoria*), though it remains problematical which activity inspired the other. For the identification of the 'geometrical explanations' with Alberti's short and essentially geometrical *Elementa picturae*, see Parronchi's article in *Cronache di Archeologia e Storia dell'arte*, 6, 1967.

Book II

25–26. In §25 Alberti at times uses the term 'pictura' to embrace the related arts of sculpture and modelling, but he makes a distinction in §26 to place painting as mistress of all the arts (cfr. end of §27 and §58). Mallè, ed. cit., p. 77, note, draws attention to Leonardo's extension of this preeminence in his *Trattato sulla Pittura*, and rightly rejects Janitschek's contention that Alberti is here in deliberate opposition to Vitruvius's exaltation of architecture. As already observed, the Narcissus story applied to the origins of painting seems to be Alberti's own invention. We should not take him too seriously about this as a theory (he very soon explicitly rejects enquiry into origins); more important are the implications for the object of art. For some views on the interpretation of the sentence: 'Quid est enim aliud pingere quam arte superficiem illam fontis amplecti?', see Michel, *La pensée de L. B. Alberti*, cit., p. 428 and note. The expression is admittedly imprecise (and I have translated accordingly), but the implied sense is surely that painting is representing Nature faithfully through artistic means on a flat surface, just as Nature (Narcissus) is reflected truly in the flat mirror of the pool. In this sense the painter is, as it were, an imitator of reflections, and holds a mirror up to Nature. See note to §19, and Introduction to *De statua*, p. 18.

28. Alberti here mentions in passing the 'images made by chance in Nature', and without thinking of them as the possible origins of artistic reproduction. Cfr. previous note, and *De statua* §1; also Introduction to *De statua*, pp. 18ff. Note reference in this para to Alberti's own activities as a painter, and see Appendix, pp. 143ff.

31–32. *Circumscriptio* is the equivalent of drawing the outline of a shadow, indicating the space area occupied by any given object (see *De statua* §13). *Compositio* concerns the relation-

ship of surfaces within that outline, and *receptio luminis* the incidence of light and shade on those surfaces. This triple division presupposes the basic instruction of Bk. I and the drawing of the pavement, to which Alberti will return in §33. Regarding the 'velum' and Alberti's claim to have invented it, there seems to be evidence for the use of some kind of grid in painting two centuries before Alberti. Whatever function this performed, it could not be the same as that of Alberti's net, which is essentially bound up with his theory of vision and perspective in painting. From his time onwards it was much used by artists all over Europe and appeared as a device in standard drawing books (see Mallè, ed. cit., p. 83 note, and Gadol, op. cit., p. 121). Its value to the painter is especially emphasized by Alberti for the rendering of objects that are in relief, or round or concave, which he envisages as capable of being broken down into facets or lesser planes according to the incidence of light and shade.

33. The procedure for drawing walls and buildings is simpler than Alberti makes it seem. It is based on the proportional 'braccia' of the checker-board pavement described in Bk. I, which make it easy to draw the length and breadth of buildings at their foot wherever they stand on the pavement. They also make it possible, though perhaps less obviously, to draw the height of these buildings in similarly correct relationship, since in the particular case where the centric line (horizon) is placed at the height of the man in the picture, the distance from any transversal to the horizon line will everywhere be proportional to three 'braccia'. Hence in the foreground as in the background a twelve 'braccia' high wall will rise from the pavement at any point four times the distance from that point to the horizon line, as in the following figure. Where necessary for greater detail, Alberti divides the 'parallels' (meaning quadrangles) of the pavement by using intersecting diameters, as at AB/CD.

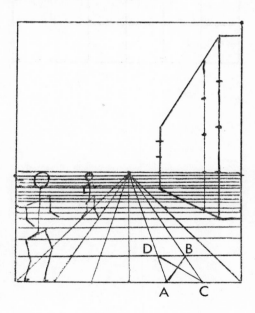

34. For the meaning of the term 'areola' (here translated as 'drawing board') see note to §20 above. The procedure here described is as follows. For convenience of demonstration I show the 'areola' immediately below the painting surface.

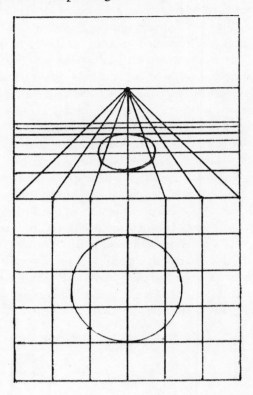

DE STATUA : ON SCULPTURE

Leo Baptista Albertus Iohanni Andreae episcopo Aleriensi salutem plurimam dicit

MEA tibi placuisse opuscula, id quod *De pictura* et id quod *De elementis picturae* inscribitur, vehementer gaudeo. Iudicio enim probari tuo ad fructum laborum meorum deputo, idque praesertim quod, etsi me ames, tamen hoc scio non amore magis te quam integerrimi doctissimi viri officio solere in huiusmodi atque in caeteris omnibus rebus proferre quid censeas. Tertium hoc item opusculum, quod non magis ad pictorem quam ex multa parte ad architecti ingenium pertineat, spero futurum ut legas cum voluptate. Colossum enim qua ratione notis et certis dimensionibus possis astruere disquirit atque demonstrat. Peto a te, censoria tua circa litteras gravitate et diligentia, siquid offenderis quod minus probes, liberrime id ad arbitrium emendes, immutes, demum oblitteres. Nemo est omnium hac aetate cui mea aeque atque tibi esse non ingrata cupiam. Praeterea quae scribimus, ea nos non nobis sed humanitati scribimus, cui tu et ductor meus et coadiutor, siquid attuleris, facies quod te deceat. Vale.

To Giovanni Andrea Bishop of Aleria

Greetings.

I AM delighted that you liked my works *On painting* and *On the elements of painting*. I consider it of great benefit to my labours to have the approval of your judgement, especially since, though you love me, I know that in these and all other matters you are accustomed to giving your opinion no less as a very learned and sincere man than as a friend. I hope that you will read with pleasure this third work, which concerns the painter as well as in many ways also the skill of the architect, for it enquires into and shows how one may construct a colossus from certain known measurements. I would ask you to give me your serious and careful opinion about my writing, and if you come across anything you do not approve, freely to correct, alter or indeed delete as you please. There is no living person I would have my writings please as much as you. Besides, we write what we do, not for ourselves but for all men. Whatever you, my guide and helper, add to it, will make it worthy of yourself. Farewell.

De Statua

1. Artes eorum, qui ex corporibus a natura procreatis effigies et simulacra suum in opus promere aggrediuntur, ortas hinc fuisse arbitror. Nam ex trunco glebave et huiusmodi mutis corporibus fortassis aliquando intuebantur lineamenta nonnulla, quibus paululum immutatis persimile quidpiam veris naturae vultibus redderetur. Coepere id igitur animo advertentes atque adnotantes adhibita diligentia tentare conarique possentne illic adiungere adimereve atque perfinire quod ad veram simulacri speciem comprehendendam absolvendamque deesse videretur. Ergo quantum res ipsa admonebat lineas superficiesque istic emendando expoliendoque institutum adsecuti sunt, non id quidem sine voluptate. Hinc nimirum studia hominum similibus efficiendis in dies exercuere quoad etiam ubi nulla inchoatarum similitudinum adiumenta in praestita materia intuerentur, ex ea tamen quam collibuisset effigiem exprimerent.

2. Sed via alii alia non eadem id omnes assequi didicere. Namque hi quidem cum additamentis tum ademptionibus veluti qui cera et creta quos Graeci πλαστικούς (plasticos), nostri fictores appellant, institutum perficere opus prosecuti sunt. Alii solum detrahentes veluti qui superflua discutiendo quaesitam hominis figuram intra marmoris glebam inditam atque absconditam producunt in lucem. Hos quidem sculptores appellamus, quibus fortassis cognati sunt qui sigillo interlitescentis vultus lineamenta excavationibus eruunt. Tertium genus eorum est qui solum addendo operantur, quales argentarii sunt, qui aera procudentes malleo atque extendentes amplitudini formae continuo aliquid adiciunt, quoad quam velis effigiem produxerint. Erunt qui forte istic addendos censeant pictores, ea re quod colorum appositionibus utantur. Sed si cogites, eos intelliges, non tantum addendo aut diminuendo, quam suo quodam alio et proprio artificio eniti, ut quae sub aspectu posita intueantur, corporum lineamenta et lumina imitentur. Verum de pictore alibi. Hi quidem quos recensui, manu tametsi varia, omnes tamen una tendunt eo, ut quae inchoarint opera, quoad in se sit, veris naturae corporibus persimillima esse intuentibus appareant. Quam rem quidem apud nos si recta et nota peterent ratione et via, procul dubio minus et iterum minus errarent assequerenturque ut eorum opera omni ex parte probarentur.

3. Quid censes? Habebuntne fabri tignarii normam, perpendiculum, lineam, libellam, circulum, quibus directoribus et moderatoribus angulos, extensiones, coaequationesque diffinientes et terminantes opus erroribus immune perquam commodissime exequantur? Statuarius vero tam praeclara, tam admirabilia efficiet opera casu magis quam certo constantique ductu rationis? Sic statuo: cuiusque artis et disciplinae adsunt natura principia quaedam et prospectiones et secutiones, quae qui adhibita diligentia adverterit sibique adsumpserit, rem ex instituto pulcherrime

On Sculpture

1. I believe that the arts of those who attempt to create images and likenesses from bodies produced by Nature, originated in the following way. They probably occasionally observed in a tree-trunk or clod of earth and other similar inanimate objects certain outlines in which, with slight alterations, something very similar to the real faces of Nature was represented. They began, therefore, by diligently observing and studying such things, to try to see whether they could not add, take away or otherwise supply whatever seemed lacking to effect and complete the true likeness. So by correcting and refining the lines and surfaces as the particular object required, they achieved their intention and at the same time experienced pleasure in doing so. Not surprisingly man's studies in creating likenesses eventually arrived at the stage where, even when they found no assistance of half-formed images in the material to hand, they were still able to make the likeness they wished.

2. But not all learned to do this in the same way. Some proceeded by adding and taking away, such as those who worked in wax or clay, whom the Greeks call *plasticous* and the Romans *fictores* (modellers); others merely by taking away, like those who by removing the superfluous reveal the figure of the man they want which was hidden within a block of marble. We call these sculptors, and might regard as related to them those who on seals extract the features of a hidden face by excision. The third kind are those who work solely by addition, like the silversmiths who by hammering metal and spreading it out add continually to its shape until they have produced the figure you want. Some might think that painters should be included here because they work by the application of colours. But if you think about it, you will see that they strive to imitate the forms and colours of objects they see before them, not so much by adding or taking away, as by another method peculiar to themselves. But this is not the place to talk of the painter. Those whom I have mentioned all aim, though by different skills, at the same goal, namely that as nearly as possible the work they have undertaken shall appear to the observer to be similar to the real objects of Nature. If they sought this objective through correct and known methods, I believe there is no doubt they would make fewer and fewer mistakes and gain complete approval for their works.

3. I ask you: shall carpenters have set-square, plumb-line, level and circle, with whose direction and guidance they can easily make the angles, and straight and even lines and surfaces, that define and finish their work with complete accuracy, while on the other hand the sculptor is expected to execute his excellent and admirable works by rule of thumb rather than with the constant and reliable guide of rational principle? For my part I believe that every art and discipline contains by nature certain principles and procedures, and whoever applies himself to recognizing and learning them may perfectly accomplish whatever he sets out to do. For just as in a tree-trunk or clod of earth

consequetur. Quemadmodum enim praestitit natura ex trunco, uti diximus, glebave, ut fieri aliquid posse a te suis operibus simile sentires, ita ab eadem ipsa natura existit promptum habileque aliquid, quo tu quidem modum mediaque habeas certa et rata, quibus ubi intenderis facile possis aptissime atque accommodatissime summum istius artificii decus attingere. Qualia autem statuariis a natura praestentur media commoda et pernecessaria ad opus bellissime perficiendum, exponendum est.

4. Quando igitur similitudines sectantur, a similitudine ipsa ordiendum est. Possem hic de similitudinum ratione disquirere quid ita sit quod ex natura videmus eam quidem in quovis animante perpetuo solitam observare, ut eorum quodque sui generis quibusque persimillimum sit. Alia ex parte, ut aiunt, vox voci, nasus naso, et eiusmodi, in toto civium numero similis reliquorum nullus invenietur. Adde ut vultus eorum quos pueros videramus, subinde factos adolescentes cognovimus, et quos eosdem iuvenes videris, nunc factos senes etiam dignoscas, cum tanta per aetatem eos inter vultus secuta in dies lineamentorum sit diversitas; ut statuisse possimus in ipsis formis corporum haberi nonnulla quae momentis temporum varientur, aliquid vero insitum atque innatum penitus adesse quod perpetuo ad similitudinem generis constans atque immutabile perseveret. Quas res hic sequi longum et fortassis ab re esset. Nos igitur, caeteris omissis, solum quod ad coeptam explicationem faciat brevissime transigamus.

5. Captandae similitudinis ratio apud statuarios, si recte interpretor, destinationibus dirigitur duabus, quarum altera est ut tandem quale peregerit simulacrum animali huic, puta homini, persimillimum sit; Socratis an Platonis an cogniti alicuius effigiem ut referant, id minimae curae est, satis quidem se fecisse statuentes si assecuti sint, ut quod effecerint opus homini vel ignotissimo assimiletur. Altera eorum est qui non tantum hominem, verum huius istius, puta Caesaris Catonisve, hunc in modum, hoc habitu, sedentis pro tribunali aut concionantis, aut eiusmodi noti alicuius, vultus totamque corporis faciem imitari exprimereque elaborant. His duabus destinationibus, ut rem brevissime explicem, duo sunt quae correspondeant, dimensio et finitio. De his igitur dicendum est, quales sint, et quî veniant usu ad opus perficiendum, si prius quid ea quidem de se praestent, exposuero. Habent enim vim admirabilem prope atque incredibilem. Nam qui ista tenuerit, is quidem ex quo voles corpore lineamenta et partium situs et collocationes ita adnotabit certis et firmissimis consignationibus ut, non dico postridie, sed etiam post magnum annum eodem praecise ipso in loco ipsum id corpus, si adsit, iterato ad arbitrium collocet atque constituat ita ut nulla totius vel minima corporis pars non suo pristino reposita et constituta sit aeris puncto. Veluti si forte intenso digito Mercurii stellam nunc primam aut novam subapparentem lunam ostendens, velis adnotari quo praecise aeris puncto gemma istic digiti tui, aut cubiti angulus, aut quid tale sit, poteris tu quidem hisce nostris adiumentis adeo, ut ne minimus quidem sequatur error, nulla subveniat dubitatio rei quin ita sit. Tum etsi dabitur ut Phidiae fortasse

Nature's suggestions made men feel it possible to create something similar to her products, so in Nature herself there lies to hand something which provides you with a method and certain, exact means whereby you may with application achieve the highest excellence in this art. I will now explain what the convenient and necessary means are that Nature offers to sculptors to execute their work perfectly.

4. Since sculptors pursue likenesses, I must start by discussing likeness. Here I might enquire into the nature of similitude and ask how it is that Nature, as we see, is accustomed to observe in any creature that each is like the rest of its kind; and yet, on the other hand, they say, no voice or nose or similar part resembles any other among all the rest of the people. At the same time, the faces of those we have seen as boys we later recognized as adolescents, and those seen as young men you recognize even now they are old, although with age their features have changed a good deal. So that we can say that there are certain things in the forms of bodies which vary with time, while there is something else deeply embedded and inborn which remains always constant and unchangeable in relation to the species. It would take us a long time and probably far out of our way to pursue these matters here; so we will leave other considerations on one side and attend briefly only to what is relevant to the exposition we began.

5. If I am not mistaken, the sculptors' art of achieving likeness is directed to two ends: one is that the image he makes should resemble this particular creature, say a man. They are not concerned to represent the portrait of Socrates or Plato or some known person, believing they have done enough if they have succeeded in making their work like a man, albeit a completely unknown one. The other end is the one pursued by those who strive to represent and imitate not simply a man, but the face and entire appearance of the body of one particular man, say Caesar or Cato in this attitude and this dress, either seated or speaking in court, or some other known person. To these two ends, to put the matter briefly, there are two things that correspond: *dimensio* and *finitio*. I must therefore speak of these, explain what they are and how they may be used to complete one's work; but first I will set out the advantages they offer, for they have amazing and almost unbelievable powers. The man who possesses them can so record the outlines and the position and arrangement of the parts of any given body in accurate and absolutely reliable written forms that not merely a day later, but even after a whole cycle of the heavens, he can again at will situate and arrange that same body in that very same place in such a way that no part of it, not even the smallest, is not placed exactly in space where it originally stood. For example, if you are pointing with your finger at the rising planet Mercury or at the new moon just appearing, and you wish to record the position of the ring on your finger or the angle of your elbow or such like, you could do it with our instruments so that there would not be the slightest error nor any doubt that this is the way things are. And supposing I covered a statue by Phidias with clay or wax so that it became a thick column, you would then be able to say, with the help and guidance of the means I speak of, that if you drill at

statuam creta aut cera superinducta operuerim, quoad opus id crassa reddatur columna, istorum de quibus loquimur adiumento et directionibus poteris tu quidem hoc affirmare, istic ad tantam altitudinem, si perterebraris, illaesam attinges oculi pupillam, istic vero umbilicum, istic demum poplitem et cuncta eiusmodi; tanta erit hinc apud te linearum angulorumque omnium quid inter se distent aut consentiant explicatissima certitudo. Rursus ex quo velis tu quidem exemplari ductus linearum et ambitum superficierum et partium positionem ita mandabis, non picturae modo sed litteris et commentariis, ut simillimam illius et minorem et tantam et centicubitem, atque adeo ut sic audeam dicere monti Caucaso parem tuis posse, uti aiunt, auspiciis fieri non dubites, modo ad opera tam immania quibus utamur media nobis suppeditent. Et quod magis mirere, huius dimidiam ad Paron insulam, si libuerit, dimidiam vero partem alteram in Lunensibus excides atque perficies ita ut iunctiones et cohaesiones partium omnium cum totius simulacri facie conveniant exemplaribus et correspondeant. Tantarumque rerum cognitio efficiendique ratio tam erit apud te facilis, prompta, certa, expedita, ut nisi qui ex studio et dedita opera velint non obtemperasse, vix possint incidere in errorem. Non tamen is sum, qui fieri artificio posse hoc affirmem, ut universas corporum similitudines atque dissimilitudines penitus imitemur aut teneamus. Namque Herculis quidem vultus in Antaeum innitentis ut omni ex parte simillimos vivo exprimas, aut quibus sit ille quidem differentiis ab eiusdem vultu Herculis pacato atque in Deianiram arridenti dissimilis, ut perscribamus nostri non esse artificii aut ingenii profiteor; sed cum in corporibus quibusque variae sequantur figurae, mutatis membrorum flexionibus et tensionibus situque partium, quoniam et astantis et sedentis et prostrati aut in partem aliquam proni aliter et deinceps aliter corporis lineamenta finiantur, de his nobis tractandum est, quibus ista constanti ratione et via imitemur, quae ut dixi duo sunt, dimensio et finitio. Prius igitur de dimensione. **6.** Est enim dimensio quantitatum certa et constans adnotatio, qua partium, alterius ad alteram inter sese atque singularum ad totam corporis longitudinem habitudo et correspondentia percipitur ad numerumque redigitur. Atque perceptio quidem haec duabus fit rebus, exempeda et normis mobilibus. Exempeda quidem extensiones membrorum, normis autem reliquos membrorum diametros captamus et metimur. Est enim exempeda lignea quaedam regula, gracilis, aeque longa atque tota est proceritas corporis, quod dimetiri velis, a summo capitis vertice ad infimum usque vestigium pedis. Ex quo intelligere convenit pusilli hominis exempedam futuram brevem, maioris vero longiorem. Verum cuiuscumque ea quidem sit proceritas, eam dividimus punctis in partes coaequales sex, quas pedes dicimus; eaque de re a pedum numero imponimus regulae huic nomen exempedae. Rursus istic pedem quemque in partes subdividimus coaequales decem, quas unceolas appellamus. Erit igitur tota hominis longitudo unceolas sui generis LX. Rursus et ipsam unceolam subdivido in pusillas particulas itidem decem coaequales, quae

such and such a height you will there arrive without damage at the pupil of the eye, and at another point the navel or the knee, and so on for all the parts; such will be your complete certainty about the lines and angles and the distances and relations between them. Furthermore, from any given example you will be able to record, not only by drawing but also in words and figures, the direction of the lines, the extent of the surfaces and position of the parts, so that you will have no doubt of your ability to make something like it of the same size or smaller or a hundred cubits large, or even, I would say, as big as Mount Caucasus, provided the material we use were sufficient for such an enormous undertaking. What is more amazing is that, if you liked, you could hew out and make half the statue on the island of Paros and the other half in the Lunigiana, in such a way that the joints and connecting points of all the parts will fit together to make the complete figure and correspond to the models used. You will find the knowledge of these things and the method of using them so easy, clear, accurate and convenient, that it would be difficult for anyone to go wrong, unless they deliberately refused to follow them. Yet I would not go so far as to say it is possible for us by this method to imitate or master completely all the similarities and dissimilarities of bodies. I would say it is not within the power of our art or abilities to explain in detail how you might represent the exact likeness of the face of Hercules in combat with Antaeus, or in what ways it differs from the face of Hercules at rest and smiling at Deianira. But as in all bodies different forms result from changes in the bending and stretching of limbs and the position of the parts, and the lines of the body vary in a man if he is standing, sitting, lying down or leaning over, we must treat of the means which enable us to portray these things with constant method; and, as I have said, these are two: *dimensio* and *finitio*. First then *dimensio*.

6. *Dimensio* is the accurate and constant recording of measurements, whereby the state and correspondence of the parts is observed and numerically represented, one in relation to another and each to the whole length of the body. This observation is carried out with two instruments, the *exempeda* and the movable squares. With the *exempeda* we measure the lengths, and with the squares the other diameters of the limbs. The *exempeda* is a thin wooden ruler as long as the length of the body you wish to measure from the top of the head to the soles of the feet. From this it follows that the *exempeda* for a small man will be short, and for a larger man longer. Whatever the size of the chosen figure, we divide it into six equal parts which we call feet; and this is why we give this ruler its name, *exempeda*, from the number of feet. Then we divide each of these feet into ten equal parts, which we call inches. So the length of a man will be sixty inches of their particular kind. Then I divide each inch into ten small equal parts called minutes. So the *exempeda* will consist of six feet; these will contain six hundred minutes, and each foot will have a hundred of them. We use this *exempeda* as follows. If for example we wish to measure a standing man, we set it up beside him and note for each of the limbs, the height from the sole of the foot, the distance from the next

minuta nuncupantur. Hinc igitur tota exempeda pedibus constabit sex, hi erunt minuta sexcenta, et pedi cuique minuta dabuntur centum. Hac exempeda nos utimur sic. Nam si forte stantem metiri velimus hominem, statuimus hanc iuxta atque adnotamus singulos membrorum terminos, quam alte a vestigio, quam longe altero ab articulo distent, puta ad genu, ad umbilicum, ad iugulum et eiusmodi quot unceolae, quotve minuta sint. Quae res pictoribus sculptoribusque minime negligenda est; mirum enim in modum utilis et penitus necessaria est. Cognitis enim uncearum et minutorum quantitatibus cuiusque membri, habebitur eorum terminatio prompta atque explicatissima, quoad nulli errores admittantur. Neque erit ut arrogantem admonitorem audias dicentem: hoc longum nimis est, hoc autem breve. Ipsa quidem exempeda omnium erit moderatrix certa et veridica. Quod si, quas habeat commoditates exempeda haec, satis pensitaris, non dubito ex te percipies quo pacto et maiore in statua longitudines aeque atque in minore possis constituere. Facturus enim statuam fortassis longam cubitos decem, ad totam istam longitudinem parem habebis regulam ligneam cubitorum aeque decem, distinctam magnis quidem portionibus sex, sed istic aeque ad sui magnitudinem respondentibus atque brevioribus in breviori; parque erit et unceolarum et minutorum quibusque exempedarum usus et ratio. Dimidium enim maximi numeri ad totum illum maximum numerum cuius dimidium est, eadem proportio est, quae dimidii minoris ad totum hunc ipsum minorem et eiusmodi.

7. Itaque talem fecisse oportet exempedam. Venio ad normas; eas facimus sic. Erit enim earum altera ABC duabus constituta regulis, AB quam regulam nos stantem appellamus, et BC quam alteram nos regulam basim dicimus. Istarum regularum magnitudo constituenda est ut cuiusque basis capiat sui generis unceolas non pauciores XV. Sui generis appello unceolas exempedae istius corporis quod adnotaturus sis, quae, uti superius dixi, ex magna exempeda maiores, ex minore minores habebuntur. Hasce igitur unceolas, qualescunque illae quidem veniant ab exempeda, punctis et minutis distinctas ab normae angulo, puta B, incipiens signabis in basi, puta BC, aequales, ut dixi, unceolis praescriptae exempedae. Hanc sic consignatam normam, puta ABC, superponimus alteri parili normae DFG ita ut tota GC linea una ambabus sit linea et basis. Atqui esto, velim puta coronae capitis AKD diametrum metiri, admovebimus ergo normas eo et seducemus reducemusve propius normarum ambarum stantes regulas AB et DF quoad coronae ambitum attingant, basibus normarum una ad rectam lineam mutuo applicatis. Hoc pacto ex punctis contactus, A et D, qui ab stantibus illis regulis normae ad coronam dimetiendam fient, quota sit diameter compertum habebimus. Parique ratione ex unceolis et minutorum numero, quae istac in basi BC consignatae sint, cuiusvis membri crassitudo et latitudo bellissime adnotabitur. Multaque quae ad exempedae normaeque istius usum et commoditates faciant, enarrarem, ni brevitatis gratia praetereunda censerem, praesertim cum sint eiusmodi, ut quivis mediocri praeditus ingenio ex

limb, how many inches or minutes, say, up to the knee, the navel, the collar-bone, and so on. This is something painters and sculptors should take the trouble to know, for it is remarkably useful, and indeed essential. Knowing the size of each limb in inches and minutes, you will have a clear and ready record of their measurement that will eliminate all errors. And you will not hear some arrogant critic complaining this is too long, this too short. This *exempeda* will be a sure and truthful guide in everything. For if you consider well the advantages it offers, I am sure you will see for yourself how you can establish these lengths in a larger statue as well as in a smaller one. If you are to make one, say, ten cubits long, you will have a wooden ruler the same length, of ten cubits, divided into six major parts here proportionate to their own size, just as they would be smaller for a smaller statue; and the method and use of inches and minutes will be the same for any size of *exempeda*. The half of a larger number has the same proportion to the whole of which it is half, as the half of the lesser number to the whole of this lesser number, and so on.

7. So you should make your *exempeda* as I have described. I now come to the squares, which we make as follows. One of them, ABC, will be made up of two rules: AB, which we call the standing rule, and BC we call the base rule. The size of these rules should be such that the base is not less than fifteen inches of its kind long; and I say 'of its kind', meaning inches of the *exempeda* of the body you are to measure, for, as I said above, these will be greater taken from a large *exempeda*, and smaller from a smaller one. Whatever their size as taken from the *exempeda*, you will mark off these inches along the base rule BC, starting from the angle of the square at B, and divide them into minutes; and they will be the same inches as those of the relative *exempeda*. We super-impose this square ABC, marked in this way, on another similar square DFG, so that the line GC constitutes a base common to both. Supposing I wish to measure the diameter of the head AKD, we will apply the squares to it and move the standing rules AB and DF nearer together or further apart until they touch the circumference of the head, with the bases of the squares forming one single straight line together. In this way we will learn what the diameter is from the points of contact A and D, which measure

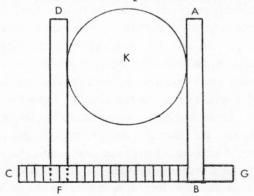

Fig. 1: *Normae*

sese, animum intendens, facile possit advertere et perspicere; veluti si libeat diametri alicuius partem quotam adnotare, puta diametri illius quae a dextera ad sinistram aurem dirigatur, vel non ignorare quo persecet diametrum alteram quae a fronte perducatur ad occiput et eiusmodi. Caeterum his exempedis atque normis artifex, si me audiet, utetur fidissimis et constantissimis consultoribus atque directoribus, non solum ubi opus aggrediatur atque perducat, verum longe ante ita rem sibi comparabit istarum adminiculis, ut nulla vel nimia futuri simulacri pars sit, quin illius omnes extensiones et diametros quales et numero et productionibus sint, perspectum penitusque cognitum et per quam familiare habeat.

8. Quis enim se audeat fabrum navalem profiteri, si et quot sint partes navis, et quid a navi navis differat, et quid cuiusque operis partes inter se conveniant, non tenuerit? At ex nostris statuariis quotus quisque erit, qui si rogetur, quaenam membri istius ratio, quaenam ad illud aut alterius ad hoc, aut istorum ad totam corporis habitudinem proportio sit, uspiam satis notarit aut teneat, uti par est? Suam quemque didicisse artem decet quam profiteatur. Et discuntur artes ratione imprimis et via, proxime agendo comprehenduntur. Et faciet nemo arte quidpiam, cuius partes non didicerit. Sed de his hactenus. Diximus de dimensione, quo pacto exempeda et quo pacto normis recte habeatur. Sequitur ut de finitione dicendum sit. Est enim hic finitio ea, qua linearum productiones et flexiones angulorumque omnium et prominentiarum et retractionum omnium modum et terminationes et situs et collocationes adnotamus vera indubitabilique ratione et perspicua. Dictaque finitio est, quod linearum omnium a medio quodam positi centri perpendiculo ad ultimos corporis terminos productarum prolixitatem extremosque fines adnotet atque perscribat. Inter dimensionem igitur, de qua supra transegimus, et finitionem hoc interest, quod dimensio quidem stabilius quidpiam animantibus a natura insitum communiusque inventum sequitur atque usurpat, uti sunt membrorum longitudines, crassitudines, latitudines. Finitio autem momentaneas membrorum varietates, factas motionibus ex novissimis partium collocationibus, adnotat atque determinat. Ad finitionem hanc recte habendam instrumento opus est; cuius instrumenti partes sunt tres: orizon, radius et perpendiculum. Est enim orizon limbus circuli inscriptus particulis coaequalibus et numeris. Radius vero est linea recta, cuius alterum caput in centro circuli istius perstat, alterum vero caput circumducitur ad arbitrium, ut volens ad omnes orizontis particulas dirigatur. Perpendiculum demum est linea recta, a summo radio pendens orthogonaliter ad usque pavimentum, in quo adnotandum finitionibus exemplar stat. Fitque instrumentum ipsum hoc sic. Tabula sumitur plana, bene levigata. In ea inscribitur circulus, cuius diameter pedes capiet tres. Ambitum circuli istius extremamque circuitionem in partes divido coaequales, similes partibus, quas in astrolabio inscribunt astronomi. Has partes gradus appello. Et particulam quamque istarum subdivido in quotas libuerit, puta sex, minores particulas, quae minuta dicantur. Inscriboque gradibus ex ordine numeros primo 1,

off the circumference on the standing rules of the squares. In the same way the width and thickness of any member can easily be measured from the inches and minutes marked on the base BC. I could recount many things regarding the use and advantages of the *exempeda* and square, if I did not consider it necessary to omit them here for the sake of brevity, especially as they are such that anyone of moderate intelligence, by applying his mind, can easily see and understand them for himself: for example, if you want to measure any diameter, say from the right to the left ear, or find out where it intersects the other diameter from the forehead to the back of the head, and so on. If he will take my advice, the artist will use these *exempedae* and squares as his most faithful and constant guides and touchstones, not only when he begins and continues his work, but he will prepare himself well before with their assistance in such a way that there will not be the slightest part of the figure he is to make whose every length and diameter, both in number and extent, he does not know thoroughly and in every detail.

8. Who would dare to claim to be a shipbuilder, if he did not know how many parts there are in a ship, how one ship differs from another, and how the parts of any construction fit together? Yet among our sculptors how many will there be who, if asked, will have observed and properly understood the structure of any limb, the proportions within it and of other limbs to it, and those of all of them to the form of the whole body? Everyone should have learned the art he professes. Arts are learned first by study of method, then mastered by practice. No one will do anything in an art whose parts he has not learned. But no more for the present on such matters. I spoke about *dimensio* and how it may be properly carried out with *exempeda* and squares. I must now speak of *finitio*. *Finitio* is the means whereby we record with sure and accurate method the extensions and curves of lines, and the size and shape and position of all angles, protuberances and recesses. It is called *finitio* because it registers and describes the length and extremities of all lines produced from a perpendicular dropped through a fixed centre to the outermost parts of the body. There is, therefore, this difference between *dimensio*, which I dealt with above, and *finitio*: *dimensio* follows and governs that which is more stable and fixed by Nature and more commonly found in living creatures, such as lengths, thicknesses and widths of limbs, whereas *finitio* records and determines the variations in limbs from time to time caused by movements and new dispositions of the parts. In order to carry out *finitio* properly an instrument is needed which has three parts: horizon, radius and perpendicular. The horizon is the circumference of a circle inscribed with equal parts and numbers. The radius is a straight line, one end of which is fixed in the centre of that circle, while the other can be rotated at will and made to point at all the divisions of the horizon. The perpendicular is a straight line hanging directly down from the outer end of the radius to the ground on which the example stands whose limits you wish to measure. This instrument is made as follows. You take a smooth flat surface and on it inscribe a circle three feet in diameter. I divide the outer

secundo 2, tertio 3, quarto 4, et deinceps huiusmodi usque omnes suas particulas suis numeris notaro.

9. Hic igitur limbus ita inscriptus orizon nuncupatur. Ad hunc ipsum circulum adiungo radium mobilem. Is fit sic. Capitur regula recta, gracilis, pedes sui generis longa tres. Alterum istius caput affigitur centro sui circuli, ut applicatum haereat; alterum vero caput producitur expeditum et liberum, ut possit circumagi. In hunc ipsum radium adscribo punctis unceolas quot capiat, pares unceolis suae exempedae, de qua supra dictum est. Et itidem unceolas minutis subdivido particulis minoribus atque inter se comparibus his, quae in exempeda sunt; inque singulis unceolis, a centro incipiens, numerum inscribo primo 1, secundo 2, tertio 3 et eiusmodi. Ad radium autem hunc appendo perpendiculum filo tenui cum plumbeolo. Totum hoc instrumentum, quod circuli orizonte et radio et perpendiculo constat, finitorium appello; estque istiusmodi quale hic lineis exscripsimus. Hoc finitorio instrumento sic utimur. Esto, sit exemplar, a quo finitiones sumendae sint, Phidiae statua equum ad bigam sinistra manu continens. Colloco igitur finitorium hunc circulum, ut in statuae caput superne pendeat ex plano quoque undique ad libellam, centro sui praecise in statuae vertice constituto. Verticis autem punctum, supra quod circuli centrum adsideat, adnoto illic infixa acu ex aere. Tum et certo loco primum in orizonte inscriptum gradum versione instrumenti colloco, ut apud me constet quo versus directum sit. Id fit sic. Nam radium quidem, hoc est regulam mobilem in circulo, cui appensum est perpendiculum, diduco eo ut ad primum dirigatur gradum orizontis, et sic constitutum una cum toto circulo orizontis inverto, ut filum ex eo pendens attingat statuae istius primarium aliquod et prae caeteris perspicuum membrum, puta dextrae manus pollicem. Potero hinc adeo, quandocunque libuerit, finitorium hoc tale instrumentum iterum atque iterum ad arbitrium abmovere ab statua rursusque restituere, ut aeque adstet uti prius steterat, hoc est, ut acus ex vertice statuae per centrum finitorii penetrans et perpendiculum a primo gradu orizontis pendens pollicem hunc ipsum attingat manus.

10. His positis et comparatis, esto, volo sinistri cubiti angulum adnotare scripto memoriaeque mandare. Facio igitur sic. Firmo finitorium instrumentum centro sui in statuae exemplaris vertice, positum ad eum ipsum, quem diximus, statum ita ut tabula, in qua inscriptus est orizon, penitus sit immobilis. Radium autem circumduco quoad linea perpendiculi dependens ipsum hunc attingat statuae, quem adnotare velimus, cubitum. Ex hac re sic constituta tria dabuntur, quae faciant ad rem. Primum erit, ut hinc adnotes quam longe nunc distet in orizonte radius a pristino, unde deductus sit, loco. Spectabis igitur quem in orizonte numerum radius ipse instrumenti petat, vigesimum an trigesimum aut eiusmodi. Secundum erit, ut ex particulis in radio consignatis adnotes quot unceolis quotve minutis illa distet perpendicularis a medio circuli centro. Tertium erit ut adstituta et applicata ad filum perpendiculi exempeda adnotes quot unceolis, quot item minutis angulus istic ipsius

edge of this circle into equal parts, like those which astronomers inscribe on astrolabes. I call these parts degrees. Then I subdivide each part into several lesser parts, say six, which are called minutes. I number the degrees in order, 1, 2, 3, 4, and so on until I have marked all the parts with figures.

9. This circle, inscribed in this way, is called the horizon. To this circle I add a movable radius, made as follows. You take a straight thin ruler, three feet long of its kind. One end is fixed to the centre of the circle so that it is firmly attached; the other end is left free so that it can be moved around. On this radius I mark as many inches as it will hold, equal to the inches on the relative *exempeda* of which I spoke above. I also subdivide the inches into lesser parts or minutes equal to those on the *exempeda*; and I number each inch, starting from the centre, 1, 2, 3, and so on. To this radius I append a perpendicular in the form of a fine thread and lead weight. This whole instrument, consisting of horizon, radius and perpendicular, I call a *finitorium*, and it is like the one we have sketched here (see fig. 2, p. 141). We use the *finitorium* in the following way. Supposing we have as our example, from which we are to take the outer measurements, a statue by Phidias holding in the left hand a horse harnessed to a two-wheeled chariot. I put the circle of the *finitorium* with its centre set exactly on the highest point of the statue, so that it rests on the head of the figure in an absolutely horizontal position. I mark the vertex on which the centre of the circle stands, and fix it with a bronze pin. Then by rotating the instrument I place the first degree on the horizon in a certain position so that I can establish its orientation. This is done as follows. I move around the radius (that is, the moveable ruler on the circle to which the perpendicular is attached) until it points at the first degree on the horizon; then in this position I turn it together with the circle of the horizon so that the thread hanging from it touches some principal and conspicuous part of the body, say the thumb of the right hand. In this way I can, whenever I please, take away the *finitorium* from the statue and put it back again so that it is in the position in which it was before, that is, with the pin through the middle of the *finitorium* on the top of the statue and the perpendicular hanging from the first degree of the horizon touching this thumb.

10. Having made these preparations, supposing I wish to measure the angle of the left elbow and put it down in writing. I proceed as follows. I set the *finitorium* with its centre on top of the model, positioned in the way I have described, so that the surface on which the horizon is drawn is completely immobile. I then move the radius round until the thread of the perpendicular hanging from it touches the elbow of the statue we wish to measure. Three things of importance will follow from this placing of the instrument. The first will be that you can tell how far the radius now is from the original position whence it was moved. You will see to what number on the horizon the radius of the instrument points, the twentieth or thirtieth or some such figure. The second will be that you can tell from the divisions marked on the radius how many inches or minutes the perpendicular is from the centre of the circle. The third will be that by

cubiti distet alte a pavimento, quod vestigiis prematur statuae. Adnotatio autem istarum rerum fiet scripta in codicillis hunc in modum: puta cubiti sinistri angulus in orizonte gradus XI, minuta V; in radio gradus VII, minuta III; a pavimento gradus XL, minuta IV. Parique ratione caeteras omnes insignes partes ab exemplari adnotabis, uti sunt, puta genu, spatulaeve angulos et caeteras prominentias et eiusmodi. In retractionibus vero puncta adnotanda si erunt seducta introrsus quoad perpendiculi filum eo adpelli non possit, puta ad retractionem concavi quod inter spatulas in dorso est, tunc id belle fiet si radio aliud quoque adegeris perpendens perpendiculum, quod ipsum ab primario et prius posito perpendiculo quantum lubeat distet. Gemino enim perpendiculo istiusmodi dabitur, ut per ambarum linearum directiones veluti ad planam superficiem applicatus ambasque intersecans lineas stilus et introversus ad statuam productus, axim usque intimam, hoc est perpendentem a centro finitorii intimam lineam, quae medianum perpendiculum dicitur, ex sui directione possit petere.

11. Haec si satis cognita sunt, facile poteris didicisse quo pacto, quod supra commonefecimus, si forte statuam creta ad quotam aliquam crassitudinem circumducta operuerint, possis perterebrando quodcumque velis punctum adnotatum in statua petere via expedita, certa, aptissima. Nam promptum quidem est circumversione radii istius fieri ab linea perpendiculi ut in aere perscribatur curva cylindri superficies, quo cylindro statua istaec concipiatur. Id si ita est, tu quidem qua ratione dum expedita et nulla materia circum illita aut obducta erat statua, pulchre stilo istic aerem penetrando potuisti punctum adnotatum, puta menti prominentiam, petere, eadem poteris ratione ipsum id agere, ubi totus istic aer cylindri in ceram aut cretam converteretur. Ex his etiam, quae recensuimus, dabitur, ut id etiam bellissime possis, quod commonefeceramus, dimidiam quidem statuam in Lunensibus, alteram vero dimidiam volens in Paro perficies. Nam, esto, secetur exemplar statuae Phidiae in partes duas, et sit sectio facta ad planam superficiem, illic puta ubi incingimur, procul dubio finitorii huius nostri instrumenti adminiculis fretus atque adiutus poteris omnia quotcumque puncta adnotare, quae in limbo secantis superficiei adnotanda constitueris. Hoc si posse concesseris, quidni et integro etiam ab exemplari quamcunque tu quidem partem duxeris, recte ad arbitrium perficies? Signabis enim rubrica lineam in exemplari tenuissimam, quae illic sit loco limbi sectionis, ubi sectio ipsa finiretur, statua si esset secta; et punctis illic adnotatis, quae ad opus absolvendum facerent caetera, uti exposuimus, assequere.

12. Demum ex omnibus, quae hactenus recensuimus, satis constare certum est, ab vivo etiam exemplari cum dimensiones tum etiam finitiones captari adnotarique posse percommode, ad opus arte et ratione perficiendum. Hoc opusculum cupio meis pictoribus atque sculptoribus fore familiare, qui si nos audierint congratulabuntur; cum et nos, quo res exemplis clarior haberetur, quove plurimum nostra prodesset opera, hunc nobis suscepimus laborem adnotandarum dimensionum

setting up the *exempeda* beside the thread of the perpendicular you can see how many inches and minutes high the angle of this elbow is from the ground on which the statue stands. The record of these things should be made in writing in the following form: e.g. angle of left elbow, on horizon 11 degrees, 5 minutes; on radius 7 degrees, 3 minutes; from ground 40 degrees, 4 minutes. By the same method you can record particulars of all the other principal parts from the model, for instance the knee or angles of the shoulders and other projections. With recesses, if the points to be recorded are so far in that the thread of the perpendicular cannot be made to reach them,—e.g. the hollow between the shoulder-blades of the back,—then it can easily be done if you add another perpendicular to the radius at whatever distance you please from the first one. With a double perpendicular of this kind it will follow that a stick applied along the direction of these two lines, as it were against a plane surface and intersecting them, and produced towards the inside of the statue, will point directly at the inner axis, that is, the line straight down from the centre of the *finitorium*, which is called the median perpendicular.

11. If you properly understand what we have said, you can easily grasp how, as we have stated above, if they covered some statue in clay to a certain thickness, you can by drilling find any previously recorded point in the statue you wish, easily and accurately. For it is evident that by the rotation of the radius a curved cylindrical surface is described in space by the perpendicular, within which the statue is enclosed. This being so, in the same way as when the statue was free and not covered by a mask of other material you could easily find the recorded point (say the jut of the chin) by passing a stick through the air, so you could do the same thing if the air space of this cylinder were made up instead of clay or wax. By this same means also which we have described, you could, as we said, if you wished, make one half of the statue in the Lunigiana and the other half on Paros. For, supposing the example of the statue by Phidias were cut in two, and the section made at a horizontal plane, say at the waist, there is no doubt that with the assistance of this *finitorium* of ours you could record the position of all the points you wished to locate on the rim of the section. If you agree this is possible, why should you not also accurately make from some complete model whatever part you wish? Mark a thin line in red on the model where the rim of the section would be if the statue were cut in two; register these points at this place, then proceed with the rest of the things needed to complete the work, as we have explained.

12. Finally, from all we have said so far it is quite clear that *dimensiones* and *finitiones* can easily be taken and recorded also from a live model in order to make a figure artistically and methodically. I wish this work of mine to be familiar to my painter and sculptor friends, who will applaud my advice, if they take heed. Furthermore, so that the subject may be clarified by examples and my work most useful to many people, I took on the task of recording the *dimensiones* of man. I proceeded accordingly to measure and record in writing, not simply the beauty found in this or that body, but,

praesertim in homine. Ergo non unius istius aut illius corporis tantum, sed quoad licuit, eximiam a natura pluribus corporibus, quasi ratis portionibus dono distributam, pulchritudinem adnotare et mandare litteris prosecuti sumus, illum imitati qui apud Crotoniates, facturus simulacrum Deae, pluribus a virginibus praestantioribus insignes elegantesque omnes formae pulchritudines delegit, suumque in opus transtulit. Sic nos plurima, quae apud peritos pulcherrima haberentur, corpora delegimus, et a quibusque suas desumpsimus dimensiones, quas postea cum alteras alteris comparassemus, spretis extremorum excessibus, si qua excederent aut excederentur, eas excepimus mediocritates, quas plurium exempedarum consensus comprobasset. Metiti igitur membrorum longitudines, latitudines, crassitudines primarias atque insignes, sic invenimus. Nam fuerunt quidem membrorum longitudines sic.

TABULAE DIMENSIONUM HOMINIS

Altitudines a vestigio	pedes	gradus	minuta
Maxima altitudo ad dorsum pedis	0	3	0
Ad talum exterius	0	2	2
Ad talum interius	0	3	1
Ad rectractionem sub pulpa tibiae interius	0	8	5
Ad rectractionem sub prominentia ossis, quod est sub genu interius	1	4	3
Ad articulum qui est in genu exterius	1	7	0
Ad coleos et idem ad usque sub natibus	2	6	9
Ad os, sub quo pendet penis	3	0	0
Ad nodum coxae, hoc est ischiam	3	1	5
Ad umbilicum	3	6	0
Ad ubi incingimur	3	7	5
Ad mammillas et furculam stomachi	4	3	5
Ad furculam iuguli	5	0	0
Ad nodum colli	5	1	0
Ad mentum	5	2	0
Ad prominentiam sub scapulis posterioribus ad spatulas	4	2	5
Ad foramen auris	5	5	0
Ad summas radices capillorum in fronte	5	9	0
A mento ad summam verticem capitis	0	8	0
A mento ad foramen auris	0	3	0
Ad longissimum digitum manus pendentis	2	3	0
Ad articulum manus pendentis	3	0	0
Ad articulum cubiti brachio pendente	3	8	5
Ad angulum sublimem spatulae	5	1	0

as far as possible, that perfect beauty distributed by Nature, as it were in fixed propor-tions, among many bodies; and in doing this I imitated the artist at Croton who, when making the likeness of a goddess, chose all remarkable and elegant beauties of form from several of the most handsome maidens and translated them into his work. So we too chose many bodies, considered to be the most beautiful by those who know, and took from each and all their *dimensiones*, which we then compared one with another, and leaving out of account the extremes on both sides, we took the mean figures validated by the majority of *exempeda*. By measuring the principal and most important lengths, widths and thicknesses of limbs, we found as follows. The lengths were:

Tables of measurements of man

Heights from the ground	Feet	Degrees	Minutes
Maximum height to top of instep	o	3	o
To the outer ankle bone	o	2	2
To the inner ankle bone	o	3	1
To the recess below the fleshy part of the inside lower leg	o	8	5
To the recess beneath the projecting bone below the inside of the knee	1	4	3
To the joint of the outer knee	1	7	o
To the testicles, and also to the base of the buttocks	2	6	9
To the bone below which hangs the penis	3	o	o
To the hip joint	3	1	5
To the navel	3	6	o
To the waist	3	7	5
To the nipples and fork of the stomach	4	3	5
To the fork of the throat	5	o	o
To the node of the neck	5	1	o
To the chin	5	2	o
To where the bottom of the shoulder blades protrude behind	4	2	5
To the hole of the ear	5	5	o
To the roots of the hair on the forehead	5	9	o
To the top of the head from the chin	o	8	o
To the hole of the ear from the chin	o	3	o
To the middle finger of the hand hanging down	2	3	o
To the wrist	3	o	o
To the elbow joint with the arm hanging down	3	8	5
To the point of the shoulder	5	1	o

	pedes	gradus	minuta
Sedentis a vestigio ad summum in genu	–	–	–
Ab angulo ex genu sedentis ad extremas nates	–	–	–
Ab angulo cubiti plicato brachio ad articulum manus	–	–	–

Latitudines sunt quae a dextris ad sinistram metiuntur.

	pedes	gradus	minuta
Maxima igitur vestigii latitudo	o	4	2
Maxima vestigii latitudo in calcaneo	o	2	3
Maxima latitudo inter prominentias talorum	o	2	4
Retractio tibiae supra talos	o	1	5
Retractio in medio tibiae sub musculo	o	2	5
Maxima prominentia ad musculum tibiae	o	3	5
Retractio sub prominentia ossis ad genu	o	2	5
Maxima prominentia ossis ad genu	o	4	o
Retractio coxae supra genu	o	3	5
Maxima latitudo ad medium coxae	o	5	5
Maxima prominentia inter articulos ischiae	1	1	o
Maxima latitudo inter ambo latera supra ischiam	1	o	o
Latitudo ubi incingimur	o	9	o
Maxima amplitudo in pectore sub asellis	1	1	5
Maxima latitudo inter angulos scapularum	1	5	o
Maxima latitudo inter mammillas	o	7	o
Latitudo colli	o	3	5
Latitudo inter genas	o	4	8
Latitudo manus in vola	–	–	–

Brachii latitudines et crassitudines motibus
inconstantes sunt. Eas tamen fere tales esse
adnotavimus:

	pedes	gradus	minuta
Brachii latitudo ad articulum manus	o	2	3
Et latitudo ad musculum et cubitum	o	3	2
Et latitudo ad musculum sub umbone superiorem	o	4	o

Crassitudines sunt quae ab anterioribus ad posteriora eunt.

	pedes	gradus	minuta
Vestigii longitudo a pollice ad calcaneum	1	o	o
Crassitudo a collo pedis ad angulum calcanei	o	4	3
Retractio supra collum pedis	o	3	o
Retractio sub musculo ad medium tibiae	o	3	6
Ubi prominet musculus tibiae	o	4	o
Ubi prominet patella in genu	o	4	o
Crassitudo maxima in coxa	o	6	o
A pene ad prominentias in natibus	o	7	5

	Feet	Degrees	Minutes
From the ground to the top of the knee of a sitting man	–	–	–
From the bend of the knee of a sitting man to the back of the buttocks	–	–	–
From the bend of the elbow to the wrist with the arm bent	–	–	–
Widths are measurements from right to left			
Maximum width of foot	0	4	2
Maximum width of foot at heel	0	2	3
Maximum width between ankle bones	0	2	4
Where the leg narrows above the ankles	0	1	5
At mid-calf below the muscle	0	2	5
At widest point of calf muscle	0	3	5
The narrow part below the knee bone	0	2	5
Maximum width at knee bone	0	4	0
Width of thigh above knee	0	3	5
Maximum width at mid-thigh	0	5	5
Maximum width between hip joints	1	1	0
Maximum width between sides above hips	1	0	0
Width at waist	0	9	0
Maximum width of chest beneath armpits	1	1	5
Maximum width between point of shoulders	1	5	0
Maximum width between nipples	0	7	0
Width of neck	0	3	5
Width between cheek bones	0	4	8
Width of palm of hand	–	–	–
The widths and thicknesses of the arm vary according to movement. But for the most part we found them as follows:			
Width of the arm at the wrist	0	2	3
Width at the muscle and elbow	0	3	2
Width at the muscle of upper arm below the deltoid	0	4	0
Thicknesses are measurements from front to back.			
Length of foot from big toe to heel	1	0	0
Thickness from top of foot to point of heel	0	4	3
The narrower part above the top of the foot	0	3	0
Idem below the muscle at mid-calf	0	3	6
Where the calf muscle is widest	0	4	0
At the knee cap	0	4	0
The thickest part of the thigh	0	6	0
From the penis to the buttocks	0	7	5

10

	pedes	gradus	minuta
Ab umbilico ad renes	o	7	o
Ubi incingimur	o	6	5
A mammis ad prominentias dorsi	o	7	5
Ab iugulo ad nodum colli	o	4	o
A fronte ad occiput	o	6	4
A fronte ad foramen auris	–	–	–
Crassitudo maxima manus	–	–	–
Brachii crassitudo ad articulum manus	–	–	–
Et crassitudo ad musculum sub cubito	–	–	–
Et crassitudo ad musculum sub umbone	–	–	–
Umbonis crassitudo	o	3	o

13. Ex his promptum erit, singulas membrorum relationes ad totam corporis proceritatem atque alterius ad alteram inter se proportiones prospexisse, quales sint, quid conveniant, quid differant; quam rem habendam censeo, plurimum enim iuvabit. Tum et multa possent recenseri, quae variantur in homine aut sedente aut alteram in partem prono, sed ea nos artificum diligentiae solertiaeque relinquimus. Ossium vero numerum, musculorumque atque nervorum prominentias non ignorasse ad rem vehementer conferet. (Tum etiam novisse vehementer conferet qua ratione a sectionibus corporis adnotemus limbos. Nam veluti si quis stantem cilindrum ita sectet ut eius pars altera, quam intuens videas, a parte altera, quam eodem prospectu non videas, dividatur, fient nimirum isto ex cilindro gemina corpora, quorum maxime basis aequalis inter sese uniformisque constabit, circumsepta lineis et circulis quattuor; similis in sectionibus corporis de quibus loquimur adnotatio est. Praescriptio enim eius lineae, ad quam conterminetur, et qua dividatur superficies haec quae istinc sub isto prospectu videatur ab altera quae post hanc istius interpositionem non videatur; quae quidem linearum praescriptio, si in pariete quali oporteat ratione adnotetur, persimilem refert figuram ei quam illic compleret umbra reddita ex interceptione luminis si adstaret illuminans eodem ipso aeris puncto quo et prius spectantis exstiterat oculus. Sed huiusmodi sectionis et limbi adnotandorum ratio magis ad pictorem pertinet quam ad sculptorem.) Sed de his alibi. Tum quantum maxima cuiusque membri prominentiave rectractiove ab certa linearum positione distet annotasse in primis ad istius artis professorem pertinet.

	Feet	Degrees	Minutes
From the navel to the kidneys	0	7	0
At the waist	0	6	5
From the breasts to the back	0	7	5
From the throat to the node of the neck	0	4	0
From the forehead to the back of the head	0	6	4
From the forehead to the hole of the ear	–	–	–
Maximum thickness of the hand	–	–	–
Thickness of the arm at the wrist	–	–	–
At the muscle below the elbow	–	–	–
At the muscle below the deltoid	–	–	–
Thickness of the deltoid	0	3	0

13. From these you will see the relations of each of the limbs to the whole length of the body, and the proportion each limb bears to another, what they are and how they agree and differ. I believe this is worth knowing, for it will be of great help. Many other particulars could be gone into, which vary in a man if he is seated or leaning to one side, but we will leave these to the diligence and skill of sculptors. It would also be extremely valuable to know the number of bones and the projections of muscles and sinews. It is also very important to understand how we observe the outlines of the body by sections. For, if someone cuts an upright cylinder so that the part you can see is divided from the part you cannot see from that same position, two bodies are made out of this cylinder, though their base remains equal and the same, and they are still contained in four lines and circles. The same is true of our observation by sections of the body. There is the outline at which the surface we see from a particular viewpoint ends and is separated from the other we cannot see by virtue of the part that stands between; and this outline, if it were drawn properly on a wall, would produce a figure exactly like the one a shadow would make by interception of light, if the source of light were placed at the same point in space where the eye of the observer had been before. But this theory of observing sections and outlines is more a matter for the painter than the sculptor. But of these elsewhere. It is also of primary importance for whoever professes this art to know how far from a fixed position of the perpendiculars lies the maximum or minimum projection of each limb.

Notes to De Statua

References to the text of *De statua* are to paragraphs.
For details of works cited see bibliographies, pp. 29–30.

Letter

Giovanni Andrea de' Bussi (1417–1475), born in Vigevano, and educated in Paris and Mantua (with Vittorino da Feltre), came to Rome via Genoa in 1452. There he remained, despite nomination as bishop of Accia (1463), then of Aleria (both in Corsica). Active and renowned as a scholar and textual critic, he assisted the famous printers Schweinheim and Pannartz, and edited many classical texts. He later became Vatican librarian. These brief details explain Alberti's admiration for Bussi in this letter, from which it is possible to infer that he may have had in mind publication of his treatises on art through Bussi's agency. The letter must have been written after July 1466, when Bussi became bishop of Aleria; and it is conceivable that it may have been written late enough for Alberti's death (in 1472) to have interfered with any project for publication. On Bussi, who would repay further study, see G. Mancini, *Vita di L. B. Alberti*, cit., pp. 484–485, and the large bibliography in M. Cosenza, *Dictionary of Italian humanists*, Boston, 1962, vol. 1.

De statua

1. On this theory of the origin of the plastic arts, see Introduction pp. 21–22, and Parronchi, 'Sul *De statua* albertiano', cit., pp. 9 ff., though it does not seem necessary to disturb Alhazen for the theory of vision explaining how Man sometimes sees things that are not in effect there, or to invoke the imaginings of lovers (Dante, Petrarch). More relevant are Parronchi's references to Aristotle's *Physics* as probable sources for Alberti's concept of the similar functions of Nature and Art (*Nat. ausc.*, II, viii; *De part. anim.*, I, 1).
2. Parronchi, art. cit., p. 13, also indicates in Aristotle the probable source of Alberti's distinction between the various types of plastic artist, including the operation made famous by the dictum of Michelangelo (in Alberti's words 'by removing the superfluous (to) reveal the desired figure of a man hidden within a block of marble'): *Nat. ausc.*, I, x.
3. The basic idea of this paragraph possibly derives from Alhazen, *De aspectibus*, II, 75, with some allusion to Aristotle, *Physiognomonica* (Parronchi, pp. 13–14).
5. I have kept the Latin terms *dimensio* and *finitio* in the English translation, for lack of precise equivalents that correspond to the operations and methods described. On the passage in lines 17–21 of the Latin text (Veluti si forte . . . quin ita sit) cfr. Flaccavento, 'Per una moderna traduzione del *De statua*', cit., p. 58, and Parronchi, art. cit., p. 17 (though there seems no reason to bring in astronomy where all that is intended is an indication of a particular attitude and position of the body). The extreme cases cited in this paragraph (of being able to reconstruct a figure accurately from precise records even many years later; of determining the precise position of parts of a figure even when enclosed in a cylinder of clay or wax; of being able to make a statue of the same form of any size whatever, or to construct it, part in one

place and part in another) are given to underline the almost fabulous properties of the instruments he will describe as well as the constancy of proportions. For possible sources of Alberti's ideas here, see Parronchi, art. cit., pp. 15–16 (Aristotle, *Nat. ausc.*, III, v, vi, viii). The final sentences (concerning representation of Hercules) make it clear that Alberti's treatment of sculpture here and the methods he describes are essentially and deliberately limited to measurement; but they imply that it was as much the sculptor's as the painter's business to render the emotions through physical dispositions and differences.

6. Alberti explicitly says that the name 'exempeda' is based on the fact that it contains six 'feet' (cfr. Panofsky, *Meaning in the visual arts*, cit., p. 125, n. 80).

8. The opening sentence may be an oblique allusion to Alberti's own work on the building of ships, entitled *Navis*. It is referred to at the end of the proem to Alberti's *De re aedificatoria* and was known in the 16th century, but has since been lost. The part of the 'finitorium' Alberti calls the 'horizon' is very similar to the disc used in the *Descr. Urbis Romae* (ed. cit., pp. 60–63), and probably derives from Witelo's *Perspectiva*, II, i (Parronchi, art. cit., p. 18), though the adaptation of the radius and plumb-line and their particular use are Alberti's own. For the general context of these scientific instruments (marine, astronomical, surveying), see Gadol, op. cit., pp. 143 ff.; and for very similar technical instructions to those that follow here in *De statua*, see Alberti's *Ludi matematici*.

10–11. See fig. 2. The operation of the 'finitorium' is based on the relationship between the central median perpendicular dropped through the figure from the top of the head to the ground, and the cylinder described around its centre by the plumb-line at the point of furthest lateral extension.

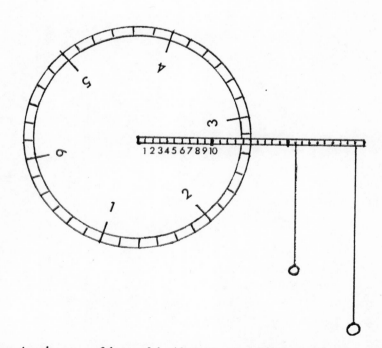

Fig. 2: *Finitorium*

12. It is less easy to imagine the successful use of the 'finitorium' on the head of a live model. Note here (and cfr. §13) the relevance of these measurements and proportions to painters as well as to sculptors. For 'the artist at Croton' cfr. *De pictura* §56, and note. In the tables figures

are lacking in all the MSS examined for certain measurements. In other instances some MSS have statistics, others not. I have conflated the available data. There are some minor variations in figures, but none of any consequence. To avoid misunderstanding I have regularized the orthography of the MS sources in some cases, e.g. *ischia*, not *stia* (fem. sing.).

For pictorial illustration of the tables see Plate I.

13. As indicated above (p. 6), the passage 'Tum etiam novisse vehementer conferet' to 'magis ad pictorem pertinet quam ad sculptorem', occurs in only part of the MS tradition. It has the air of an afterthought, added with some reservation to the other final observations thrown out but not developed at the end of the work. Though it is true that the content of this addition is of particular importance for the painter who represents a section of a body on canvas, it is not irrelevant for the sculptor whose task is to make all possible visible sections (depending on the changing viewpoint) true to Nature.

Appendix

ALBERTI'S WORK IN PAINTING AND SCULPTURE

I. *Documentary evidence*

(i) 'Vita anonima' (15th century); a principal source for Alberti's biography, and possibly written by himself. It contains more than one reference to his artistic activities. The most important reads as follows:

Familiares arcessebat, quibuscum de literis et doctrina suos habebat perpetuos sermones, illisque exscribentibus dictabat opuscula, et una eorum effigies pingebat aut fingebat cera. Apud Venetias vultus amicorum, qui Florentiae adessent, expressit annum mensesque integros postquam eos viderat. Solitus erat rogare puerulos eam ne imaginem, quam pingeret, nossent, et negabat ex arte pictum dici quod non illico a pueris usque nosceretur. Suos vultus propriumque simulacrum emulatus, ut ex picta fictaque effigie ignotis ad se appellentibus fieret notior.[1]

(He used to invite his friends with whom he had continual discussions about letters and learning; he would dictate his works to them as they wrote, and meanwhile paint their portrait or model them in wax. In Venice he did the heads of friends in Florence months or a year after he had seen them. He used to ask boys whether they knew the portrait he was painting, and he denied that anything was painted with true art that could not at once be recognized by a child. He did his own head and portrait, so that from a painted and modelled likeness he should be more readily known to visitors who had not met him.)

(ii) Cristoforo Landino (1424–98)

'Né solamente scrisse, ma di mano propria fece, e restano nelle mani nostre commendatissime opere di pennello, di scalpello, di bulino e di getto da lui fatte'.[2]

(He not only wrote, he also practiced the arts himself, and we possess excellent works done by him of painting, sculpture, engraving and casting.)

The statement is very general, but reliable, as Landino was among Alberti's closest friends. Through him, probably more than anyone else, Alberti's reputation passed to the younger generation of Poliziano, whose praise of the author of *De re aedificatoria* includes the statement: 'Optimus praeterea et pictor et statuarius est habitus' (He was also considered an excellent painter and sculptor).[3]

[1] *Opere volgari di L. B. Alberti*, ed. A. Bonucci, vol. 1, Florence, 1843, pp. xc ff.; the passage quoted is on p. cii.

[2] C. Landino in the chapter on 'Fiorentini eccellenti in dottrina' in the proem to his commentary on Dante's *Comedy*, first published in Florence in 1481.

[3] Dedicatory letter to Lorenzo de' Medici, prefaced to the ed. princeps of Alberti's *De re aedificatoria*, Florence, 1485.

(iii) Giorgio Vasari, *Vita di L. B. Alberti*, in *Le vite de' più eccellenti architetti, pittor et scultori italiani*, 1st ed. 1550, 2nd ed. 1568.

Nella pittura non fece Leonbattista opere grandi, né molto belle, con ciò sia, che quelle, che si veggiono di sua mano, che sono pochissime, non hanno molta perfezione, né è gran fatto, perché egli attese più a gli studi, che al disegno; pur mostrava assai bene, disegnando il suo concetto, come si può vedere in alcune carte di sua mano, che sono nel nostro libro: nelle quali è disegnato il ponte sant'Agnolo, et il coperto, che col disegno suo vi fu fatto, a uso di loggia, per difesa del sole ne' tempi di stati, e delle piogge, e de' venti l'inverno, la quale opera gli fece far papa Nicola quinto, che aveva disegnato farne molte altre simili per tutta Roma, ma la morte vi si interpose. Fu opera di Leonbattista quella, che è in Fiorenza su la coscia del ponte alla Carraia in una piccola cappelletta di Nostra Donna, cioè uno scabello d'altare, dentrovi tre storiette con alcune prospettive, che da lui furono assai meglio descritte con la penna, che dipinte col pennello. In Fiorenza medesimamente è in casa di Palla Rucellai un ritratto di se medesimo, fatto alla spera, et una tavola di figure assai grandi di chiaro, e scuro. Figurò ancora una Vinegia in prospettiva, et San Marco; ma le figure, che vi sono furono condotte da altri maestri: et è questa una delle migliori cose, che si veggia di sua pittura.[4]

(In painting Alberti did not accomplish anything of great importance or beauty, for those one sees done by him (and they are very few) are not very well executed; nor is this surprising, since he devoted himself more to study than to draughtsmanship. Yet he was able to express his ideas very well in drawing, as can be seen from some sketches by him that are now in our collection; they are of the Sant' Angelo bridge and the roof over it, done to his design, in the form of a loggia for protection against the sun in summer, and the rain and winds in winter. He was commissioned to do this by Pope Nicholas V, who had planned to carry out many similar projects throughout Rome, but was prevented from doing so by his death. There is a painting by Alberti in Florence in a little chapel of Our Lady on the abutment of the Carraia bridge; it is an altar-piece containing three small scenes with perspectives, which he described much better with his pen than he painted them with his brush. Also in Florence, in the house of Palla Rucellai, there is a self-portrait, done with the aid of a mirror, and a panel with large figures in chiaroscuro. He also painted a picture of Venice in perspective, and St. Mark's; though the figures in it were done by other artists; and this is one of the best of his paintings that we have.)

Later testimony adds nothing to our knowledge of Alberti's work.[5] It is interesting, nonetheless, that Vasari's silence about Alberti's activities as a sculptor should

[4] I take the passage quoted from Vasari, *Vite cinque*, ed. G. Mancini, Florence, 1917, pp. 39–40 (with useful notes).

[5] For some other references see G. Mancini, *Vita di L. B. Alberti*, Florence, 1912, p. 120.

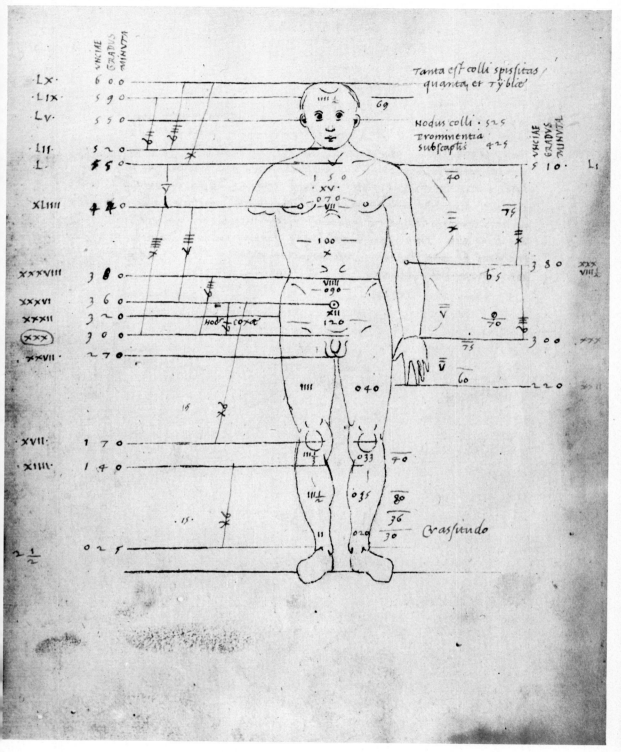

I. MS. Canon. Misc. 172, fol. 232 verso. Oxford, Bodleian Library (see p. 142)

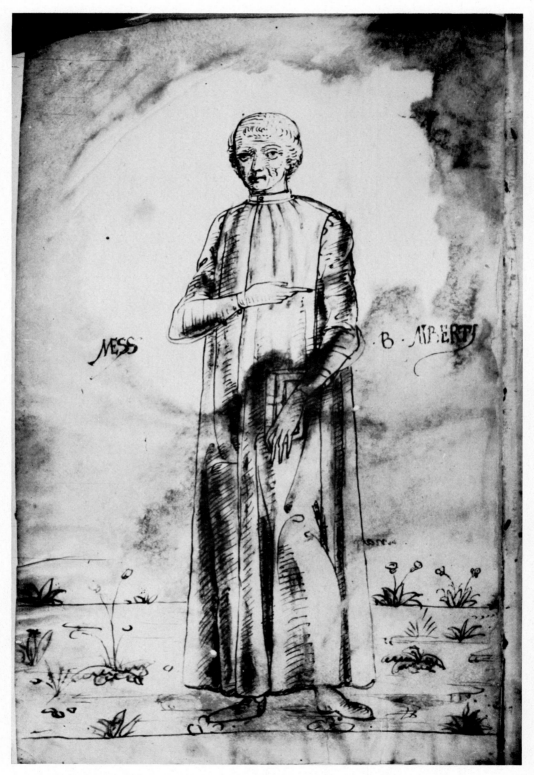

II. Self–Portrait of Alberti (?). Rome, Biblioteca Nazionale, Fondo Vittorio Emanuele, MS. 738
(see p. 153)

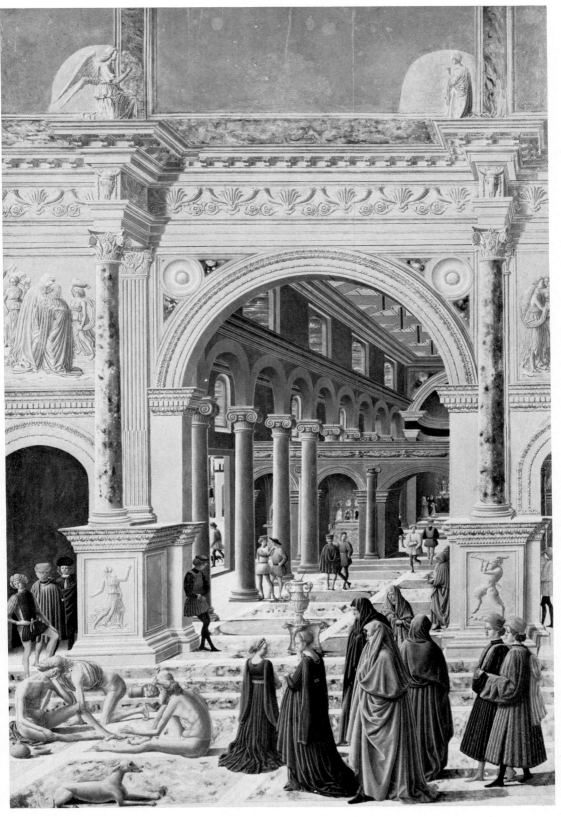

III. The Presentation of the Virgin. Boston, Museum of Fine Arts (see p. 153)

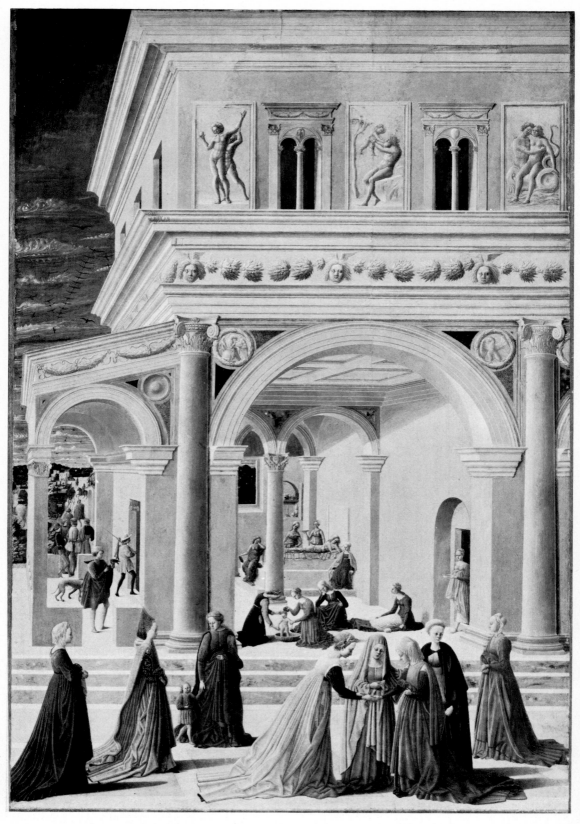

IV. The Nativity of the Virgin. New York, Metropolitan Museum of Art (see p. 153)

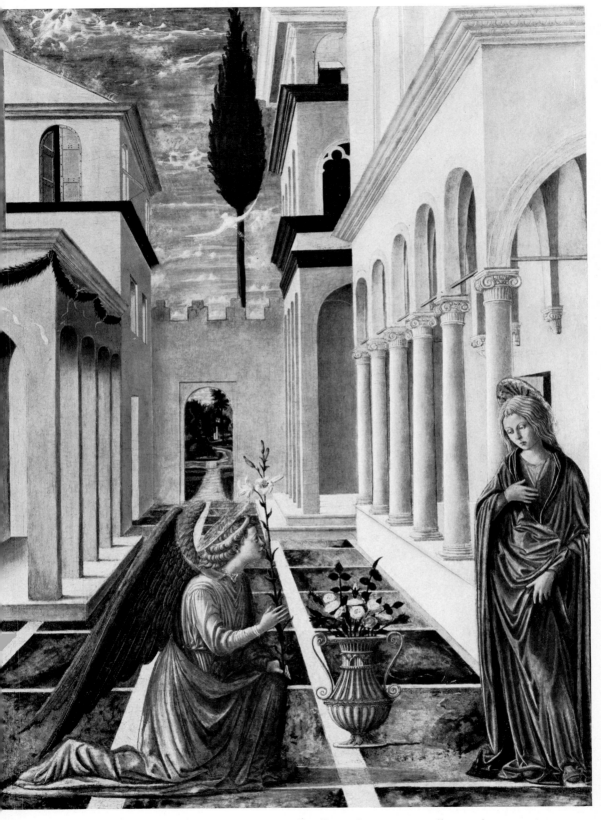

V. The Annunciation. Washington, National Gallery of Art, Kress Collection (see p. 154)

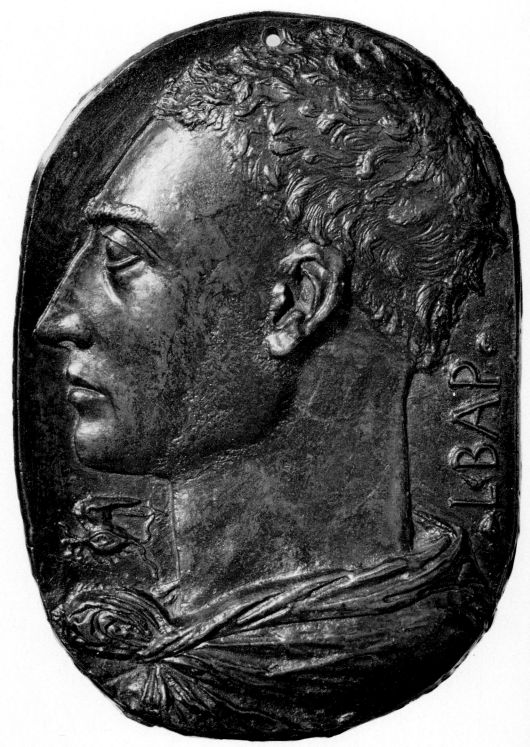

VI. Self-Portrait of Alberti. Bronze plaquette.
Washington, National Gallery of Art, Kress Collection (see p. 154)

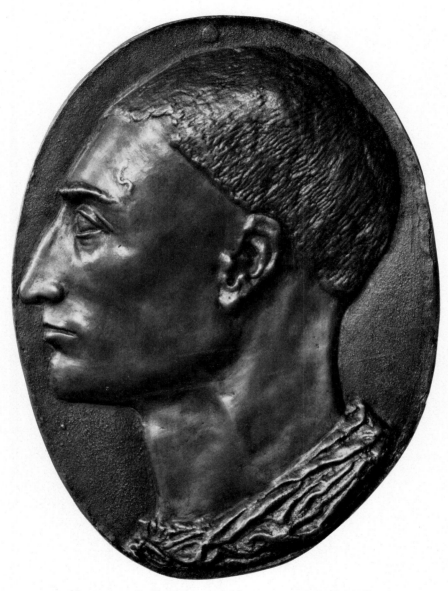

VII. Self-Portrait of Alberti. Bronze plaquette. Paris, Louvre (see p. 154)

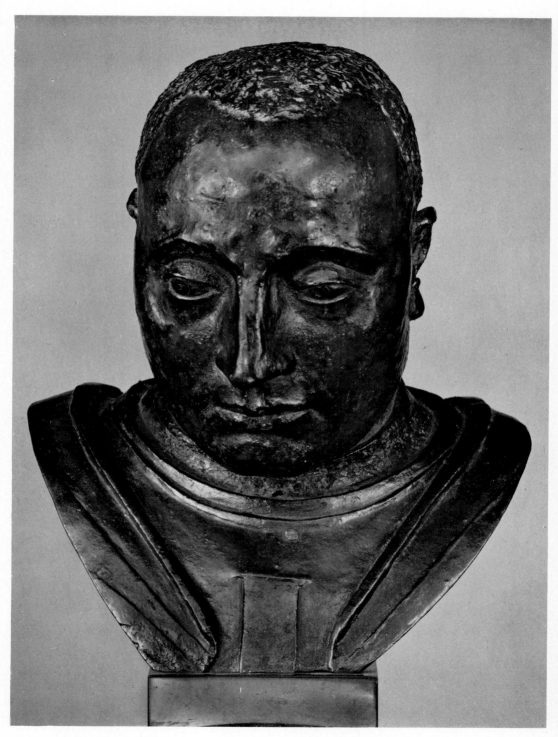

VIII. Bust of Lodovico Gonzaga. Bronze. Berlin, Staatliche Museen (see p. 154)

eventually develop into a specific denial that he accomplished anything in this field. In Raffaello Borghini's *Il Riposo . . . in cui della Pittura e della Scultura si favella*, Florence, 1584, Alberti is described as a learned man, architect and painter (p. 42), but when it comes to accepting his authority about the superiority of the art of painting, sculptors object, 'dicendo che egli è stato giudice, e parte, percioche egli era pittore, e non iscultore, perciò che in questo no se gli dee prestar fede' (saying that he was both judge and interested party, since he was a painter and not a sculptor, so his word should not be accepted in this matter; p. 44). Even then, Alberti does not figure in book III of *Il Riposo* among the painters from Giotto to the sixteenth century.

II. *Attributed works*

(a) *Painting and drawing*

None of the works mentioned in the above sources is now extant or identifiable with certainty. In these circumstances it is tempting to regard the pen and ink drawing on the flyleaf of MS 738 of the fondo Vitt. Emanuele, Biblioteca Nazionale, Rome, as a possible self-portrait (Pl. II) of the kind referred to in the 'vita anonima' (the one mentioned by Vasari presumably being a painting, done full-face in a mirror).[6]

The painting of Venice in perspective may have been done on similar principles to that of Rome, the basis for which is described in Alberti's *Descriptio Urbis Romae* (cfr. also his *Ludi matematici*, in *Op. volg.*, ed. Bonucci, cit, vol. IV, p. 430), but no certain evidence exists for their survival.

A bold attempt was made a few years ago by Professor Parronchi to identify the altar-piece in the chapel on the ponte alla Carraia with two panels generally ascribed to the 'Master of the Barberini panels': the 'Presentation of the Virgin' and the 'Nativity of the Virgin', now respectively in Boston and New York (Pl. III–IV).[7] There are difficulties about accepting this attribution to Alberti. A major one is the question of size. The chapel no longer exists, but we know it to have been very small. These two panels are each approximately three feet wide by four feet high; so that a triptych of these proportions would have been roughly nine feet wide. On Parronchi's reconstruction of the perspective the width would be more like twelve feet. These measurements seem highly unlikely for what

[6] C. Grayson, 'A portrait of L. B. Alberti', in *The Burlington Magazine*, vol. XCVI, n. 615, June 1954, pp. 177–178, with full bibliography.

[7] Alessandro Parronchi, 'Leon Battista Alberti as a Painter', in *The Burlington Magazine*, vol. CIV, n. 712, July 1962, pp. 280–286. Many earlier attempts had been made to identify the 'Master of the Barberini Panels', the most recent and persuasive by F. Zeri, *Due dipinti, la filologia e un nome*, Turin, 1961, who proposed the name of Giovanni Angelo di Antonio da Camerino. For further bibliography see Shapley, cit infra, p. 3.

Vasari can call a 'scabello d'altare'. But even if one discarded the hypothesis that these panels had anything to do with that chapel, it is still difficult to accept Alberti as the artist. Whilst there are some possible Albertian elements and allusions in them, as Parronchi maintains, their perspectival construction does not seem to conform to the mathematical precision recommended in *De pictura*. The acid test should be, rather than the recognition of vanishing points on the extreme right and left of these panels (there are imperfections in the actual paintings which do not appear in the drawing A accompanying Parronchi's article), the examination of the recession of the transversals. Preliminary work on these lines carried out a few years ago, suggests that they are based on a system similar to the rule of thumb method criticized by Alberti in *De pictura* (see §19), and not on his 'costruzione legittima'.[8] This kind of examination needs further development. If Parronchi were right about these two panels, it would follow that Alberti also painted the Annunciation in the Kress collection in Washington (Pl. V)[9] and a portrait of Frederick III (Uffizi). Whatever the merits of the Kress Annunciation, it is hard to imagine Alberti painting the vase between the two figures, as it is clearly not standing on the floor, but seems suspended in mid-air.

(b) *Sculpture*

The allusions in the 'vita anonima' and in Landino together confirm that Alberti modelled, sculpted, and cast, and that his subjects were probably the heads of himself and his friends. We know nothing of any work in clay or wax or stone. Three works in bronze are generally accepted as Alberti's:

(1) the fine portrait head in the Kress Collection in Washington (Pl. VI); plaque in low relief, 200× 135 mm.;

(2) a somewhat similar portrait head in the Louvre, Paris (Pl. VII); plaque in low relief, 155× 115 mm.;[10]

(3) a bust of Lodovico Gonzaga of Mantua in the Kaiser Friedrich Museum, Berlin (Pl. VIII), at one time tentatively attributed to Donatello.[11]

In none of these cases do we possess documentary evidence in support of the attributions, which rest on technical and artistic appreciation, and on probability.

[8] I refer to an examination of the panels carried out by Mrs. Frances Robb for a seminar on Alberti at Yale in the autumn of 1966.

[9] See F. R. Shapley, *Paintings from the Samuel H. Kress Collection, Italian Schools XIV–XV Century*, London, 1968, p. 3.

[10] G. F. Hill, *A corpus of Italian medals of the Renaissance before Cellini*, London, 1930, vol. I, pp. 5–6, vol. II, Pl. 2, nos. 16–17; and with full up-to-date bibliography J. Pope-Hennessy, *Renaissance Bronzes from the Samuel H. Kress Collection*, London, 1965, pp. 7–8.

[11] Kurt Badt, 'Drei plastische Arbeiten von Leone Battista Alberti', in *Mitteilungen des Kunsthistorischen Institutes in Florenz*, Achter Band, Heft II, Sept. 1958, pp. 78–87. This attribution now seems generally accepted.

Index

Index

Except where otherwise indicated (e.g. by page and note number), all references are to paragraphs (without prefix for *De pictura*; prefixed by *S* for *De statua*).